PHOTO PROJECTS

First published 2006 by Argentum,
an imprint of Aurum Press Ltd
25 Bedford Avenue, London WC1 3AT

A catalogue record for this book is
available from the British Library.

ISBN 1-902538-44-7

1 2 3 4 5
2006 2007 2008 2009 2010

Printed in China

Designed by Chris Dickie.
Typeset in Din and Utopia.

All photographs are © the photographers as credited.
Cover collage image © Chris Dickie.
Individual cover images © Tessa Bunney, John Claridge,
Simon Denison, Chris Dickie, Nigel Green, Paul Hart,
Chrystel Lebas, Andrew Shaylor and Hugh Symonds.

PHOTO PROJECTS

Plan & Publish Your Photography
– in Print & on the Internet –

CHRIS DICKIE

Argentum

Contents

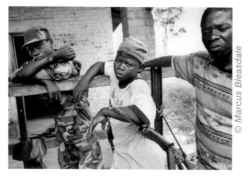

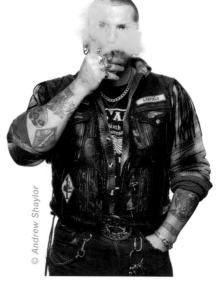

CONCEPTION

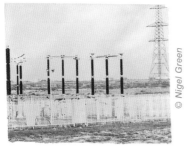

© Nigel Green

© Marcus Bleasdale

© Andrew Shaylor

PLANNING

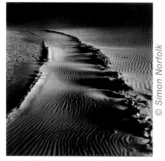

© Simon Norfolk

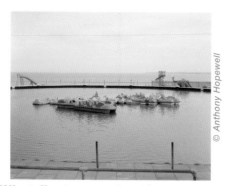

© Anthony Hopewell

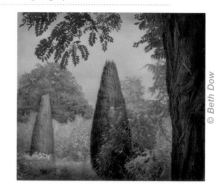

© Beth Dow

PUBLISHING

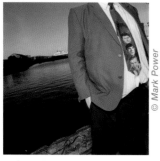

© Mark Power

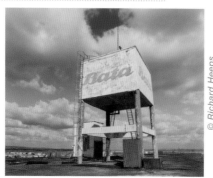

© Richard Heeps

© Dominique Bollinger

© William Curwen

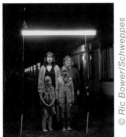

© Ric Bower/Schweppes Photographic Portrait Prize

NEW IN PRINT 93

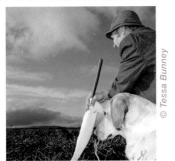

© Tessa Bunney

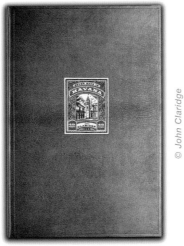

© John Claridge

© Alan Knowles

lost and stolen

ed swinden

© Ed Swinden

peeled**eye**shop™ contemporary fine a

Home Search All Artists A-Z Browse

List of Photographers

Stefan Bajic — view all, view artists gallery
Patrick Baldwin — view all, view artists gallery
George Brooks — view all, view artists gallery
Justin Canning — view all, view artists gallery

Duncan Davis — view all, view artists gallery
Patrice De Villiers — view all, view artists gallery
Tim Doyle — view all, view artists gallery
Tim Gravestock — view all, view artists gallery

Tim Platt — view all, view artists gallery
John Potter — view all, view artists gallery
Valery Rizzo — view all, view artists gallery
Ian Sanderson — view all, view artists gallery

© PeeledEyeShop

Ag

Ag NOIR

the international quarterly journal of photographic art & practice

● COVER STORY
John Claridge has been making portraits of the regulars at a famous Soho watering hole – The French House.

(h)arris by John Darwell

© John Darwell

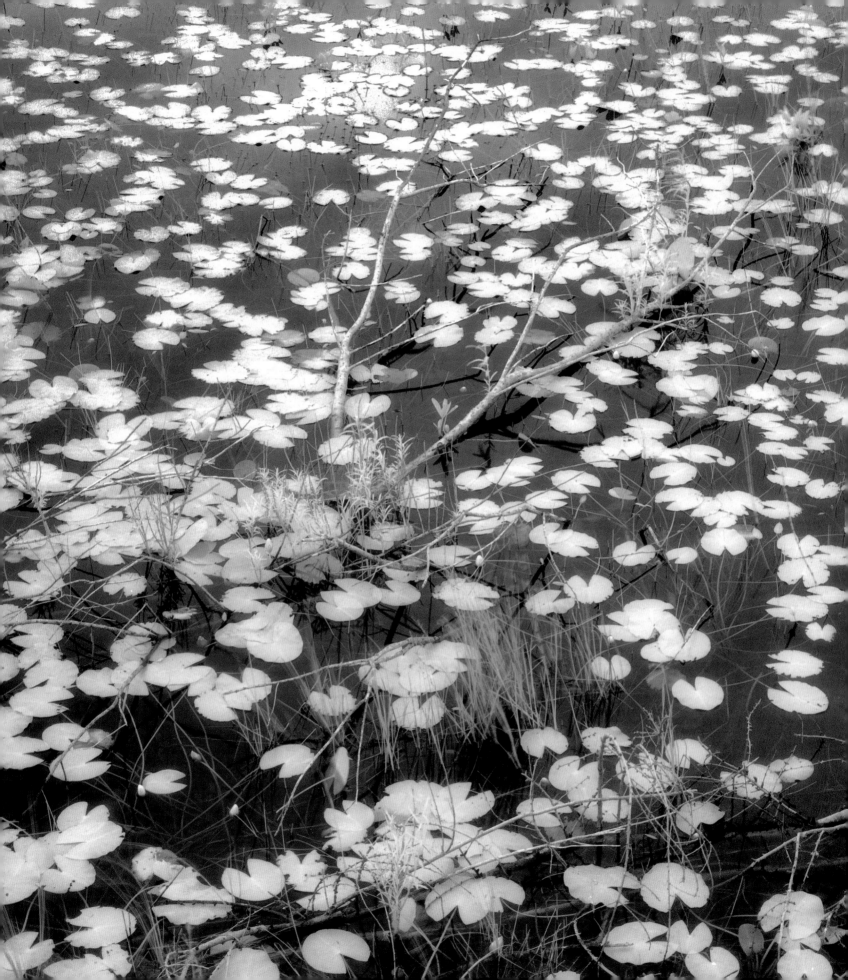

Foreword

YOU MAY HAVE NOTICED the word "passion" woven into the cover collage. Passion? If you weren't passionate about making photographs it is unlikely you would be reading this. And the same can be said of all the photographers who have contributed to this book and whose work demonstrates that their passion extends beyond the simple creative act of making an image to embrace that which is being photographed. For them the process of recording is just a small technical aspect of the investigation, of discovery and the collecting of evidence, and a mode of portrayal and expression. In the pages that follow these photographers share not just their images but the inspiration behind them, the source of that inspiration, the objectives they set themselves and the discipline that saw the work through to completion. They talk about the obstacles they faced and overcame, how funds were raised and utilised, exhibitions mounted, publishers' arms twisted, printers charmed into excelling themselves... .

They talk also about a photographer's need to develop a visual language: a way of telling that fits comfortably with the subject matter which is an essential factor in achieving coherence in a body of work. Many mention the persistence necessary to see a project through to a satisfactory conclusion and their unwillingness to compromise; frequently they quote instances of the way in which self-help has given them the edge in gaining help from others. A single-minded approach to a set of clear objectives may not be as easy as it sounds to stick with, but it is at least one of the things these photographers have in common.

This is not intended as a step-by-step manual of bright ideas for photo projects: what you will read is the voice of experience and real achievement. What follows is about making the jump from mere technical competence with an eye for a good snap to a teller of tales – an image-maker in the role of explorer whose disclosures deserve a wider

audience and merit exhibition and publication. And how – based on what these photographers have learned – to set about making it happen.

Passion comes in as the driving force behind the work. It is something that is felt and provides the motivation to investigate, to dig into and around, to find and reveal. If you couldn't care less about what you are photographing you should ask yourself why you bother. The projects featured here are many and various, but in its own way each has succeeded through the photographer's curiosity, a determination to explore, and resolve to find a way to reach a wider audience. Never has there been an easier time to reach that audience: and while this is an undoubted benefit, don't let it cloud the primacy of the image. Worth a thousand words? And the rest.

Chris Dickie

Above and facing: from In From The Sea, a project documenting the ecology of the west coast of the Isle of Lewis, the largest of Scotland's Western Isles. The work has been self-published in book form using the internet 'on-demand' printing service lulu.com. © Chris Dickie.

Introduction

THE ODD THING about an Introduction is that you do it at the end and put it at the front. That way you know what you're introducing and readers find it before they find anything else. Always assuming they start at the right end. Anyway, I don't know about you but I've finished. Well, very nearly. If you've opened this the right way round then you're just beginning. But for me it's almost done: you know, the project, this book. It has taken a while to draw everything together, principally due to the number of photographers who have collaborated in helping me make my point – in fact several points, at least some of which I trust you will find helpful – and the number of images included, from which I hope you draw inspiration. You can be certain of the inspiration of those who made them.

And where did my inspiration come from? Where did I get the idea for this book? For the past 25 years I have been employed in the publication of photography magazines and books, and the last eighteen have been spent in the professional/semi-professional market. I now have my own business publishing the quarterly fine art photo journal *Ag* – more of a cottage industry, really. When you publish a periodical for a professional readership you inevitably attract a substantial number of non-professionals – readers who either aspire to become pros or who are content with their day job and simply photograph to professional standards often using pro quality equipment. The more the merrier, I say. And I've seen a lot of photographs from all of them. Mountains of very good individual photographs, in fact, but not always successful work, particularly from the latter group.

You can hone your technique until your images are technically flawless, invest in the best optics money can buy, observe the Zone System to the letter (that probably should be to the number) and refine your chemistry and processing procedures to create the perfect negative – but that won't give your images meaning. And that, I believe, is where a

project-based approach to photography comes in. By undertaking a project you are forcing yourself to think about your photography: what it is you are trying to achieve and how you are going to achieve it. The pictures acquire a point and a purpose beyond looking pretty, sharp and well composed. And subjecting yourself to the necessary discipline helps you and your photography develop. There is also great satisfaction in finding yourself with an identifiable, discrete body of work that has something to say, rather than another pile of snaps to join those in the shoebox under your bed.

So, I thought, let's listen to those who have travelled this road. See what they created, why and how, and then what further opportunities presented themselves – an exhibition, a book? And I owe a very big thank you to all the photographers who gave me their time, their images and their thoughts, and so made possible the pursuit of this project and the completion of this – nearly finished – book.

*The whole gamut: facing is **Parc de Jeurre**, © **Lynn Geesaman** from **Gardenscapes**, her commercially published book from the Aperture Foundation that draws on a body of work created over ten years. Above: from the **Fonephoto** series © **Hugh Symonds** in which he experimented with the imaging capabilities of a camera phone. The images are rather too low resolution for printing and will show pixellation, but are ideal for publishing on the internet: **hupix.net**.*

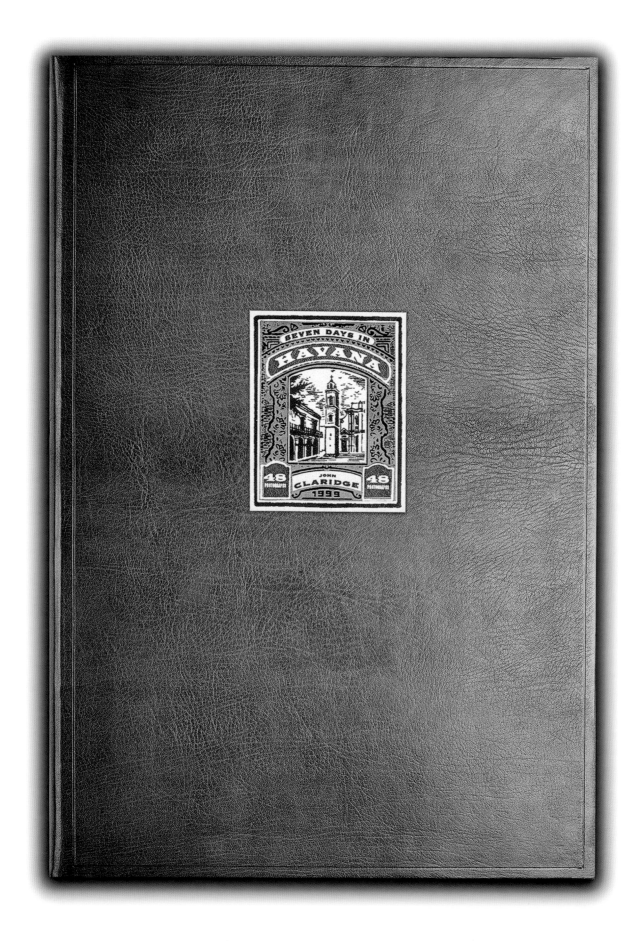

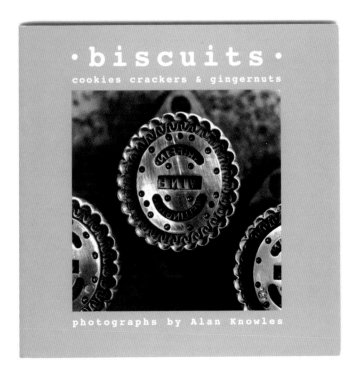

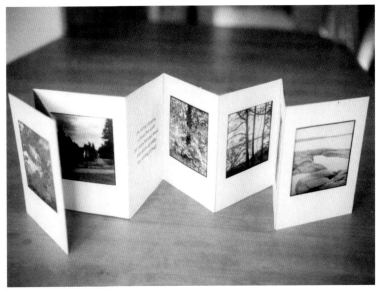

While the first half of this book looks at the concept of projects and one's approach to them, the second part considers what might come after the work is completed – or after it has at least achieved a well-rounded but maybe 'on-going' status. The topic is publication. Publication in the literal sense of being made public. And there are many options here, as we shall see, increasingly so thanks to the technological advances of recent years.

For simplicity you can divide publication in two: the exhibition and the book. For many, the latter has greatest appeal, implying as it does something lasting and permanent. But within these two broad categories exists a plethora of forms: the gallery in which you exhibit no longer needs to be a physical space; the book you publish may never go near a piece of paper… . As our photographers reveal, there is often an inextricable link between a show and a book. Having work exhibited can act as a lever in attracting funding or sponsorship, it can persuade a publisher to take a chance on you as it offers the potential for book sales. And if all else fails, or you don't wish to conform to someone else's idea of how to package your work, you can do it yourself. And there are examples that run the whole gamut of self-publishing in the following pages.

There is the single copy artist's book bound together with nuts and bolts, or the limited edition hand-pulled volume that sells for a cool £825 a copy. There are books printed 'on-demand' that are so inexpensive that the production cost is no more than the return postage, and virtual books where the only printer they will come across is the one sitting on your desk.

It seems generally agreed that the book is the optimum medium for the display of a body of photographic work. It is a physical object that can be revisited at will and the best of them have an aesthetic value of their own achieved through the design, paper choice and binding, and of course careful printing. The author is able to sequence and juxtapose the images to control the way in which the work is viewed: you can try doing this in a gallery, but you can't make the visitors stroll round in a certain direction, and even if you did you can't force them to view the work in a particular order. The vagaries of ambient lighting are less of a problem with a book: at worst you can move a book to a better position, something you would find is not generally approved of by gallery staff, were you to attempt to rearrange their display.

So that's me done. What was nearly finished about 1000 words ago is now complete. Left until the end, I will now put it near the front. I hope you find the experience of those who have contributed here useful. There are some great pictures, many inspiring stories, a lot of hard graft and determination… and, above all, plenty of passion.

Chris Dickie

More examples of scale and range: facing is Seven Days in Havana, © John Claridge, self-published in a lavish leather tooled binding, hand-pulled printing and a limited edition of just fifty, this is very much a collector's item and with a price to match.

Above right: Frank Watson's fold-out hand-made book could hardly be simpler.

Above left: small format self-cover booklet Biscuits © Alan Knowles was produced to coincide with his exhibition of the same name.

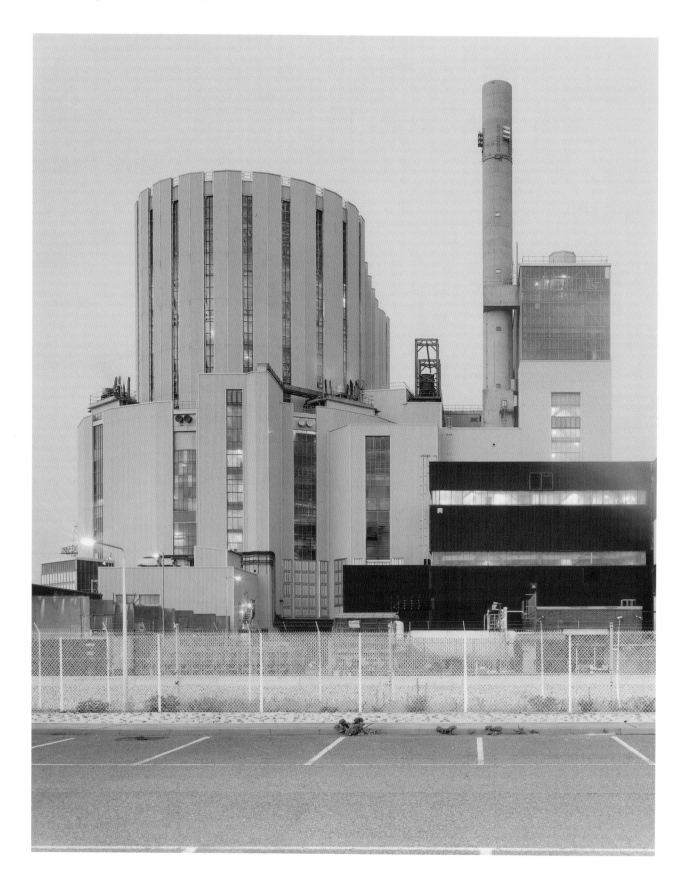

A little self-discipline

Embarking upon a photographic project with specific objectives is a very satisfying way of developing your own photographic practice

WHAT'S THE POINT in involving yourself in a project – sounds a bit like going back to school? And what, photographically, makes a "project" anyway? Some photographers may never have asked themselves the question, having instinctively worked in this way since picking up a camera; and the others, well they haven't thought about it much either, being content to pursue their hobby in search of the pretty picture. And if you fall into the latter group you have to ask yourself "What am I doing making pictures? Am I really making the most of the medium? What am I achieving?"

Pursuing a project can be very like schoolwork. You have an objective, a target, and, in the process of achieving it, you learn. Through this you and your practice develop, and you become a better photographer. By exploring your subject you gain insight and understanding, and your images make this knowledge available to others. The end-product is a coherent body of work where the whole is greater than the sum of its parts, rather than a set of chocolate-box tops. You demonstrate that you have something to say about your subject beyond simply having an eye for a good snap. A successfully executed project works like a well-argued essay;

indeed that is what it is, except that pictures provide the propositions and conclusions rather than words. And where conclusions are elusive at least there will be questions.

All in all a much more satisfactory and engaging outcome for both photographer and viewer. Unless you are obsessed by chocolate-boxes, that is.

All the projects that feature in this book explore their subjects from one angle or another and maybe several simultaneously. The purpose of exploration is discovery and the job of the photographer is to find and show what is or has been; how looking at something with different eyes can reveal afresh; reinterpretation of the thought-to-be-familiar through the photographer's unique vision; revelation of the unfamiliar.

A word that features regularly in the following pages is "discipline", another feature of school life, or so it used to be. It is a quality required for success in most fields of endeavour: not in the old sense of self-denial and being on your best behaviour, but in terms of concentration and focus, keeping 'your eye on the ball', avoiding distraction. The beauty of a self-initiated project is that it provides a framework for this focus, an objective, a purpose and fulfilment

Above and facing:
Nigel Green *spent about four years photographing in and around the nuclear power stations at Dungeness where his father had worked. He won a commission to develop the work into a book and exhibition from Brighton-based Photoworks; full details overleaf.*

*Images © **Nigel Green**.*

Featured project:
DUNGENESS
By Nigel Green
Theme: The nuclear power station complex at Dungeness on the Kent coast. A selection of images online at **www.photoworksuk.org.**
Exhibitions: Exhibited twice in its entirety (66 images) – Sasoon Gallery and Rye Art Gallery; a selection of work was also shown at Photofusion, London.
Book: Published by Photoworks at £17.95.
Format: 300x245mm, 72 pages plus cover, casebound with four-colour dust jacket, printed four-colour.
Designed by Stuart Smith; main text by David Chandler, with accompanying 'impressions of Dungeness' text by Jonathan Glancey.
ISBN: 1-83984-476-0
Print run: 700, printed by Dexter Graphics, Dartford.
Funding support: The project, exhibitions and publication were funded by Photoworks.

way beyond the self-gratification of running out into a sunny day for more pretty pictures. The project gives your photography a point. Your photography becomes a means to an end and not simply the end in itself.

The photographers behind the projects featured here talk about their work and the experience of trying to obtain funding, an exhibition or a book. Their experience might affect your thinking when it comes to approaching your own project. There is no reason on earth why your pursuit should interest anyone other than yourself, but if you wish to engage others in the work, in particular with a view to obtaining material support, then its significance to them must not be overlooked. Navel gazing can be a great source of inspiration to the artist, but don't expect to be swamped in the rush to insspect your midriff. Here are some thoughts from Magnum photographer Mark Power, based on his own experience. (His career-launching project *The Shipping Forecast* features on pages 24–29.)

"Getting good ideas, particularly sustainable ideas, is the conundrum facing all photographers. You must try to be open-minded and learn to recognise an idea when it presents itself. They can come from anywhere… *The Shipping Forecast* came from a tea-towel! And remember, the simplest ideas are usually the best ideas. How many times have we seen a body of work by someone else and wished that we had thought of that? How bloody obvious it was? How gloriously simple yet how utterly profound? So don't over-complicate, try always to pare it down to the bare essentials. I believe also that there are some ideas which lend themselves to photography while others really don't. Some ideas are better to talk about, or write music about, or whatever. What made *The Shipping Forecast* sustainable for me personally was that it allowed me pictorial freedom. I only needed to refer to the sea in some way in each image. Otherwise it was much like street photography… I never knew what I would find when I went out to work. Therefore a sense of discovery, and some naive kind of excitement, prevailed and kept me going. Had I done it differently, for instance if I had borrowed from Sugimoto's seascapes, then I might – at the time – have found it more difficult. Who knows?

"There are plenty of good photographers out there, and advances in digital technology mean that it is now even easier to take so-called 'good pictures'. (By the way, this democracy of photography is precisely what appeals to me about the medium, and is the reason why I moved away from painting – which I studied at art college – in the first place). We now live in a world in which what you do with photography is all-important. It is not about your technical ability or your money so much anymore. We should rejoice for this.

"Personally I always work in series, building towards something – I hope – bigger than the single image, something which – though I really dislike this term – I want to say. So if you have an idea that you believe in then pursue it at all costs; even through the darkest moments – for you will surely experience these – try and keep going.

"Take your time, live, breathe and understand your work. Try not to repeat yourself. And with each subsequent idea try and set yourself a new and fresh challenge."

Nigel Green was born in the same year, 1965, that the nuclear power station Dungeness 'A' on the Kent coast was brought into operation. Green's father worked on the project. Over the years his fascination with the place has grown and he had had occasion to discuss this long-standing interest with David Chandler, director of Photoworks, several times. In due course his *Dungeness* project was commissioned by Brighton-based Photoworks and, including work carried out ahead of receiving the commission, Green spent about four years photographing in and around the nuclear power station complex. Two principal – and very different – bodies of work have emerged: the first, large format colour studies of the interior and exterior of the installations (22 in all); and subsequently a series of 44 small abstracted and distressed monochrome prints, or 'fragments'. The culmination of Green's project was the book *Dungeness*, published by Photoworks, which includes an essay by Photoworks' director David Chandler and a 'personal guide to Dungeness' by Jonathan Glancey. The work was also exhibited locally and, in part, at Photofusion's gallery in London. Nigel Green writes:

"The evolution and development of the project took place over several years and during that time there were many changes. These included not only the work itself but also very practical problems such as negotiating access to the power station, the final

*Images © **Nigel Green**.*

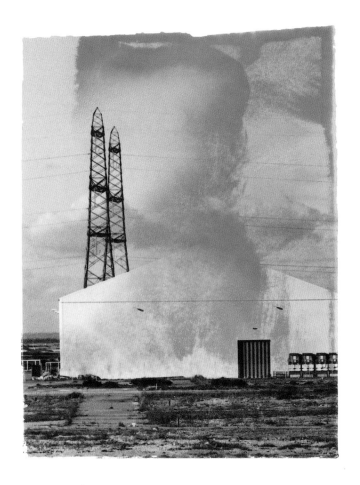

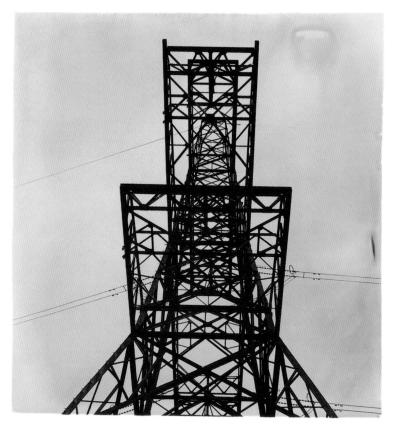

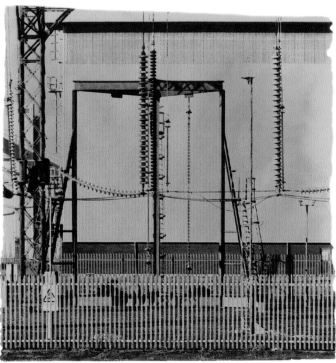

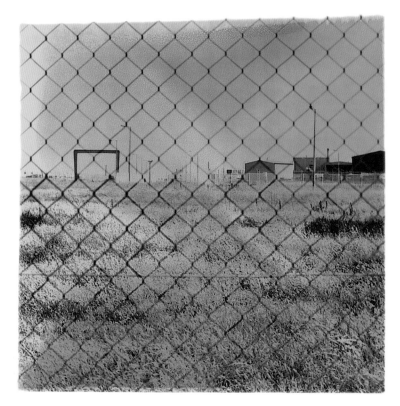

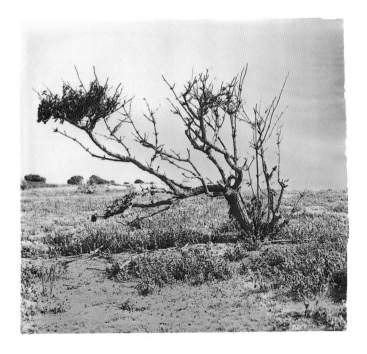

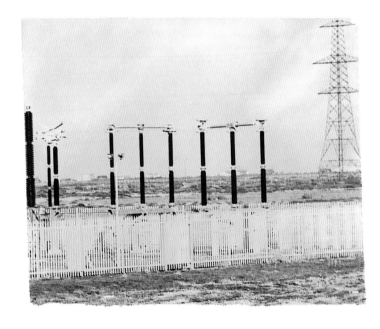

exhibition layout and venue, as well as the form the book might take. The exhibition was negotiated by Photoworks and the main criterion was that the venue had to have a proximity to Dungeness. The gallery, museum and library complex also house the Dungeness archive.

"The main thing is to be very focused on the realisation of the project and to negotiate any setbacks or problems as they arise. And it's important to point out the enormous amount of work and effort put into the project by other people.

In my case everybody at Photoworks was incredibly supportive and excellent to work with, and equally the project would not have been realised without the access and help provided by many different people at Dungeness B.

"The development of the book was almost another project in itself with many hours spent on its design and layout. Also there were those involved in printing, framing and the installation of the exhibition, all of whom played a vital role in the completion of the final project."

Above and facing are examples from the 'Fragments' series of distressed monochrome prints that form the final part of Nigel Green's Dungeness project.

All photographs © Nigel Green.

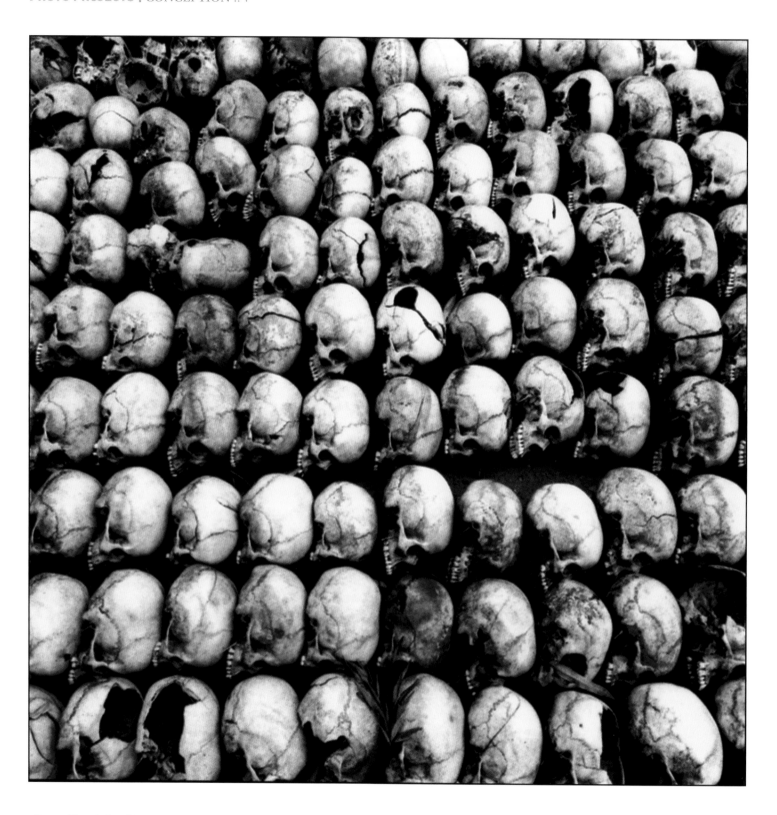

Above: The skulls of bodies found around the church at Ntarama, Rwanda, brought together at the beginning of the process of building a memorial.

Facing: Former prison at the monastery of Phnom Srei, Kompong Cham Province, Cambodia. © **Simon Norfolk** *from* **For most of it I have no words.**

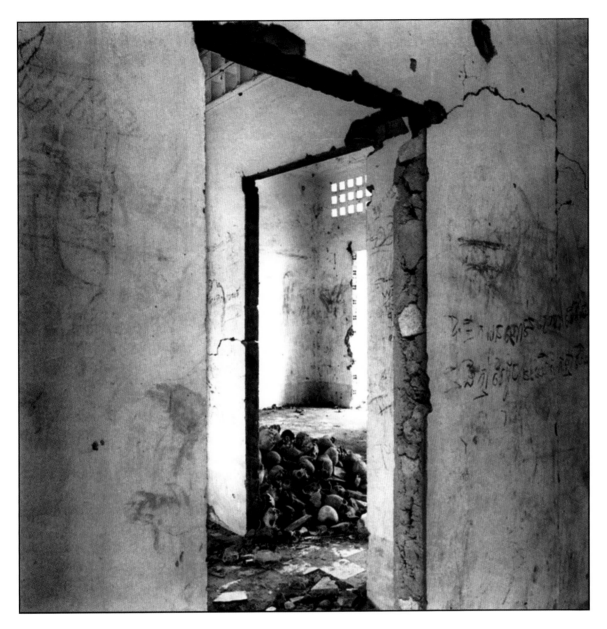

For most of it
I have no words

photographs by Simon Norfolk
essay by Michael Ignatieff

Featured project:
**FOR MOST OF IT
I HAVE NO WORDS**
By Simon Norfolk
*Theme: World sites of
genocide.*
*Examples online at
www.simonnorfolk.com.*
*Exhibitions:
Impressions Gallery,
York, then touring.*
*Book: Published by
Dewi Lewis Publishing
at £30.00.*
*Format: 320x225mm,
168 pages plus cover,
thread-sewn casebound,
embossed spine with
colour dust cover,
printed duotone.*
*Designed by Martin
Colyer; introductory essay
by Michael Ignatieff.*
ISBN: 1-899235-66-3.
*Print run: 2000, printed
in Italy by EBS, Verona.*
*Sponsorship: Fotospeed
(chemicals and paper for
exhibition prints).*

Let me tell you a story

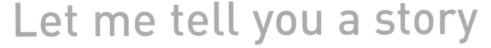

*A project provides an excellent framework for you to develop your
visual communication skills and a way of speaking photographically*

AS A PHOTOGRAPHER you are in the business of visual communication. You employ still images to tell a story, each one said to be worth a thousand words… . Well, that is a bit of a cliché, but if we didn't believe there was some truth in it we would all be writers. And like writers the world over we don't all use the same language; but whatever language or other way of communication we do use, it is through practising that we become more effective and therefore better communicators. Just

*Facing, top left clockwise:
Nose wheel of an F-5E
fighter-bomber, at the
military museum, Ho Chi
Minh City, Vietnam.*

*"The newly-invented
telegraph allowed the
authorities to make swift
and co-ordinated action
against the unsuspecting
Armenians."*

*"A first wave of RAF
high-explosive bombs
would blow the city of
Dresden open, then three
hours later would come
the second wave."*

*"The forests at Bykivnya,
near Kiev in the Ukraine,
hide the mass graves of
200,000 victims."*

like written and spoken language, visual communication improves with practise.

The body of work featured here, by Simon Norfolk, is called *For most of it I have no words*. It describes a difficult subject – genocide – and Norfolk talks about this need for the photographer to develop a satisfactory visual language, something that is particularly relevant to this project. I think we all understand the need for a body of work that comprises a project to be coherent, to hang and work together, and by the use of effective 'language' the photographer can achieve this aim. Through project-based practice the photographer is able to develop his or her own voice. With practise you may even become photographically 'multilingual'. Like a writer, however, it is recommended that you stick to one language per story… .

Simon Norfolk studied documentary photography at Newport College and left with his practice very much in the photojournalism mode: 35mm camera, wide lenses, fill the frame, present all the facts. But when he first embarked on the project that was to become his first book – photographing sites of genocide in countries around the world – he found the conventional journalistic approach was inadequate for conveying the message. The tightly cropped, tilted wide-angle frames went out of the window and he adopted an approach much more akin to landscape photography. Over the four years or so it took to complete the work, Norfolk reckons the first two were spent "slowing down".

"Photographers all need to learn to 'talk'", he says. "They need to develop a visual language which sits on top of the content in a satisfactory way."

For most of it I have no words arose out of his experiences as a photojournalist. One of the stories he followed involved far-right political groups, their meetings and rallies, and associated Holocaust-deniers and revisionists. In thinking of producing work that would debunk these "bizarre ideas" he formed the view that conventional photojournalism might be capable of reporting the facts, but is unable to convey the complexity of a many-layered story. In a move away from 35mm his first camera was a rollfilm Mamiya 6 with a 6x6cm format: "What to do with all that foreground?" – his conclusion on printing out those early square pictures was that here was "room to think: 'What is this?'" In photographing sites such as Auschwitz in

this more considered, less histrionic way, Norfolk feels he can "trust the viewer to bring what they know about this place" into their interpretation of his images.

The project involved eight principal sites and in the book a chapter is devoted to each. The cost of the considerable travel involved was partly kept down by embarking on a seven-week trek around Europe in his own car, and partly subsidised by his work on the features desks of the *Daily* and *Sunday Telegraph* newspapers. Vital to the successful compilation of book and exhibition proposals is access to a photocopier, and although the one at the *Telegraph* office was "run dry" during illicit early morning copy sessions, Norfolk is confident that the newspapers would have been proud to sponsor the work – had they known about it. There is also more than a little irony in the fact that a main source of the income that underwrote his project came from photographing for the *Sunday Telegraph* property pages.

Some 25-feet of bookshelves attest to the amount of research he undertook in preparation for the project. Not only did he want to be certain of his facts, but he had no intention of stopping a passer-by in, say, Rwanda and asking for directions to genocide sites. In Armenia he was briefed in private by a local who then insisted that Norfolk's notes be destroyed in his view; there was to be no documentary evidence should the Briton be stopped on his travels, everything had to be committed to memory.

Norfolk works with a 'double-ended' notebook. At the front he stores the 'facts' – notes on images and places – and at the back he keeps track of ideas, scenes, metaphors, titles; in short the acquired knowledge that will help him develop and fill out the front of the notebook. On his travels he may also carry small examples of the kind of imagery he is looking for. He is always on the lookout for interesting symbolism, and these visual notes make asking the question: "Where can I find something like this?" much easier.

From the earliest stages Norfolk saw his project as culminating in a book; exhibitions of the work were as much a way of securing a publishing deal (by providing a marketing platform for sales of the book) as an end in themselves. He had ideas about the book's content, its design, and what he calls its "curve" – this being his way of describing the

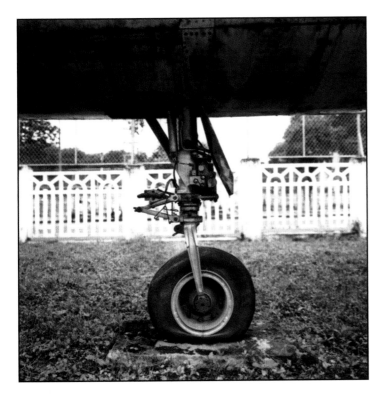
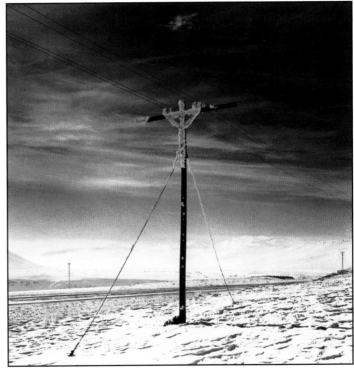
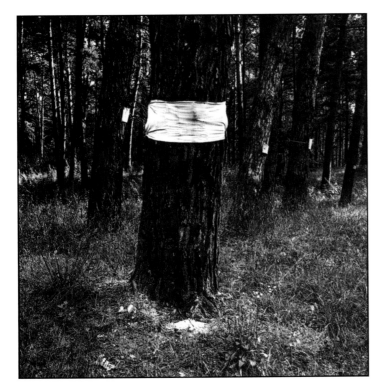

progression of the imagery through the book, both in sequencing and content. The inspiration for the 'curve' was Joseph Conrad's *Heart of Darkness* with its increasing use of symbolism and metaphor as the story progresses; in the case of Norfolk's book the reader begins the journey at the "atrocity exhibitions" of Rwanda and follows the curve through to the sand dunes of Namibia, "the sublime silence of infinity".

It is difficult for a relative unknown to interest a commercial publisher, but Norfolk had his thoughts so well ordered, with work in progress to show and a clear plan for the book, that he managed extract a firm expression of interest from publisher Dewi Lewis on the understanding that he would carry through the project and deliver the work to plan. Having already arranged exhibitions of the work at several venues, Norfolk was also offering the publisher the likelihood of book sales at those venues to underwrite some of the cost of production. The work was first shown at Impressions gallery in York, and toured around twelve venues including the Imperial War Museum in London. And now that he has several books under his belt, finding a publisher is rather easier.

"You have to work hard at the marketing and getting shows" is Norfolk's advice for those hoping to find a publisher. He also spent a great deal of time getting the look of the prints right for the exhibition. This comes back to what he spoke of earlier: "Finding a way of speaking, a vernacular", suited to the subject matter and what the photographer is saying. The objective was to perfect a technique that would render the images with suitable gravitas, while allowing the viewer to "look straight through the technique to the content". The steely blue/black of the exhibition prints was achieved after many hours of experimentation in the darkroom, and many gallons of gold toner. He was helped in this by generous donations of chemicals and paper by suppliers Fotospeed.

As far as Simon Norfolk is concerned the secret lies in putting together a programme to sell the book – in his case a series of exhibitions – and of course this remains true if you are publishing the book yourself. Turn this around and even if your ambitions don't extend to a full-blown hardback production, if you manage to secure an exhibition – and ideally this would be several shows across various venues – you have created the opportunity to sell a catalogue of the work. So publish it.

There is no better place to sell a printed collection of your work than at the place where the originals can be seen on the walls.

Facing: **"Auschwitz** is the moral equivalent of Copernicus. All our ethical measurements need recalibrating now that we know it exists."

Above left: **Armenia** – "The evidence of an intention to commit genocide is incontrovertible."

Above right: **Namibia** – Von Trotha's extermination order was: "All Herero must leave the country. If they do not do so, I will force them with cannons to do so… They must either return to their people or they will be shot at."

Images © **Simon Norfolk** from **For most of it I have no words.**

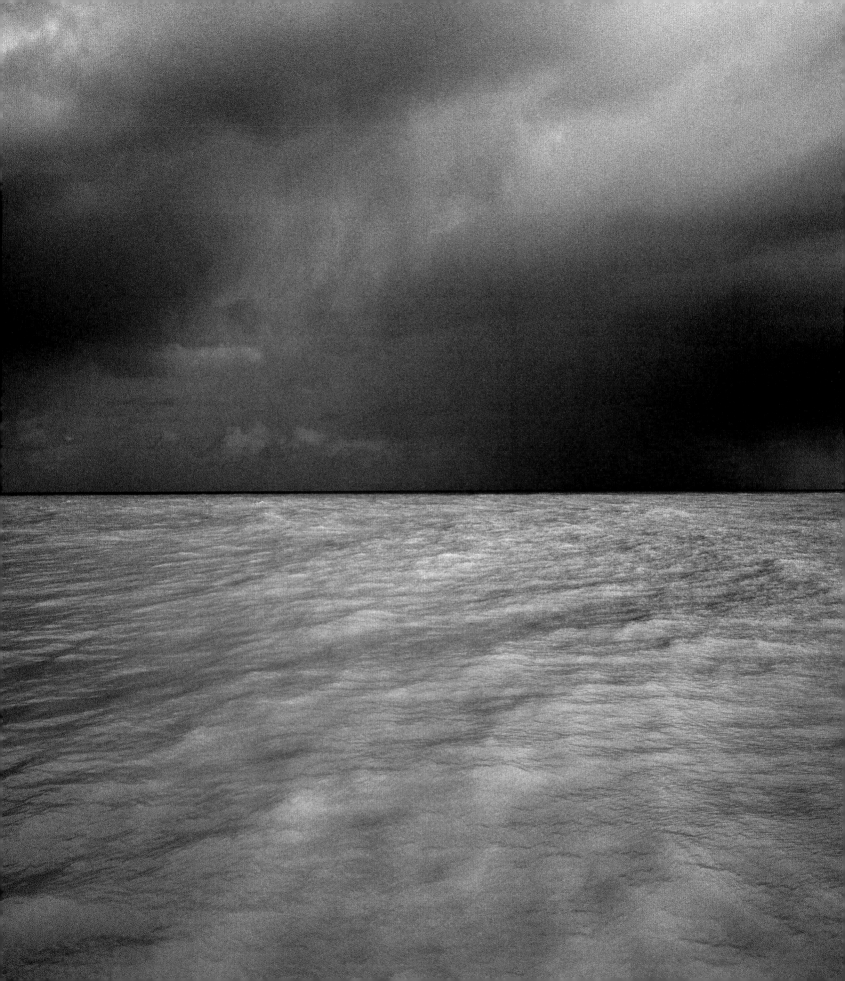

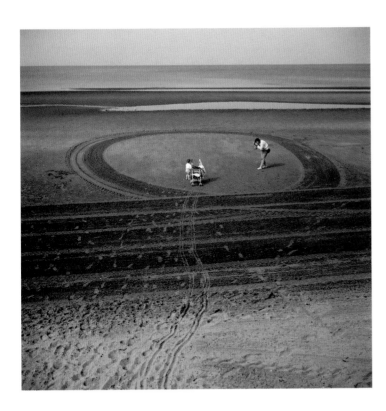

Determination to succeed

The first step is to identify an original and worthwhile theme, then comes the tricky business of sticking with it through thick and thin

HAVING ESTABLISHED that undertaking a project is a rewarding way to develop one's photography the next question would be: "Where to start?" Were this a how-to book there would follow a list of "101 Great Ideas for Photo Projects", but that's not the point of it. And, anyway, there is a danger that such a list would include many clichés, ideas that have been done a thousand times before. Even the concept of a list is itself now a cliché and seemingly the source of endless newspaper and magazine articles – or even novels. How one might approach a project at the outset is the subject of a later section (beginning on page 36), but here we listen to the experience of Mark Power who describes the germination and development of an original theme, and how he followed it through with a great deal of determination. He talks about how the idea first came to him, how he mastered the ambitious scope of the project, and how, eventually, *The Shipping Forecast* came to be a hugely successful toured exhibition and a book which has sold some 10,000 copies to date.

Mark Power began teaching photography in the early 1990s after several years photographing for magazines and charities. The project he embarked upon at that time and which resulted in his first book was elegant in its simplicity – one of those ideas we all wish we that had come up with – but grand in scale and therefore costly. Further, there was to be an exhibition, also grand in scale if Power could pull it off, which was to feature a body of work that publishers were to tell him was "too parochial". Not a promising sounding start, but Power stuck to his guns and, as he explains, all came good in the end.

Facing: **Wight, Saturday 18 February 1995**. *Northwesterly backing southwesterly 6 or 7, increasing gale 8 for a time. Showers then rain. Good becoming moderate or poor.*

Above left: **Malin, Monday 6 September 1993**. *Southeast backing easterly 4 or 5, increasing 6 in south. Mainly fair. Moderate or good.*

Above right: **Plymouth, Friday 12 August 1994**. *North or northwest 3 or 4. Mainly fair. Moderate or good.*

All © Mark Power.

Featured project:
**THE SHIPPING
FORECAST**
By Mark Power
*Theme: The sea areas
around the UK which
feature in the BBC Radio
weather forecast for
shipping. Online at
www.markpower.co.uk.*
*Exhibitions: Initially
Brighton Museum,
thereafter a further 21
venues. 50 images
exhibited.*
*Book: Published by Zelda
Cheatle Press in
collaboration with
Network Photographers
at £19.95 (hardback) and
£16.50 (softback).*
*Format: 280x238mm, 88
pages plus cover, printed
duotone.*
*Designed by Ian Noble;
introductory text by David
Chandler.*
*ISBN: Hardback
1-899823-02-6;
softback 1-899823-03-4.*
*Print run: First edition
1700 (hardback), 300
(softback), printed by
BAS, Hampshire.
Subsequently: 2nd edition
1000 hardback, 2000
softback; 3rd edition 5000
softback.*
*Production cost:
Approximately £16,000 for
the book's first edition.*
*Funding support:
$25,000 from the
Mosaique Fund.*

"An idea of some kind had entered my head way back in the mid '80s when I bought a tea towel in the RNLI shop in Great Yarmouth. It showed a map of the Shipping Forecast areas, which I found fascinating since the forecast had been very much a part of my childhood. My father had passed his National Service in the Merchant Navy, and had then become a very keen dinghy sailor. He built me my first dinghy, an Optimist, when I was seven years old. I know now that he used to tune in to the forecast in order to assess the sailing conditions, which implies that he understood it! For me, though, it was a kind of wallpaper; something which always seemed to be part of my surroundings. This, I later discovered, was not unusual; many others whose parents had listened to the Home Service – now Radio 4 – felt very much the same.

"When the project began, in 1992, I had just started teaching at the University of Brighton. I felt that it was time to practise what I preached: I needed to work on a project which was interesting enough to get me bounding out of bed in the morning, something which might consume me, which was something I really cared about. I decided to begin *The Shipping Forecast*, but exactly how this vague idea of finding out what these far flung places – these strange esoteric names which had, over the years entered my consciousness – actually looked like was unclear at the time. Looking back, if I had really considered the logistics of completing the work (I was surviving, at the time, on a salary of £600 a month from teaching) I would probably never have started. Anyway, I began to work locally, along the south coast of England (I live in Brighton) in order to work out exactly what I was trying to do, but without spending too much. I was also trying to work out some kind of visual language for the work. I say all this because I knew, in the back of my mind, that this would be a long-term project and, therefore, there was a right and a wrong time to look for sponsorship.

"After a year I began to write rather lavish proposals, over several pages, which included photocopies of early pictures from the series and possible 'outcomes' for the work. I also tried to think laterally about where I might apply for funding – not just the Arts Council but the commercial sector as well; in my case any company that I could think of which might be connected to the sea. I sent my proposal to Bird's Eye, Findus,

various oil companies, the Met Office, the BBC, the list went on and on. The results of all this were, sadly, ineffective, but I realise now that I didn't spend enough time trying to reach the right people in each company, and, I'll admit, I was slack in following up the proposal on the phone. However, back in a more conventional world, I did secure free film from Fuji for two years (a great help!), some paper from Ilford and some paper and chemicals from Agfa, as well as some expenses from the University of Brighton. But I must stress that I began to ask only after I had a concrete idea in place, and I really think it helped to be able to show examples of the work, so that people could see what they were 'buying into'.

"I went to see Brighton Museum and Art Gallery when the work was 80% complete. I decided on a museum rather that a photography gallery as my first port of call because I was interested in tapping into the museum circuit. I knew it was going to be a big show (at least, that is what I imagined) and traditionally museums offer larger spaces. Also I wanted to get it out of the apparent ghetto of photo galleries. I thought a museum-based show might reach more people, people who wouldn't normally visit photography shows. This, remember, was at a time before the appreciation of photography had reached the unprecedented levels it enjoys today.

Brighton Museum and Network (the agency I was represented by at the time) worked on securing the other venues, while I provided them with 6x7cm transparencies of some of the work and a mock-up of a framed photograph, together with a brief synopsis of what the show was about, why I did it, and so on. It was frustratingly slow at first: it seemed like Brighton was to be the only venue for a very long time. But after the first show, in January 1997, it gained a real impetus. The show and the book received an enormous amount of press coverage for a photo exhibition (this was were Network Photographers really came into its own) and the tour lasted for over three years in the end. Incidentally, it went to a mixture of photo galleries and museums which gave me the best of both worlds. It went abroad too.

"I was assuming, in my naivete, that the museum might offer some financial help, but that didn't happen beyond the invitations and the posters. So I was left with a date for a show, an almost finished body of work (but if you look at the book you will

Fair Isle, Sunday 28 January 1996. Southwesterly 4 or 5, occasionally 6 in southwest at first. Mainly fair. Good

Finisterre, Friday 9 April 1993. West or southwest 4 or 5, increasing 6 or 7. Showers. Moderate or good.

Trafalgar, Sunday 12 June 1994. Northeasterly 6 to gale 8, decreasing 5 or 6. Fair. Good.

Tyne, Sunday 25 July 1993. West or southwest 3 or 4, increasing 5 or 6. Showers. Good.

German Bight, Sunday 27 August 1995. Northwesterly veering northerly, 5 to 7, decreasing 4 for a time in east. Squally showers. Good.

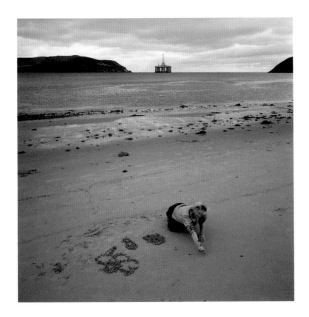

*Left: **Cromarty, Saturday 21 August 1993**. Westerly veering northwesterly, 4 or 5, occasionally 6. Showers. Good.*

*Right: **Dover, Friday 6 August 1993**. Northwesterly 5, becoming variable 3. Fair. Good.*

notice that the pictures from 1996, the final phase of the project, are all from far-flung, expensive to get to, places which at the time I had no idea how I could afford to reach), no catalogue… and no money. I applied to the Arts Council, but, as luck would have it, this was the first time that the traditional 'Photography Panel' had been absorbed into Visual Arts, and, frankly, black and white documentary photography was of no interest to them. I was on the verge of pulling out of the Brighton show when I heard that I had secured a grant of $25,000 from the newly established Mosaique Fund. It is now sadly defunct, but at the time it offered large sums of money to bring projects about Europe to fruition. *The Shipping Forecast* ticked all the right boxes. Suddenly it all became possible. I was able to sink $10,000 into the exhibition, $10,000 into the book and the remainder was used to get to the Utsires (Norway), South East Iceland, the Faeroes and Fair Isle to complete the project. The irony is that the Mosaique award came from Luxembourg, a land-locked country on which any conceptual notions of the work would have been completely lost. But could I get any serious funding from anywhere in the UK? Of course not!"

Despite the generous size of the Mosaique award the costs involved were substantial. The geographical scale of the project involved travel to the tune of around £5000, materials and processing clocked up a further £6000 and the exhibition some £8000. And then there was the book. There was further help at hand, however: film from Fuji (for two years), some paper from Ilford and paper and chemicals from Agfa, plus some expenses were covered by the University of Brighton. Power estimates that there was still a balance of around £8000 to be found and this came from his agency Network Photographers and himself.

"When I approached mainstream UK publishers (really all that was available at the time) I was told by all of them that the work was 'too parochial' and therefore wouldn't sell abroad. One even said that if they published then they would need a colour picture on the cover, specifically 'a man in a yellow sou'wester taking a weather reading'. In other words it was all about 'dumbing down' the product. When I did secure some funding I was adamant that I wanted to produce a serious photography book with no commercial compromises, and the fact that a completely unknown photographer was able to sell 10,000 copies of his first book only goes to prove that the public are not as stupid as those publishers really thought. Most of the time (though as the work progressed I went through long periods when I lacked confidence in what I was doing) I believed that I was doing something worthwhile, as well as something which had the potential to tap into an audience beyond the traditional photobook-buying crowd. I heard an interesting statistic at the time – which probably (hopefully?) isn't very accurate anymore – that of a print run of 2000 books around 700 would be bought by other photographers. The other 1300 would sit around for years before being remaindered. And the book would lose money. In the case of *The Shipping Forecast* it made a small profit, but had we had the confidence to produce a first edition of 10,000 we would have done very well indeed. Hindsight is a wonderful thing!"

*All images are from **The Shipping Forecast**, © **Mark Power**.*

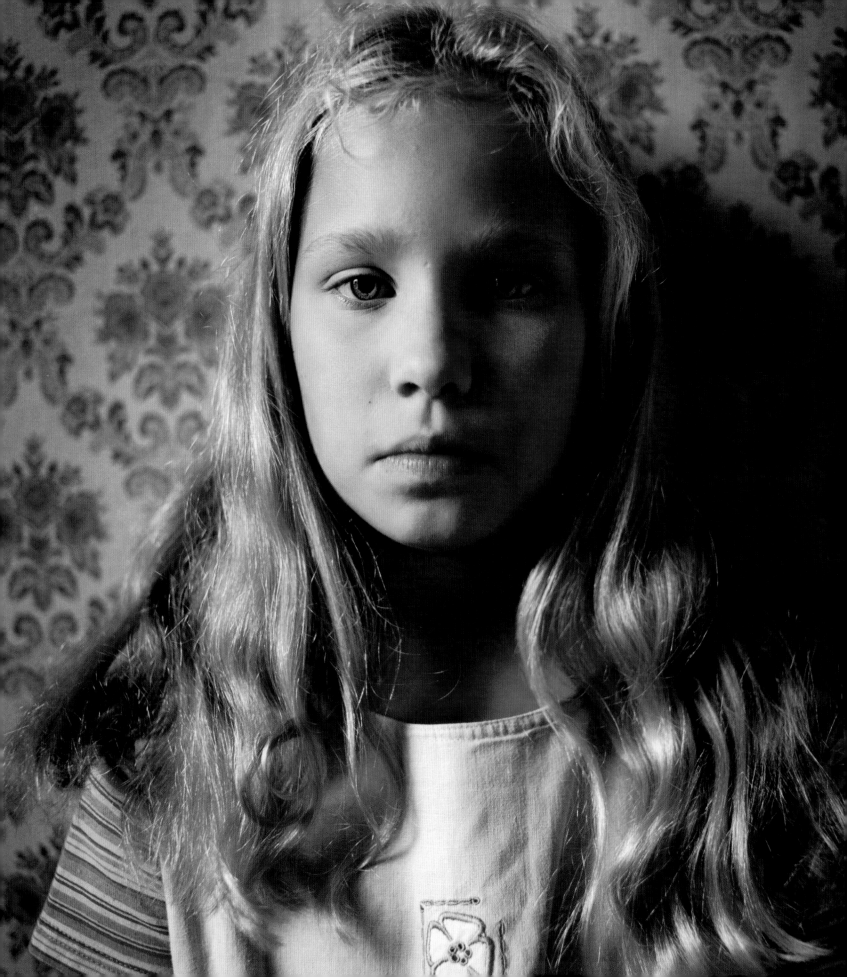

School days and beyond

Projects are considered an important part of photography education, underlining their contribution to every photographers' development

ADOPTING A PROJECT-BASED approach to photographic practice is something that comes naturally to some, while others find that it slowly creeps up on them. If you undertake a formal study of photography it may very well be forced upon you – in fact it probably will. The 'main' or 'major' project is an established part of most college and university courses. At postgraduate level it may comprise pretty much the entire course. So, irrespective of the specific course or venue, the project is something to be undertaken as part of the learning process. On some of the heavily theory-based courses it may not actually involve the making of photographs, but for our purposes we shall assume that it does. And having said that study courses all have this in common, they may do so in name but not necessarily in nature.

To illustrate the point, take many of the colleges teaching photography at what one might call intermediate level. There are many competitions aimed at photography students, since sponsors see them as the prospective customers of tomorrow, and it is quite common for participation in the established competitions to be written into the course curriculum and become the final-year project. In many respects this suits all concerned: the sponsor receives a high level of publicity; the student stands to gain materially and bolster his/her CV and portfolio; and the course tutors don't have to scratch their heads over setting a brief each year. The downside for the student is that the brief, while open to interpretation, is already set and can be very specific, and this limits the degree of creative input that is possible. The tight brief is there to make the judging process easier because it presents clear parameters against which to assess the entries, but I can tell you it can also make the judging a pretty dreary process.

At the other extreme the course may require you to devise your own project, its objectives and terms of reference. At postgraduate level this will certainly be the case. And the fact that the self-initiated project is integral to photographic education underlines the thesis of this book: whether you are in formal education or not, a project-based approach provides a framework for learning and development; much like a study-plan, but one you set out for yourself. Publication of one's work being the other half of the thesis of this book, it is also interesting that it has become popular for student projects to be presented on completion as a book. As discussed elsewhere, this is partly because today's technology allows economical production of the artist's book in a variety of forms, and also because many photographers believe that the book is the ideal medium for the display of a completed body of work.

All photographers operate under influences and the honest ones admit this. We all have our photographic heroes and heroines and there is nothing wrong in allowing some aspect of their work to influence our own. But there is a distinction between influence and plagiarism, although this is sometimes a difficult differentiation and students are not the only ones who sometimes fail to make it. However the project provides a personal space in which to shake off bad habits and develop a visual language of one's own, and many of the photographers featured in this book make that very point.

The two projects illustrating this section are very different, representing – so far as just two bodies of work can – the range of work undertaken by photography students. Indeed Marcus Bleasdale's project continued beyond college and, although completed in the sense of having appeared as a book and in exhibition, continues to this day.

Betsie van der Meer studied for her MA at the London College of Communication. The work here is from her project *Farm*, created over a period of fifteen months and involving several trips to the

*Facing: From **Farm**, by **Betsie van der Meer** (full details overleaf). The young girl is the only element in the work that the artist brought into the space photographed; she represents a memory of **van der Meer** herself as a little child.*

Netherlands to make the work. She has self-published *Farm* as a slim casebound book.

"I grew up on a farm in the south west of the Netherlands. I had not visited the farm for a long while and went back to photograph my memories of growing up there. Many farms have become unprofitable within the changing economies of Europe and, more specifically, as a result of the way in which land-use has been reconstituted in the Netherlands. What has happened to the house symbolises many of the wider processes that are happening to farming families in the area. My images constitute a story about the end of farming life in that my family had lived in the house for four generations and through two wars.

"I spent most of my childhood on the farm, leaving when I was about seventeen. I hadn't visited the farm in a long time and so I wanted to say something about my memories of growing up there. I keep dreaming about the space. While photographing I learned that my family had decided to demolish the house and so this gave me a sense of urgency about the project – I wanted to have a record of the space before the opportunity was lost.

"I never felt fully at home on the farm, my family was working the land most of the time and this was in total contrast to my involvement – I was reading books. They must have thought I was completely useless really, except in the summer holidays when I too worked on the land, bringing in the straw bales and generally helping out. I realised on moving to the city that I did miss the advantages of a flat terrain, particularly being able to see the sun on the horizon.

"I went back to the house and had a good look at the space, took a couple more trips and then slowly started to develop a story… I found things in the house, which were at first a surprise, and then I realised that they could be used within the project. I found the model house that my brother had built and in it I found the white horse and the hunter… they fitted well with my idea of how the story was developing. The only element I personally brought into the space was the little girl who represents a memory of myself as a little child. I felt she had to be there in order to restore some of the memories – she looked exactly like me at seven years old.

"I think my pictures show a childhood that I would describe as lonely. Everyone around me was working on the land so I spent my time alone creating an inner world for myself. Now I look back at this and can see that I desperately wanted to get away from the place, but couldn't work out how I was going to make it happen. At first I had posters of animals on my wall and then started putting up pictures of palm trees and faraway places.

"When my father died everything changed suddenly and dramatically. What had been a safe and solid space changed overnight into something broken. But it meant I had the chance to go to college in the city; I probably wouldn't have become a photographer if I had stayed on the farm or moved to the village.

"It's my story and my reality. Some of my family may have a different story to tell – they don't really like these images, they find them too dark, too uncomfortable. But my mother seems to understand them. This is for myself. This is about my history and I don't care too much about what people think about them. At the time the house was demolished I was quite relieved to see it going down as it had become very sad. It was starting to fall into disrepair and that was difficult to stand by and watch. I didn't have time to take it all in… I was too busy trying not to get hit by the demolition crane.

"For the book I made a dummy (including text by Paul Halliday) which I designed and printed myself and then gave it to a bookbinder to make it into a hardback book. Before working on my book I had talked to several photographers who had published books, been to workshops on book publishing and talked to book publishers. With this dummy I went to see publishers, including Kessels Kramer of Amsterdam. I had seen Erik Kessels before when I was still working on the project and I went back to show him the dummy. Kessels publishes his own photographic books and he helped generously with advice and production.

"When it came to printing I went to Belgium to discuss the dummy book; we printed tests on two different papers and having checked the colour reproduction [on this particular paper, which is cream] made further colour and contrast changes on computer. When the book was being finally printed I went back and checked the pages on-press. The book of *Farm* is distributed by Schaden publishers (www.schaden.com) and I handle distribution myself to art and photo specialist bookshops in the Netherlands and in London."

Featured project: **FARM** *By Betsie van der Meer* **Theme:** *The ending of farming life and the farmhouse in which the family had lived and worked for four generations and through two wars. View online at:* **betsievandermeer.com.** **Exhibition:** *MA final year exhibition at the London College of Communication; Naarden Foto festival, Netherlands. 15 images exhibited.* **Book:** *self-published (Pinken Publishing) at £18.00* **Format:** *220x220mm, 32 pages plus cover, casebound with embossed cover and spine, printed four-colour.* **Designed by** *Krista Rozema at Kessels Kramer, Amsterdam; text by Tyler Whisnand.* **ISBN:** *90-809557-1-X.* **Print run:** *500, printed Dikeure, Belgium.* **Production cost:** *£3800.* **Funding support:** *Exhibition – Fotofestival Naarden paid expenses for the framing and printing of 4 extra prints, and shared the expenses of shipping the photographs to the Netherlands. Book – £1000 David Sproxton Award (for best student photographs, received at the MA exhibition opening night).*

Facing: All from **Farm** *© Betsie van der Meer.*

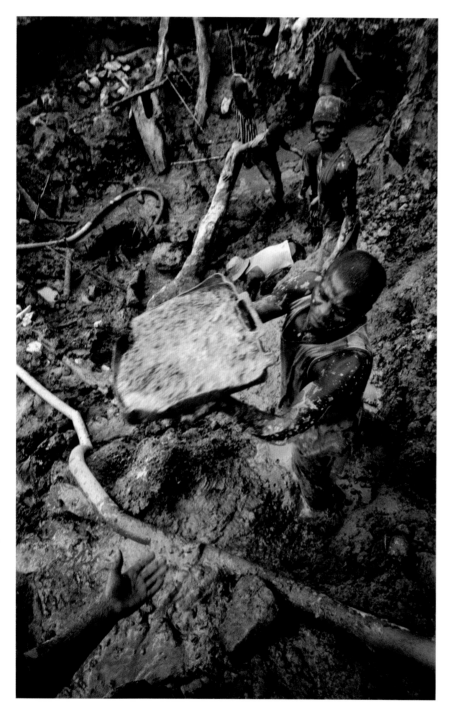

*Above and facing: From **One Hundred Years of Darkness**, by **Marcus Bleasdale**. These photographs are from a series on goldmining in Congo and form part of Bleasdale's ongoing project which takes its title, in part, from Joseph Conrad's 100-year-old classic tale set in the same area. All images © **Marcus Bleasdale**.*

Marcus Bleasdale began his project *One Hundred Years of Darkness* while at college. By the time he published the work as a book the project had taken three years and £3000 in materials and processing. But it did not finish with the publication, and through affiliating himself with Human Rights Watch he has been able to continue the project. Bleasdale's advice is to "look for any funding – anywhere". He himself received support from The Soros Foundation and 3p Foundation following formal application, and submission of images. The work has been exhibited widely: arranging a show at the Spitz Gallery (a brasserie in London's Spitalfields Market) was straightforward – the venue was available and free. It doesn't get any better than that. The high profile shows in Perpignan and New York were secured by direct submission, and the exhibition in Geneva was organised through Human Rights Watch, who now use the work to highlight the issues of the Congo.

At 2720 miles, the Congo is the fifth longest river in the world and second only to the Nile on the African continent. It is also sub-Saharan Africa's greatest thoroughfare: a living roadway up which, even at the driest times of the year, barges in excess of 1000 tons are able to penetrate more than 650 miles. But the heart of darkness referred to in the title of Joseph Conrad's famous story didn't originate in the unexplored upper reaches of the river. Instead it slid against the flow towards the interior during the vast region's exploitation by nineteenth-century colonialists. Conrad witnessed this rape first-hand in 1890, was horrified by it, and *Heart of Darkness* was the parable by which he described its effect upon him. One hundred years on from first publication of Conrad's classic story Marcus Bleasdale found himself sitting on the banks of the river reflecting on the manner in which the inheritors of the colonial past have so easily adopted the manner of their European predecessors. In his introduction to *One Hundred Years of Darkness* he talks of witnessing through Conrad's lens the "anonymous lives" of today's Congolese: "as desperate and as dire today" as in the time of Conrad's fictional creation, Kurtz.

The book was self-published and distributed to UK bookstores and overseas by Art Books International. It also sells on the internet via Amazon where there is also a review from *British Journal of Photography* to read.

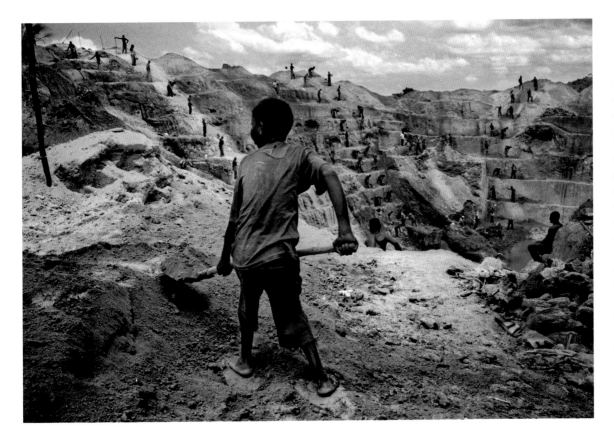

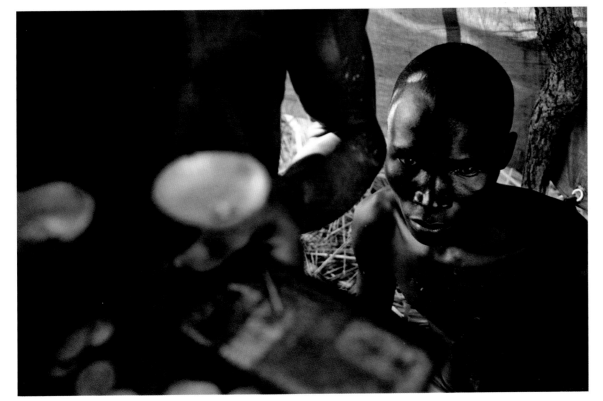

Featured project:
**ONE HUNDRED YEARS
OF DARKNESS**
By Marcus Bleasdale
Theme: The lives of the
Congolese a century after
publication of Conrad's
classic Heart of Darkness;
images viewable online at
marcusbleasdale.com.
Exhibitions: Spitz
Gallery, London; Visa
Pour L'Image, Perpignan;
Atrium Gallery,
Switzerland; and the
Moving Wall exhibition,
New York. Between 25
and 60 images exhibited,
depending on venue.
Book: Self-published,
Pirogue Press, £25,95.
Format: 144 pages plus
cover, printed tritone
black and white.
Designed by Susan Olle;
text by Jon Swain, of the
Sunday Times.
ISBN: 0-954301-50-1.
Print run: 2000, printed
in Hong Kong.
Production cost:
Approximately £3000 in
materials and processing;
book production £12,000.
Funding support: Project
and exhibition supported
by the Soros Foundation
and 3p Foundation;
funding towards book
from Congolese Foreign
Affairs Ministry.

 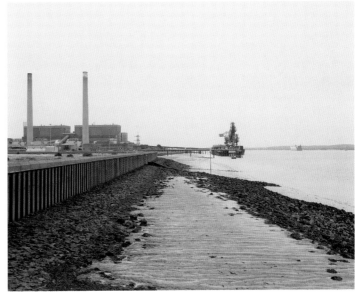

What floats your boat?

There is no set way to approach a photographic project – the only criterion should be that you choose a subject that interests you

A SELF-INITIATED PROJECT requires an element of discipline on your part which can also benefit the development of your practice beyond the project in hand. This is the discipline needed to pursue a theme through to the production of a coherent body of work that is a satisfactory summation of your feelings about that theme. There must therefore be a plan which the discipline can be applied to and measured against. Point number one of the plan will be the topic you intend to investigate and portray, the theme, the subject matter, the point and the purpose.

I remember almost 25 years ago talking with the Magnum photographer David Hurn, then head of the renowned documentary photography course at Newport College (as it was then known) in Gwent, just over the border in Wales. Although this was (and still is) one of the most sort-after courses for would-be photographers to attend, and therefore heavily over-subscribed, Hurn told me that in selecting students both he and his colleagues – and there were several other well-known photographers among them – did not set particularly high store by

an applicant's photographic experience or ability. What was far more important in their eyes was that students should have an abiding interest in something, a passion that would drive them to explore a subject or issue in the deepest, most thorough manner, to get right to the bottom of things. If they could also take a good snap then so much the better, but that would come with practise, that could be taught. What couldn't be passed on was the instinctive curiosity and fascination, the passionate interest and lateral approach needed to get to the soul of the subject.

While many photo projects are, in the broad sense, documentary, this is not a prerequisite. A documentary project will have an extra layer of meaning, a story, compared, for instance, with one where a particular photographic process is used to reinterpret the subject; this is the journalistic approach as against fine art, although these theoretical boundaries become very blurred in the work of many of the best-known practitioners. And while your project may not set out to tell a tale in the documentary/journalistic sense, its purpose

Facing page:
Margate Dreamland.
Left above: **Tilbury, high water.** *Right above:*
Tilbury, low water.

Featured project:
SEACHANGE
By Anthony Hopewell
Theme: An exploration of the Thames Estuary. Viewable online at **anthonyhopewell.com.**
Exhibitions: *University Arts Centre, Nottingham, and the Robin Gallery, Docklands, London; 30 prints exhibited.*
Production cost: *Materials, processing and travel £2500; exhibition prints and framing £7000.*
Sponsorship: *Discounted processing and scanning from Service Graphics, Nottingham, and Scanshop, Nottingham, respectively.*

Facing page: Margate.

should be some form of exploration, the objective to reveal something new. If you have an objective and a plan of how to achieve it you have a project.

So a good starting point is to consider what you care about. Or another (more cynical?) approach is to tackle something that lots of other people seem to care about and use the project to discover whether or not you empathise, to tell the story through their eyes as much as your own. Several of the projects featured in this book do not tell a story as such, but careful attention to approach, style, lighting, composition and process results in a coherent body of work which is revealing of its subject matter and of the photographer's relationship to it. And that is a tale in itself.

A wide range of project types illustrates this book. Examples that do not set out to tell a story include the carefully observed found objects photographed by Hugh Symonds using, of all things, a camera phone; the dreamy 'Gardenscapes' of Lynn Geesaman; and the intimate plant portraits of Paul Hart. The dividing line between documentary photography and photojournalism is often tricky to pin down, but I feel safe in describing Andrew Nadolski's project on the geology of a Cornish beach and Nigel Green's work at Dungeness as documentary, whereas Simon Norfolk's project on sites of genocide began as journalism, but as he explains, his approach evolved into something more akin to landscape photography. In at least one example, that of Peter Dazeley, the final object – a book – is in effect itself the project, put together to accompany an exhibition of his platinum prints and thus serving as a catalogue, and indeed a portfolio that he employs in his day job as an advertising photographer.

Perhaps the simplest form of project, yet in terms of the required commitment the most difficult, is the diary. How many have begun a written journal only to give up around January 5th? If you stick with it you might be surprised at the body of work you accumulate. And although a commercial publisher will probably be underwhelmed – unless your surname is Cartier-Bresson – you can always publish the material in the form of a weblog or 'blog'. There are at least two positive aspects to adopting a diary-style project: on the one hand the discipline necessary is self-evident and being used to working in a disciplined manner will benefit all that you do; on the other hand you should be able

to fit it in around work of a more structured nature without getting the two confused. Theoretically.

Decide what it is you want to achieve and then lay the plan to get there. At the outset you might not complicate things by including a book or exhibition in the equation; without any existing images that will be putting the cart before the horse. But it is something to be aware of as things progress because what may become of the images after the project is completed – and sometimes they are never finished – can have implications for their number or size, or some other technical consideration that you can't revisit afterwards. And whatever plan you put in place will change, and when it does this is a good sign. It shows you have got into the project and identified a better route than before you started; that there is something you have discovered you wish to explore; there has been a slight change of direction; that there is more to it than at first met the eye. Progress is being made. But you still need that initial plan of action as a set of ground rules, rules you can happily break when a better set emerges. A set of clear objectives and a route map – where have I heard that before?

Anthony Hopewell's idea of making a series of images of the Thames estuary was inspired by yachting literature – the estuary has a rich literary and artistic history – and a trip he made by sailing-boat from Walton-on-the-Naze, in Essex, to St Katherine's Dock in London a few years ago. Hopewell spent about two years researching his subject and a further eighteen months making the photographs for *SeaChange*. At the time of writing the work has been exhibited twice: the first show in Nottingham was secured by personal contact – Hopewell had previously exhibited at the University Arts Centre – the second show, at the Robin Gallery in London's Docklands, came through meeting the gallery owner at the annual Rhubarb-Rhubarb photo event in Birmingham. Networking, it seems, works. Hoping that a book might be in the offing, Tony has produced a dummy which, like networking, is never a bad idea.

"Using the forensic aesthetic of large format, large scale photography, I am exploring the tidal reaches of estuaries", Hopewell explains. "The single images concentrate on the notion of usage, focusing on the various demands of leisure, housing and industry. The diptyches examine the binary rhetoric

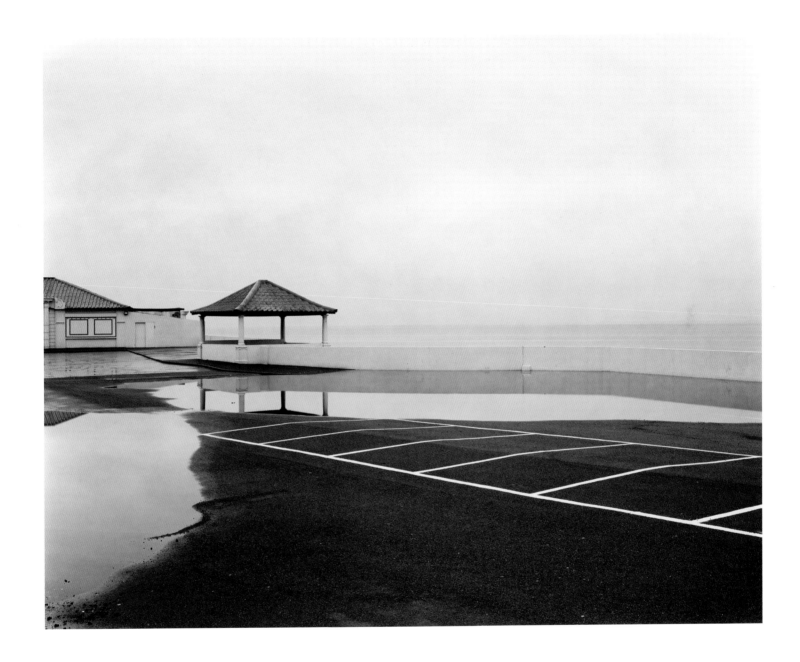

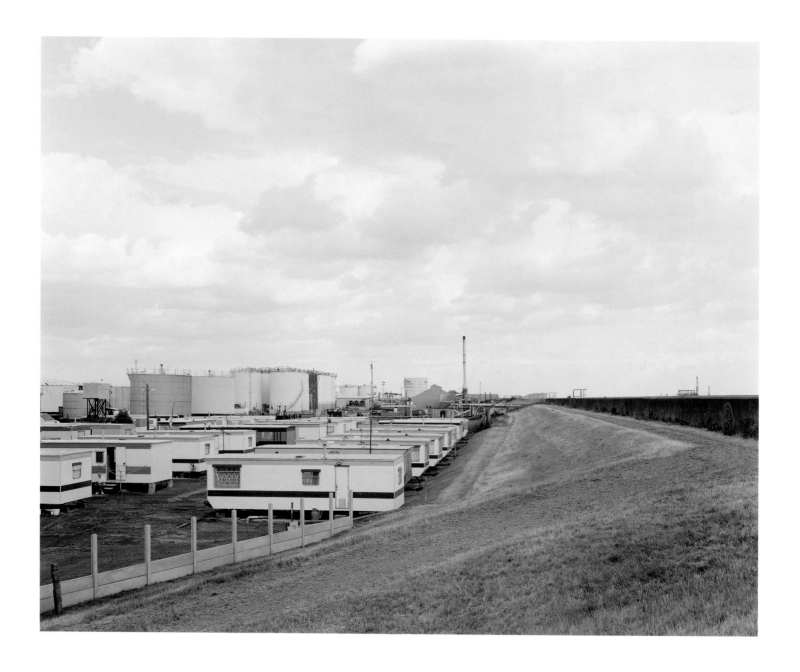

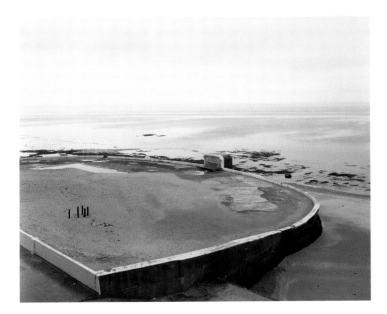

Facing page:
Holehaven caravans.

Above left, clockwise:
**Margate; Ramsgate;
Grays Beach; and
Grays goalposts.**

of concealment/revelation through exploring of the inter-tidal zone. This is achieved by photographing the identical view at both high and low water. I am concerned with areas of coastline which are not considered beautiful in the traditional sense, but in which the intersection of the man-made with the natural creates its own aesthetic.

"The works are all 'neo-realistic' in nature, being based in the tradition of straight photography, but with the intent of going beyond superficial surface description, to investigate and demonstrate underlying ideas. They function also to provoke thought about, and a critical review of, our environment. Much of the work is rooted in the landscape, particularly at the point at which the natural and the man-made collide."

The images are made on a 10x8 view camera, ensuring that even the tiniest detail is recorded. Hopewell began by making diptyches of the same scene at high and low water, one example – a pair taken at Tilbury – is shown on page 37. He then modified his approach to include single frames in which the sense of the river lingers, even if out of shot, recording the disconcerting and paradoxical relationships between leisure, domestic life and industry along the estuary. Having committed himself to the project and succeeded in getting it exhibited and published in periodicals, Anthony Hopewell's view of the process is pragmatic and to the point: "The short answer is that it is bloody hard work. It is essential to keep putting the work 'out there'. Above all, you need to be patient."

*All images
© Anthony Hopewell,
from SeaChange.*

Mission control

Settling on a plan of action will provide something to measure progress against and it is also the first step towards calculating your budget

YOU HAVE A BRIGHT IDEA. It's all worked out in your head. You know exactly what your objectives are and how you are going to approach and achieve them. You have a plan of action. Now, before any action takes place, you should write it all down.

The statement of purpose, or "mission statement", beloved of modern corporate culture does in fact have a purpose beyond contributing to executive gobbledegook. When presented as a set of bullet points it is easier to make sense of a project, spot any holes in the plan or purpose, highlight strengths and weaknesses. It is a simple way of denoting the route from A to Z, and serves as an available reminder of where focus should be, and will help identify times when you are drifting "off-message". See, that gobbledegook stuff is so easy.

If you hope to raise some funding or sponsorship to help with the project or a subsequent publication or show, you will have to provide a document like this as part of your application. And having carefully written – and rewritten – your statement, you will have everything clear in your own mind, making it easier to articulate your aspirations when talking with would-be benefactors. The statement will also form the basis of the summary you will eventually write to provide context, a kind of group caption for the images, a description of what you have explored and a round-up of the purpose of that exploration. You may prefer to let the images reveal what it is you have found, but don't be afraid to spell this out unless it is insultingly obvious. A little explanation never did any harm and the text, often called an "artist's statement", will accompany the images wherever they travel and to whoever views them.

Pinning down your plan of action is the first stage in the realisation of the project and the point at which you can get down to the nitty gritty of mundane matters such as costs, timing and considerations of scale. Experience tells us that any or all of these factors are likely to change over the lifetime of the project, but without setting targets you will be in danger of floundering around. In short, this is about adopting a professional approach which, besides helping the project reach a successful conclusion, is what will be expected of you by any potential sponsor or funding body.

A slightly different take on the funded project (more on these beginning on page 82) is where, instead of applying for support for a self-initiated project, you put yourself forward for a commission or bursary, set up by the funding body, often in collaboration with a third party closely linked to the subject matter. Here your plan of action is just as important as when you are trying to persuade a funding body of the worthiness of your own idea, although in these circumstances you are looking to convince them of your ability to deliver a successful interpretation of their own brief. An example of this kind of project is the body of work, *A Different Light*, created by Richard Heeps. It began life as an exhibition linked with poetry performance, and – with the help of funding from the National Lottery – grew into a book of even wider scope than was possible in the exhibition.

Richard Heeps explains: "*A Different Light* was the title of a project developed through the Arts Generate programme in Thurrock. Arts Generate is an initiative funded by Arts Council England East which aims to highlight regeneration needs in a region that is generally seen as fairly affluent, and also to demonstrate how the arts can contribute to the regeneration agenda. The Arts Council worked with five local authorities with significant regeneration issues – as well as Thurrock, these were Great Yarmouth, Southend, Luton and Dunstable. Arts Generate in Thurrock focused mainly on social regeneration, which would come about through the imminent increase in population due to the Thames Gateway developments. Changing the cultural climate and perceptions – both internally and externally – of the borough, was

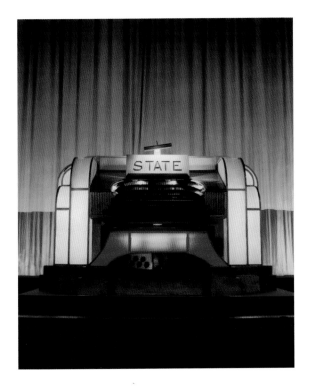

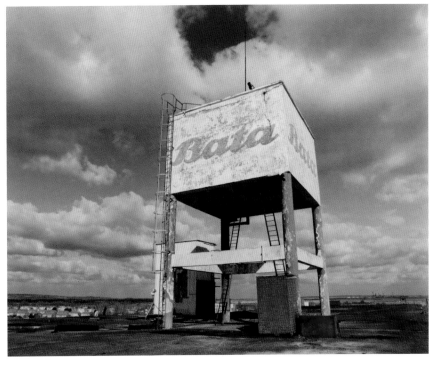

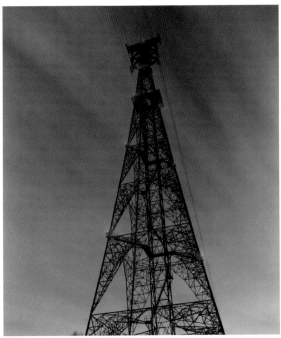

more important at this stage than contributing to the physical regeneration that will come later.

"The project was aimed directly at changing perceptions of the borough – trying to move away from what Jonathan Glancey called the 'cockney Siberia' image of Thurrock. The original idea was to commission a photographer to create a body of work that shows what Thurrock is like now, poised on the edge of change, showing it in a different light but not trying to edit out its faults. On receiving the commission I chose to take the concept of a different light as an artistic brief as well as a philosophical one. The influence of the Thames on the borough was a major theme within the work I produced. The photographs became the inspirational starting point for a parallel performance poetry project, managed by the national performance poetry agency Apples & Snakes. Five poets worked with five different socially excluded groups – challenging young people, older people, learning disabled adults, ethnic minorities and refugees and asylum seekers – whose voices and opinions are not often heard.

"Initially the photographic work was framed and exhibited widely in the borough, and the poetry performed in the local theatre by the groups themselves. But additional funding from the National Lottery through a 'Grants for the Arts' award enabled the council to fund the publication of a high quality paperback version of the book, bringing together much of the poetry and the photographs – in fact the council was able to include more images than were originally exhibited. This lottery support enabled the book to be sold at a much lower price than would otherwise have been the case, so increasing its distribution."

Above left: Compton Organ, The State, Grays, 2003.

Above: Water tower, British Bata Warehouse [rubber factory], East Tilbury, 2003.

Left: Tower 12,, ZR Route, The National Grid, West Thurrock, 2004.

All photographs © Richard Heeps, from A Different Light, ISBN 0-9506141-5-7.

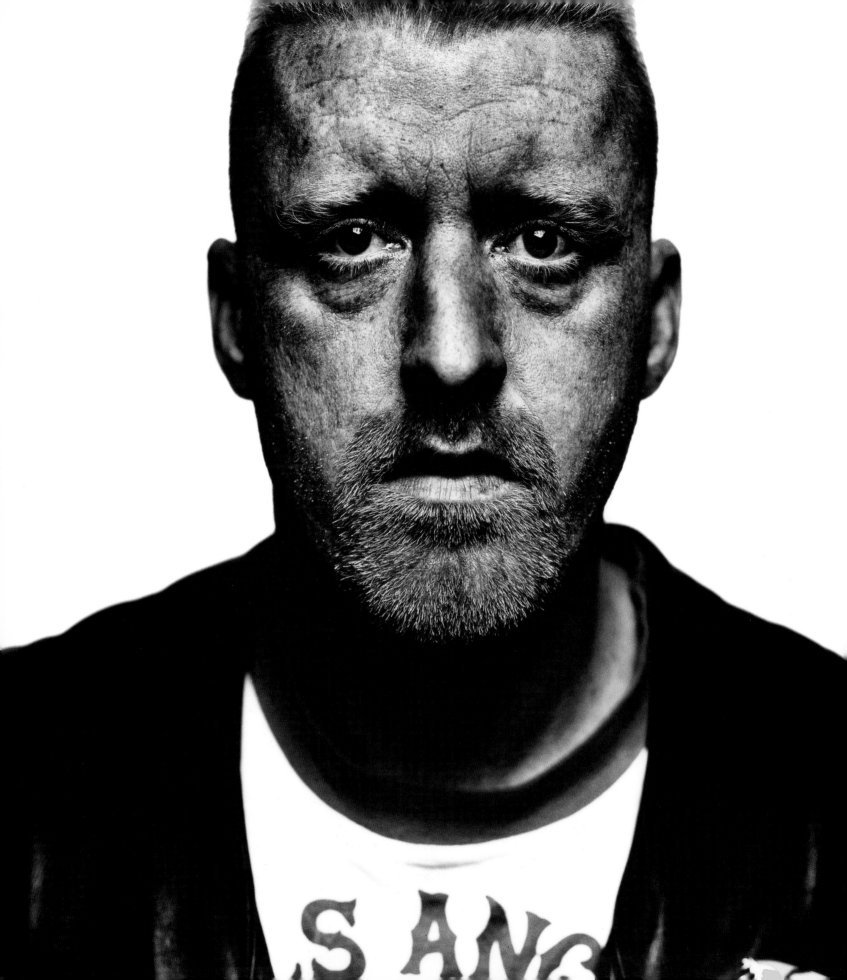

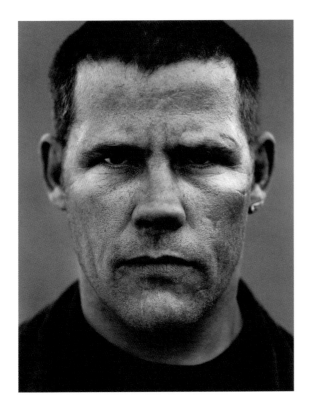

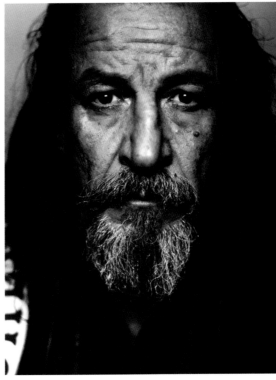

Featured project:
**HELLS ANGELS
MOTORCYCLE CLUB**
By Andrew Shaylor
*Theme: The Hells Angels,
close up and personal.*
*Exhibitions: National
Theatre, London; Arden &
Anstruther, Petworth,
West Sussex. 50 images.*
*Book: Published by
Merrell at £29.95;
followed by a collectors'
edition (leather-bound
with print) at £195.*
*Format: 288x238mm,
192 pages plus cover,
casebound with dust
jacket, printed five-colour.*
*Designed by Maggie
Smith at Sixism; text by
Andrew Shaylor with a
Foreword by Hells Angels
founder Sonny Barger.*
ISBN: 1-85894-243-8.
*Print run: 20,000 (in
multiple editions to date),
printed in Italy; 1000
copies collectors'
leather-bound edition,
printed in China.*

A question of scale

Early in the planning process you need to get a grip on the scale of the project – how long and how much will it take to complete?

EVEN IF IT IS HARD to pin down precisely, you should consider the scale of the project you are planning. If the end result is to be an exhibition or publication of whatever type, then deadlines come into play and without an idea of the scale you are working within the setting of a deadline becomes impossible. The best observation on deadlines came from the late author Douglas Adams, himself notorious for an inability to meet them: "I love deadlines. I like the whooshing sound they make as they fly by".

Many projects develop an "ongoing" status, but this doesn't have to mean that they are wholly unfinished; in many cases a coherent body of work will have been created with such a degree of success that the photographer will continue to add to it and improve on it. But if your own project seems to be in a perpetual state of "ongoingness" it has probably become a hobby rather than a focused and meaningful pursuit. Perhaps you forgot to refer back to your original plan of action – or perhaps you never quite got round to setting one down in the first place?

Consideration of scale is about setting out working parameters, the boundaries within which you will operate. This allows you to identify objectives and make estimates of the time involved, the costs to be incurred, and considerations such as whether or not you have the right equipment for the job. This is also the necessary intermediate stage between that original plan of action and finalising a budget. We will look at budgeting in more detail in the next section and if a budget is not required to form part of an application for funding it may amount to little more than a calculation of cost. But you need to know at least this much: the worst reason for a project foundering is to run out of funds part way through.

*Facing: Vaughan,
HAMC South Coast.
Top left: KV, HAMC
South West.
Top right: Tramp,
HAMC London.
All © Andrew Shaylor.*

The two projects we look at here illustrate two extremes of scale. Andrew Shaylor's years of riding with the Hells Angels required a somewhat open-ended approach to cost budgeting; ultimately, the expense was worthwhile, and indeed justified by the commercial success of the resulting book. And at the other extreme of scale are Hugh Symond's experiments with a camera phone resulting in carefully observed snippets of texture, colour and available light, presented as internet galleries and undertaken from start to finish at practically no cost whatsoever.

This issue of timing should not be underestimated. If you hope to persuade someone to exhibit the work, or to secure funding or sponsorship to underwrite the costs of the project, an exhibition or some form of publication, you will need to have work in progress to show as part of your "sales" package. If you hope to exhibit in a mainstream gallery remember that the worthwhile venues will be booked up some way ahead and you may be looking at a show that's a year or more in the future. If your project is in some way time-sensitive this is especially important; don't expect your show to open the month after your initial approach to the gallery. So you need to plan a long way ahead and allow sufficient time to get something "in the bag" before you approach third parties.

Andrew Shaylor spent four years or so travelling with and between Hells Angel Motorcycle Club (HAMC) chapters (primarily in the UK), where he photographed members, prospective members, their bikes, bashes and families. Something of a change from the corporate, advertising and editorial work that characterises his day job. You could be forgiven for approaching the subject with a few prejudices already in place. However, Andrew Shaylor says: "My idea was to present the club in a non-judgmental way and to attempt to educate those who, like me, know nothing about the club. All this coming from a middle-class country boy who has never ridden a motorcycle in his life."

The project began in 2000 when Shaylor was completing a feature on British bikers for *Esquire* magazine and photographed Sonny Barger, a founding member of the HAMC in California, and a group of British Hells Angels at the annual Bulldog Bash at Avon Park Raceway. The event is very much village fete in ambience – except for the 25,000 partying bikers, topless bike wash, rave tent, strippers and the rubber smoke over the "Run What You Brung" speed track.

Shaylor followed up this meeting with the Hells Angels by sending a copy of the Polaroid and writing to suggest a photographic project. One meeting, four years' work and about £15,000 in materials and processing later he had a unique and substantial body of work.

"I gave up calculating the cost, it was too depressing. And in truth it didn't matter because what I was doing was about more than just the money. But I probably shot over 20,000 images and this made the project very expensive, although, as I say, I felt the opportunity that I had justified a somewhat 'loose' attitude towards the cost. Then there was the cost of making and framing the exhibition prints, some of which were very large. And given the subject matter nobody was willing to fund or sponsor it.

"However, I had no problem finding a publisher. In fact I had a publisher before Merrell [the company that ultimately published the book] but a couple of things I discovered about that first company caused me to walk away. It was a risky and difficult thing to do, but they went out of business a year later. I found a very good publisher in Merrell: it is not a large company, which meant I was able to be involved in every aspect of production; it is very important to keep as much control as possible over how the book turns out.

"For the two exhibitions I contacted the galleries direct and made appointments to see them. The show at the National Theatre coincided with the book launch."

This body of work is by no means purely portraiture, but the faces are in the majority and tell most about the HAMC and its members. And while the club has, in an unusual way, become a global brand, the photographer himself observes that: "It was evident that each individual was exactly that, an individual". Remarkably, Shaylor managed to secure the cooperation of almost all of the UK's Hells Angel chapters in the making of the work. You may not be able to draw conclusions from the few images there is room for here, but you could take the photographer at his word when he says: "Life is a process of learning, and I have learned that people are rarely what they appear to be."

Facing: Paul, HAMC Ashfield.

All images © Andrew Shaylor, from Hells Angels Motorcycle Club.

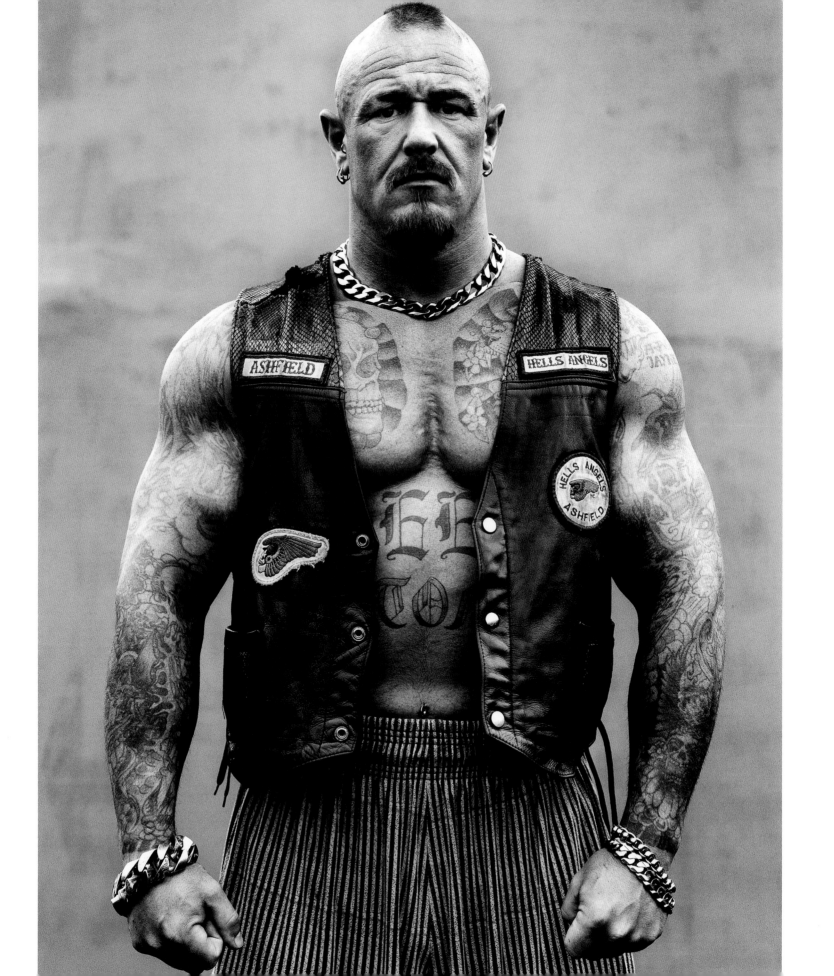

These "Fonephoto" images by **Hugh Symonds** are of perfectly adequate resolution for display on the internet where they are shown in pairs (see www.hupix.net), but they will show some pixelation in reproduction here.

Top pair: **Blue Leaves I.**
Below: **Night & Day I.**
Facing: **Beach Light 4.**

All © **Hugh Symonds**.

Hugh Symonds talks about his experiments with a camera phone: "The Fonephoto (Fp) project developed from incidental use of the camera phone as communication technology. Appraisal of the initial image quality encouraged some experimentation and consideration of the GX20 as a creative tool. The limitations of the equipment (an approximately half-megapixel camera with no effective controls – apart from a close-focus setting) demanded a reconsideration of ways to make a picture. My professional career (as a commercial film director) spanning more than 25 years has seen a terrific development in the technology of image capture and post production – culminating in the 'digital age', where digital manipulation after

shooting has become, seemingly, the most important stage, and it is certainly where a majority of the creative decisions are actually made. With the Fp project I chose to embrace the camera's limitations, work only with available light and re-confront many of the considerations and problems which have gradually disappeared from my regular creative working process. It has been very challenging, but also very stimulating. This personal project is funded by my professional work.

"I have been working on the project for almost a year. Shortly after starting, I began to think about how the photographs might be seen or exhibited. Because they are small in size by nature, a dedicated website seemed an obvious option. This

enabled me to choose the manner and style of exhibition. One great advantage of the internet is the massive potential for viewing in a pan-global environment.

"In just five months, the website was visited by people from the US, Japan, Germany, UK, Korea and Russia. It was also mentioned in several printed magazines, and received an exhibition offer from a US university and a 'daily photo' placement from a New York-based web magazine. The site has received over 2500 unique visits on a single day, although it averages fewer than that. These viewing figures and the wide range of spectator nationalities are unmatchable in any other format – this many people just don't walk into photography galleries or buy photographic monographs, unless the featured works are by a very famous practitioner.

"Typically a cellphone with camera on a simple tariff with text options (picture messaging) can be secured for around £15/month upwards. It is now possible to transfer pictures direct from cellphone to computer (for website preparation) via a hardwire data cable or one of several radio frequency options – bluetooth is a popular format. But as with all software, changes in methods and options are rapid. For instance, currently Korean cellphone users have 5-megapixel camera phones available, with up to 7-megapixel units due out by the time this book is published. But all-important lens details are hard to come by: lots of pixels are

fine, but not if they contain junk. At the moment, pictures outside my monthly contract allowance would cost me £0.36 each to email direct to myself via my service provider. But this can take some time if the networks are busy – voice always takes preference over other media.

"This project has re-connected me to what I consider to be the most vital part of any picture making experience. It has sharpened my approach – I am looking harder – and, hopefully, I am seeing better."

Hugh Symonds gives further details about setting up and managing his Fonephoto website in the section beginning on page 118.

Hugh Symonds gives further details about setting up and managing his Fonephoto website in the section beginning on page 118.

Featured project:
FONEPHOTO
By Hugh Symonds
Theme: Adventures with a camera phone.
Exhibition: Online at www.hupix.net.

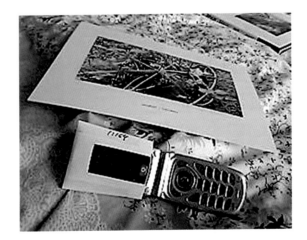

*To ensure accurate framing when shooting in panoramic format on what is, after all, a seriously unsophisticated camera, **Hugh Symonds** adopts a cardboard sleeve mask fitted over the LCD screen.*

Bench, Blenheim Palace. © *Beth Dow (see pages 52–53).*

The need to count the cost

Books and exhibitions don't grow on trees – a professional approach to budgeting is an essential part of your project action plan

IF YOUR PROJECT is to be fitted in around your other photography on an ad hoc basis, as and when you have the time and without a deadline that needs to be set in stone, then you might get away without working out a budget. However, several of the projects featured in this book involved significant costs: many miles of travel; large quantities of film, paper, chemicals and so on. And if the work is to progress to an exhibition there is the making and framing of the prints to consider. And then there is the small matter of a book… . Better to calculate your costs at the outset, and essential if you hope to raise financial support.

Many of the projects here have involved support or sponsorship from third parties, and the photographers describe how this came about. For the project itself the support may come in one of three forms: the loan of equipment or donation of materials from a commercial sponsor; the granting of an award or bursary by a foundation or charity; funding from an arts body such as, in the UK, the Arts Council or one of the regional arts boards. The support may extend to an exhibition which is an opportunity for commercial sponsors to benefit from publicity, and funding from arts bodies will often specify a publication as an end-product, typically with an exhibition as well.

The two projects featured in this section benefited from funding. In the case of Beth Dow, her *In the Garden* project would have been difficult to pursue without the aid of a generous arts grant; similarly, Chrystel Lebas was able to self-publish her monograph thanks to funding assistance.

Getting the work exhibited is key to drumming up support, particularly from companies in the photographic field. Film and paper manufacturers set aside an amount to sponsor shows, usually in the form of free materials; processing labs promote themselves by printing exhibitions – either for nothing or at least at a discount; camera and hire companies loan out equipment in return for due

credit at the show and in the catalogue. A film manufacturer is much more likely to supply materials if you have a show – or programme of shows – lined up through which they can get publicity. It is normal practice to have an opening night or private view which is an excellent way of gaining publicity for the show – assuming you invite the right people – but there are costs involved, in the form of invitations, postage and watering the guests on the night. In fact it can be quite easy to get the evening's drinks supplied free or sponsored. You just have to be imaginative in dreaming up a link between the supplier and the work, or maybe simply the location of the show. If you (or someone else) are producing a catalogue or book of the work, then the exhibition is the perfect platform for sales. The experience of many of the photographers in this book confirms this strong link between the show and the commercial viability of a publication, although that's maybe little more than common sense. The gallery will expect a discount on publications being sold there. This is negotiable, but expect to allow around a third of the cover price as the gallery's share. Producing a poster for sale is worth considering; they cost much less to produce than a book or catalogue and can be pleasantly profitable and sell to many too mean to shell out for a book. And there is the revenue potential of print sales, increasingly in the form of limited editions these days, and typically priced both with and without a frame. You will have to negotiate a commission with the gallery; this can vary enormously depending on the gallery and your own status as a photographer, but you might expect to split the income 50:50.

On the subject of publicity, a show opens up further opportunities for both your work and the sponsors, with publications as wide-ranging as photography magazines and national newspapers having space to fill with events listings. If you are handling your own publicity make sure the press

Featured project:
IN THE GARDEN
By Beth Dow
Theme: *Platinum-palladium prints that explore an ordered environment. Selected images online at* **www.bethdow.com.**
Exhibitions: *Nash Gallery of the University of Minnesota, followed by a regional tour.*
Funding support: *Initial grant from the Minnesota State Arts Board; $25,000 grant from the McKnight Foundation.*

release contains all the salient information: venue name, address, contact number and opening times and dates; title and brief description of the show; an indication of what type of prints are on view and their size. Always include a small number of images – say two or three – in digital form for ease of use, but with a hard copy version for those too lazy to put the CD in their computer. If you are lucky and a publication uses one of the images, you are going to get a much bigger and more effective (free) advertisement for your show than a simple listing. A gallery of any note will have its own publicity mailing list, but there's no harm in volunteering to contribute to ensure that all possibilities are taken care of. Make sure all this information goes off well in advance to allow for publication lead times.

Beth Dow's project *In the Garden* is still very much a work in progress, although after four years it already comprises a substantial body of work. When the project was already well under way she applied for and won funding from her regional arts board, followed by a substantial grant from the McKnight Foundation. The lack of "strings" attached to these funds proved especially beneficial and demonstrates a welcome sensitivity to the needs of the artist. Dow explains the genesis of her project and the way the funding helped it evolve.

"I have always photographed gardens along with my other work. I kept returning to these pictures and places throughout the years, so it made sense to dive in once and for all and see what could be done with the subject. These are platinum-palladium prints that explore, at their most elemental, the mystery of beauty and the beauty of mystery as found in an ordered environment.

"These pictures will first be exhibited in November 2005 at the Nash Gallery of the University of Minnesota before travelling around the region. This exhibition program is part of the grant process, but I am currently arranging further exhibitions at other venues myself. As most of my pictures were made in England, I am most interested in finding a venue there. To date there are more than fifty pictures, so I am now also assembling a book proposal.

"I am very lucky to live in Minneapolis, where there are fantastic funding opportunities for artists. In 2003 I received a generous grant from the Minnesota State Arts Board, and in 2004 I was awarded a $25,000 grant for this project from the McKnight Foundation (the family behind the 3M Corporation, information at www.mcknight.org). There is, understandably, tough competition for both grants, and detailed and persuasive proposals, CVs and work samples have to be submitted. After that, voodoo and finger-crossing never hurt!

"One of many great things about the grants I received is that they were not subject to strict accounting and budgets. Both were set amounts that could be used any way the artist required to get the job done. This freedom allowed me to experiment in ways I could never have otherwise justified. The grants also enabled me to invest in equipment and travel, opening up opportunities I would not have otherwise had. Grants provide a stamp of approval that helps open other doors, for exhibition, publication, and further grants. Most artists are obsessive, and we spend unbelievable amounts of time and money on our habit. (I couldn't begin to imagine how much I have spent on materials and processing and would rather not try! Too depressing.) Grants are fantastic gifts that both ease the pain and oil the machine. I encourage every artist to explore all possible funding opportunities, including corporate sponsorship."

Chrystel Lebas' book, *L'espace temps* (time in space), brings together several series which were produced using equipment as diverse as rotating panoramic and pinhole cameras. "My book brings together six bodies of work that investigate related themes explored during the previous six years. This series of images is linked by common research on time and space in which different photographic apparatus are pushed to their limits to record the nocturnal landscape.

"A book is a different form of display; it has a specific space and limitations, and has to bring the viewer towards reflection, contemplation and questioning. I felt it was the right time for me to assemble the works produced during previous years; it helped me to reassess, question and move forward to new bodies of works. It is difficult to say how much the projects cost because it varies according to the amount of work produced during each year, the amount of travel, or if the work is produced with an exhibition in mind.

"The Photographers' Gallery exhibited the *Moving Landscapes* and *Azure* series prior to the

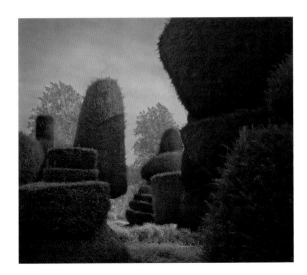

Passage, Levens Hall.

Theatre Lawn, Hidcote.

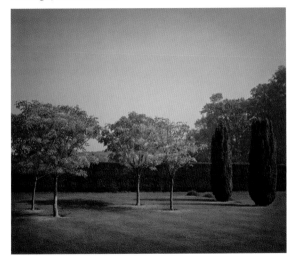

Six trees, Batemans.

Standards, Blenheim Palace.

Girl & Boy, Sissinghurst. *All © Beth Dow, from In the Garden.*

book. We had talked about a book launch, but this didn't happen due to other exhibitions being booked in. In retrospect, to have made a book to coincide with the show would have had more impact. Nichido Contemporary Art in Tokyo, exhibited the new work, *Abyss*, (that does not feature in the book) and the gallery hosted a book launch during the show. Hug, Gallery for International Photography, in Amsterdam, exhibited *Azure* after the book came out, and there was also a book launch in Amsterdam.

"The book was distributed by Art Books International, in museums, galleries, specialist outlets and some larger book retailers (such as Waterstones) in the UK; I did some distribution myself in France and the USA, and the galleries I mentioned did their own distribution in Japan and the Netherlands.

"To market the book I contacted magazines, sending the book to them with a brief synopsis. This is something that needs to be done as soon as possible, even before the book comes out, to allow for magazines planning ahead. I also entered the book in a couple of publishing awards.

"The cost is something that needs to be addressed carefully; thinking of all hidden costs is essential, as these can inflate the budget out of all proportion. The first step to publishing is to draw up a synopsis, with a few images; it should be sent to any potential sponsor or supporter. Then you can start working on the design: I had the good fortune to have an art school friend to work on it. She is now a very successful graphic designer in France, however this was her first book design and we worked in collaboration. It was as much her project as it was mine. You need to agree on a price with your designer (unless you can do it yourself), and he/she might also help in the choice of paper. I was very specific and wanted a matt, high-quality paper to work with; I saw the Photographers' Gallery magazine and liked the paper texture, so I contacted the manufacturer to get some quotes and ask for sponsorship. They did sponsor the book in part with a reduced price for the paper.

"The printer contact came through someone I know and was based in London. Printing prices can be expensive in the UK, but although Germany, Italy and Asia are cheaper, don't forget the travel costs. For a first book you need to be with the printer at each stage of the process.

"When self-publishing, you get the advantage of deciding on the design, texts and image editing; you are close to your work and will not compromise. Also, you will probably promote your own book more efficiently, because it is yours. I was lucky to know some people in publishing and design who could help me take important decisions; like the type of book I wanted to produce: for instance, is it an artist book or not?

"For research my first step was to go to book fairs and ask questions. If a gallery represents you already, it might not appreciate the financial point of helping you; yet a book will help increase your profile and maybe print sales, and of course generate interest in your work. Since the book was published I have been fortunate in placing a few articles in magazines and on the web, and have been invited to give talks at universities and at Photofusion.

"I was awarded the British Book Design & Production Award in 2004, and nominated for the *Rencontres d'Arles* book award in the same year. I will also be exhibiting at the Victoria & Albert Museum in a group show in October 2006, *The Hour of Twilight*.

"You do not make a book to make money; you have to think of it as a long-term investment. I had such a grand experience and learned a lot through this. A few times I thought the project was too much to handle, the financial side was heavy; however there are always solutions around the corner, and I don't regret it all."

Let's look at the costs involved in the two scenarios of an exhibition and a publication, and at the revenue potential of both which can be offset against the spend. If you are fortunate, the money coming in will be greater than that going out! But whatever the case you can't proceed without knowing the bottom line: you need to establish whether you can afford it yourself, or how much you need to raise to get things off the ground. Here we are looking at activity after the project is completed, the cost of getting that far is money already spent. The actual sums involved will vary greatly, depending upon a range of decisions you make yourself. We are simply providing a set of "headings" under which sums of money need to be allocated; once you have done the maths you may wish to revisit the figures and adjust your

Chrystel Lebas → L'espace temps → **Time in space**

Featured project:
L'ESPACE TEMPS – TIME IN SPACE
By Chrystel Lebas
Theme: *Six related bodies of work exploring the nocturnal landscape. Online at* **www.hughug.info, www.photonet.org.uk, www.nca-g.com,** *and* **www.chrystellebas.com.**
Exhibitions: *Photographers' Gallery, London; Nichido Contemporary Art in Tokyo; Hug Gallery, Amsterdam. In each case around twelve images were exhibited.*
Book: *Self-published (Azure Publishing) at £19.99.*
Format: *210x297mm, softcover, 98 pages. Printed 4-col.*
Designed by *Anne Martiréné; foreword by Jean-Claude Lemagny, former director of the Cabinet des Estampes et de la Photographie at the Bibliotheque Nationale (Paris); essay by Dr Deborah Schultz, art historian and Research Fellow at the University of Sussex.*
ISBN: *0-9546-478-0-7*
Print run: *1000 copies, printed by Special Blue/London.*
Production cost: *£12,600*
Funding support and sponsorship: *Arts Council England; Scheufelen (paper supplier); the galleries that represent Lebas' work.*

*Above: **Untitled no. 16, London,** (from Night 1).*

*Right: **Untitled no. 23,** (from Azure).*

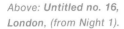

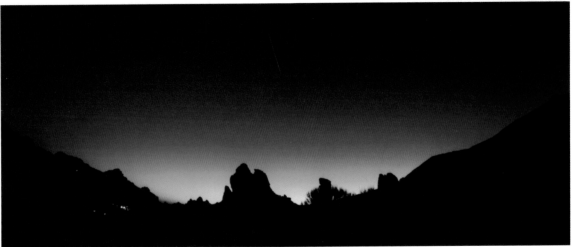

All © Chrystel Lebas, from L'espace temps – Time in space.

ambitions, but only you know where you are prepared to cut corners or compromise.

Some of the costs involved in exhibiting:

Venue hire – this may or may not be an issue, but if you're unable to get a funded gallery to show your work it may be necessary to pay and display. If hiring is out of the question, there are plenty of lower profile venues such as restaurants and bars that host exhibitions in order to have regularly changing art on the walls. Some have become so popular that the food and drink is now almost secondary. Certainly worth a go, at least for your first show.

Print making – is potentially costly. Either make your own exhibition quality prints or choose a lab close to the venue who may be interested in a sponsorship deal in return for publicity at the venue. If you use a lab regularly they could easily be persuaded, and many labs offer reduced prices to young or student photographers in the hope of future business.

Mattes & framing – another sizeable cost. Again sponsorship is worth trying, or many galleries that hire out space have stock frames available.

Press release publicity – if the gallery is selling your work they will usually handle this. Find out exactly what they plan and take a view on whether additional spending on your part is worthwhile.

Poster production – if you don't have a book or catalogue to sell at the venue posters are a less expensive alternative, and can also be used for advance publicity.

Invitation design, print and mailing – usually handled by a commercial gallery; but if you're doing it yourself it is another chance for sponsors to get publicity and so contribute to the cost.

Private view hospitality – if not laid on by the gallery try a local wine importer, or any brewer currently advertising their latest designer beer for sponsorship. If the work can be linked geographically or theme-wise to the sponsor or product, so much the better. Creative thinking needed here.

Transporting the work between venues – should not be overlooked if the show is to tour. However, if a show does tour, this aspect is often taken care of by the galleries involved.

Potential exhibition revenue:

Print & poster sales – gallery commission will vary, but expect to hold on to half of the sales revenue. The gallery needs to make money too.

Catalogues & books – the commission on book sales is negotiable, but about one-third going to the gallery, two-thirds to you, is typical.

Book or catalogue production costs:

Pre-press – in other words scanning images, design and page make-up. Do it yourself or twist a friend's arm. With the technology available today, no creative should be paying a third party for this.

Print – including paper and binding. This, of course, is the major cost with many individual elements and ways to minimise them. This is dealt with in detail in the section on working with printers, beginning on page 70.

Commission – the most effective way to get into the bookshops is to use a trade distributor, the downside is you will have to surrender about 50% of the cover price to the distributor and retailer on all copies sold. Book shops operate on a sale or return basis; it is very unlikely you will get a deal where they buy books from you and take a risk on whether or not they sell them. If you deal directly with a retailer the discount (retailer's margin) is negotiable, but typically is around one third of the cover price.

Marketing & advertising – if self-publishing this must not be overlooked. Where are you going to advertise and what is it going to cost?

Mailing – books are heavy. If you are selling direct postage can be a significant cost.

PR – as part of your marketing you need to allow for a number of free copies going out to places that may review or give some form of editorial space to your book. A press release mailshot to a large number of selected publications or media with full details, a facsimile of the cover and contact number/email for review copy requests can be most effective, and will reduce the number of copies wasted in sending them out speculatively.

Book or catalogue revenue:

Pretty obvious – but don't forget to subtract any commission due and that you will need to give away some copies for PR purposes.

Top left, clockwise:
Night Journey 10,
gelatin silver print.

Viviane, London,
gelatin silver print,
(from Sleep).

The Alps 5, *from a*
pinhole negative,
C-type, (from Moving
Landscapes).

Ireland 2, *pinhole*
negative, gelatin
silver print,
(from Night 2).

*All © **Chrystel Lebas**.*

Put your best foot forward

Getting your work published or hung on a gallery wall involves the sales process: here image selection and presentation are paramount

WHEN THE WORK IS COMPLETED to your satisfaction the next stage in the process is to sell it. Yes, I'm afraid that's what it amounts to; if you want someone to exhibit or publish your work you have to sell the idea to them, for the simple fact is that you won't be the only person in the queue. If you don't like that idea then you can do it yourself, whether in print, on the walls of a local restaurant or on the internet. But if you want a commercial gallery or publisher to back you, or a funding body to cough up some finance, then the salesperson in you must shine; and the first sales tool to get sharpened is the portfolio.

The portfolio can take a number of physical forms, and which one you opt for will depend on how you intend to present your work and to whom. Are you going to "hit" a large number of people at the same time via a mailshot? Or maybe these days an email approach might be suitable? Or are you going to visit a handful of people in person, one at a time? What is it you hope to get out of them and what in particular about your work do you think is going to interest them? So there are two aspects to your portfolio that require consideration: its physical form and its content. Both of these should be targeted as best you can at the person who is going to view it. The images, and therefore the portfolio, can exist in two basic forms: as photographic or digital prints presented in some kind of folder, binding or box; or as digital files to be viewed on-screen and distributed on CD, via email or on a website. In many cases the ideal is to have it in both forms, and we will come to that.

A print portfolio will show your work at its best; images viewed on-screen are seen at low resolution (72dpi) and accuracy of colour and tonal rendition will depend upon the quality of the viewer's monitor and how well it is set up and calibrated. However, that doesn't mean that the digital portfolio does not have its uses. If you are visiting the potential publisher or exhibitor of your work it is essential to have it in print form so you can look at the work together, while you provide a brief running commentary – as necessary – while the pages are flipped. Many photographers would prefer to show original photographic prints, but digital inkjet prints are used increasingly because of the ease and economy with which the portfolio can be updated and re-edited to suit the purpose of your visit.

A common question at this point is "How many?" Well, the question usually arises from one having a substantial body of work to choose from and feeling spoilt for choice. You have to strike a balance – particularly as we are talking about project work which will have a story to tell – between showing enough to demonstrate that this is indeed work of substance and getting the message across, and diluting the effect if the viewer has had to wade through too much. The precise number of images to show will vary according to the nature of the project, but if you take ten to twelve as a minimum and twenty as a maximum, you won't be far wrong. If you are hoping to land an exhibition it makes sense to show the images in the size and format you propose to hang on the wall; if the work is for publication go for a minimum size of 10x8in (A4), and a maximum of 11x14in (A3). On a personal visit you should take with you material you are prepared to leave behind: digital versions of the images as prints or on CD, backed up with an information sheet carrying a brief summary or statement about the work, your contact information and – if it is relevant – brief biographical details. If you are unable to visit in person and would like the material you are sending to be returned after use, supply appropriate self-addressed packaging and postage. In my view it's not worth the cost of a stamp to ask for a CD to be returned, but that's up to you.

You can spend a fortune on portfolio cases or boxes, and while it is very important that your presentation looks professional, your time, effort and money is best spent on the images themselves.

Advertising photographers' flashy portfolio cases are all part of their branding, and, in fairness, have to stand up to the vagaries of motorcycle courier delivery around town on a daily basis. For your purposes a sturdy folder with removable transparent sleeves will do the job perfectly well, and you can take out any unused sleeves – nothing looks more daft than half a dozen empty ones at the back of the book. Include the statement about your work at the front to serve as an introduction.

If you plan to send out several portfolios to publishers and/or galleries, the CD format might be your best choice. It will certainly be quicker and cheaper than putting together a large number of print portfolios. Most simply, you could dump a set of image files onto disk along with a text file of your statement, but this is not recommended as viewing the images is clumsy and you have no control over the sequence in which they are viewed. Neither will you be giving a very professional impression. Much better to put together a slide-show style presentation, perhaps using software such as PowerPoint, or better still in the form of a website gallery. You can be confident that any computer will be able to read the latter, even if they don't have internet access, because a web browser will be installed as part of its basic operating system. In addition to giving you control over the sequencing of the images, either option also allows you to incorporate text with the "pages", maybe as captions providing context for each image as part of the overall project. Having your portfolio in this form will always be useful: it provides you with something to leave behind after a visit in person – rather than your precious prints – or you can use it for a larger scale mailshot or, if it exists as a website, you can email your prospects with a short covering letter and a link to the site.

If you are hoping for publication in book form the ultimate portfolio presentation style is the dummy book. There are at least two reasons for doing this: first and foremost it is fun and satisfying; more importantly it shows you have thought about how the work might function in this form, and you will be able to incorporate any accompanying text you have planned. Indeed the dummy book will help sell your idea to any potential user when presented in tandem with your printed portfolio, as it shows the images in a proper context, in sequence, and alongside any proposed texts.

So, you have a substantial body of work and now you have to edit it down to between ten and twenty images. See this as a positive: you may well be able to produce a number of different portfolios by careful selection, and thereby increase the number of potential users of the work. For instance, photography magazines certainly publish what might be termed general portfolios, but they are also always on the lookout for work that demonstrates photographic techniques or materials. Newspaper supplements publish project-based work: sometimes it is quirky in nature, sometimes on social or environmental issues; and if there is a book or exhibition in the offing so much the better. So does your edited selection need to give the whole picture? Or might the individual you are approaching be more interested in a story within the story? Outside of a large-scale exhibition, or publication of the project as a book in its own right, some individual aspect of the work might well stand the best chance of acceptance. So thinking very carefully about the picture requirements of the person you are approaching will not only increase the possibility of success, but it will help you in the process of editing down to the required number.

Never include an image just to make up the numbers. It will stick out like a sore thumb and weaken the overall impression. Better to have a smaller strongly coherent set of images, than a larger one that looks cock-eyed. You can always indicate that there is plenty more material for consideration if they are interested. And it's no bad thing to involve a second opinion in your editing; photographers do not always make the best editors of their own pictures. You don't have to take your friend's advice, but at least listen to it. It is, after all, another third party who will sit in judgement on your work, so why not take advantage of the chance to second guess their reaction? In the same way don't let your own attachment to individual images carry too much weight in the decision-making process; think again about the person you are presenting the work to, not about your own preferences and prejudices.

*A portfolio presentation to my own magazine, **Ag**, by **Dominique Bollinger**. It looks like a book, very professional; but in fact it is a simple home-made solution. It is a set of carefully-made A4 inkjet prints with a wrap-round cover printed on oversize A3 (A3+) watercolour paper, which is big enough to cover the A4 prints with sufficient extra width for a square spine.*

© Dominique Bollinger.

Autumn 2005 | Number 41 | £12.50

Ag

THE INTERNATIONAL JOURNAL OF PHOTOGRAPHIC ART & PRACTICE • NUMBER 41

COVER STORY:
NOIR
By Erik Hijweege

PORTFOLIOS
Robert Adams
Beth Dow
Noel Myles

PRINTING & PRACTICE
Stilted by State Art
Time to self-publish
Tricolour rediscovered
Souped-up Cyanotypes
Online promo & print sales

PLUS...
New books on photography

Hold the front page

Even before the project is completed there could be opportunities to get some of the work published, thus raising its profile and yours, too

ONCE YOUR PROJECT is well under way – has reached the 'work in progress' stage, if you like – it is not too early to think about publication. The body of work you have produced up to now may not be fully rounded and ready for you to commit to an exhibition or a book, if that is your ultimate plan, but there is every chance you can interest an editor in a set of images and a few words to go with it. At a later stage when you are trying to attract funding or sponsorship for the book or show – or both – to have had part of the project already published will work in your favour. In many cases it will have raised a little finance towards your costs as well. But for your purposes, publication is the important issue, and any money accruing is a bonus.

Magazines and newspapers – The UK is the highest per capita consumer of magazines in the world. The total number of titles runs well into five figures, more than half of which are business and trade publications. The majority are specialist titles with modest circulations and publication fees are therefore likely to be modest too; but the target is another line or two on your cv and something else to add to your collection of press cuttings, not instant wealth. That comes later, and for most photographers, often not at all. There are the newspapers too, although they are less likely to be interested in a series of images, but may be up for a single image to illustrate a feature. That said, with national newspapers increasingly reliant on sourcing images from one of the huge online agency databases using keyword searches, they have become a poor market for freelance feature work. The exception to this is the weekend supplement which will often include series from project-based work; however these tend to be from well-established professionals, or if the name is less well-known usually it will be linked to a new book or exhibition. This is therefore something to think about once the project nears completion and a show or book is in the offing. Lead times on these national publications – the time between planning an issue and its publication – can be long, so you need to approach them well before the exhibition opens or the book comes out.

While national newspapers may offer few opportunities, if your project is based on an issue of local importance you stand a very good chance of gaining exposure in the local paper. Most regional papers are produced on shoestring budgets and rely on the same agency news sources as their rivals, supplemented by an underpaid reporting staff of as few as one. Neither is the standard of photography exceptional: how many different angles can you get of the mayor and his/her chain of office in the same issue? Enter your pristine images with a strong local angle and they will be falling over themselves to publish. You might wish to supply the text as well and so avoid any misunderstanding about the objectives of the project. Writers on local papers can be prone to flights of fancy, hyperbole, split infinitives – and exclamation marks!!!

Research – The huge choice of magazines means a lot of research is needed to identify those most likely to be interested in your work. There are various press guides, including *Willings*, which you will find in many library reference sections, but one of the best sources and one aimed specifically at photographers is *The Freelance Photographers' Handbook*, published annually by the Bureau of Freelance Photographers (BFP). You can buy the paperback from the BFP or become a member and qualify for a free copy. The book lists all the periodicals the BFP has been able to track down, their picture requirements, a guide to fees, and full contact information. When contacting a publication always include the individual's job title. People move around a lot in publishing, but the job title should mean your missive lands on the right desk even if the named person has moved on.

*Facing page: The front cover of a recent issue of my magazine features an image from a project, titled **Noir**, by **Erik Hijweege**. Inside the magazine a portfolio of the work accompanied by a short text by the photographer not only serves to showcase his talent, but is also a useful advertisement for a newly published book of the work. You can see more at **www.hijweege.com**. Image © Erik Hijweege.*

*You can find out more about the **BFP** and its publications at **www.thebfp.com**.*

Featured project:
INTIMATE PLANTS
By Paul Hart

"My photographic interest in plants was born out of an enthusiasm for gardening. Over the last decade my partner and I have moved home several times, and each time we have redesigned and replanted the garden. A downside of this is that plants are slow to establish, but this high turnover of gardens has, I think, taught me much about plants. Consequently, I have been photographing plants for many years and I now consider the garden as my photographic studio.

"One of the greatest attractions of the plant kingdom is its diversity: whether it be beauty, magnificence or even strangeness, the visual interest is inexhaustible. **Intimate Plants** is a series of monochrome plant portraits, which attempts to convey the wonder of these natural forms. Rather than documentary, my approach has been subjective and interpretative. So, in portraying these plants, I try, as intuitively as possible, to let each individual subject influence my interpretation. I began this work over two years ago and haven't stopped adding to it – so it is still 'in progress'.

"One of the greatest costs of this project has been in terms of time – both in photographing and printing. However, materials aren't cheap and as my working method involves producing contacts, then work prints, and then toned fibre-based exhibition prints of 12x16in, 20x16 and 20x24 sizes – costs obviously rise accordingly. I process and print everything myself to help to keep production costs down to a manageable level.

"Although I have received no funding or sponsorship for my 'Intimate Plants' project, due to its forthcoming exhibition I was able to generate a substantial amount of coverage in the specialist photographic press, and that was helpful. The project was exhibited at The Photographers' Gallery (Print Sales Gallery). I believe a major factor in securing the exhibition was the progress of the project – as I produced new work I presented it to the gallery. Eighteen prints were exhibited, with the complete body of work available to view as a portfolio.

*A selection of images from **Intimate Plants** can be viewed on The Photographers' Gallery website under 'Artists Represented': **www.photonet.org.uk**. All images © **Paul Hart**.*

*The four images here are from **Paul Hart's Intimate Plants** series (see left) which was exhibited at **The Photographers' Gallery** in London. Having a show lined up at a major venue enabled Hart to gain exposure in a number of magazines. As a project, it is also an example of work that a photo magazine might use to illustrate a technique article – on close-up photography, or toning, for instance.*

"Although the cost of producing the work was down to me, The Photographers' Gallery bore the cost of framing the exhibition, promoting it and organising a private view – and that was obviously a substantial help.
"Presentation of your portfolio can differ depending on personal style. For my style of work the quality of the print is of utmost importance. Over the last ten years I have striven continually to improve on this, so when it comes to someone reviewing my work, probably in a short space of time, having the best quality I can show is a big plus. Secondly, it is very important to present your work personally. With people having so little spare time, galleries usually prefer portfolios to be left with them for review. Although this is understandable, personal contact is a big advantage." **Paul Hart**

The nature of your project will determine the market for the images. You should also be prepared to supply text to go with them. A feature package of words and pictures will always be more saleable than the pictures on their own, so if you don't do words find a friend who does. You should always be prepared to edit the images and make the angle of the text specific to the publication's market and requirements. You will usually be wasting your time if you make a submission to a magazine that you haven't researched; and as there are so many to choose from this would be rather silly, so check out a copy in the newsagent or library before making contact with them.

Then there are the photography magazines, and there are a lot of them. As before, a ready packaged feature will always be the most saleable, but make sure it fits in with the magazine's editorial slant and is not something they have published the month before. It is common for a magazine to publish a piece on, say, the use of fill-in flash, only to receive half a dozen identical submissions in the following week's post. Engage brain before acting.

Photography magazines are always on the lookout for fresh, strong imagery and they get through a lot of pictures in the course of the year. These magazines do publish straight portfolios, but a much greater number of images are used to illustrate practical "how-to" articles. Frankly, and unfortunately, most of the time a submission with a practical bias will stand the best chance of being used: the angle might be some aspect of technique or technology; it might be about materials or processes; it might be as mundane as the selective use of depth of field. Now of course your project will not have been about technique, but don't be ashamed to admit that the work could be used in this way. It is publication, after all. That said, submissions to photography magazines that tell a story are relatively uncommon because most of the readers – like the magazines themselves – seem to be obsessed by technique. A typical "good" submission will comprise a set of technically competent pretty pictures where the whole is no greater than the sum of its parts. A well-executed project therefore has a head start here, so if you can't bear to prostitute your work to the "how-to" route, stick to your guns and submit the edited portfolio from the project, along with the statement about the work. It is not usually necessary to

provide a full-blown essay; often the published text will be written in-house based on your statement and maybe supplemented by a few telephone or email questions.

Submissions – Having identified possible markets for the work – either on the basis of the photography or the subject matter, and ideally both – the submission needs to be put together. It is generally best to make contact with the magazine's staff first to sound them out, either by letter or more commonly these days by email. In doing so you can gauge the level of interest – which can save you wasted time and effort if little or no interest is apparent – and there is a good chance you will pick up information that will help you tailor your submission to the magazine's requirements. This will help you finalise your edit of the images and may suggest an angle to take in any text you supply with them. Conversely, this might only amount to finding out in what form they prefer submissions to arrive, but this in itself will improve your chances of success. It is also important to establish who best to send the work to: if it lands on the wrong desk it might stay there – forever.

The ideal submission should comprise a brief covering letter, maybe reminding them of your previous contact, your text and the images, and any information you think will catch their eye. A long CV is unlikely to impress, unless it includes you winning World Press Photo or a Pulitzer Prize. The text will be either your statement about the work or a longer feature; only take the latter route of you are confident that is what they are after. It can work against you by limiting the way in which your work is viewed. You can always indicate your willingness to provide a longer text should they want to go ahead and publish the work. A set of inkjet prints should be included as these are quicker to view than a CD. But you should also include digital files on disk. Most magazines prefer images supplied ready digitised as this saves them time in scanning and it also means your work is available at short notice, should an opportunity arise. If you don't know their precise requirements supply the images as RGB files as large as possible at 300dpi; obviously they don't need to be any larger than a double page spread, and normally half that size – page size – will be more than adequate. You can leave the CMYK conversion down to them as their printer may have

specific requirements that you don't know about. If you want your material returned always supply self-addressed packaging with adequate postage. Magazines don't employ staff to return material sent in on spec and they certainly don't want to pay the postage themselves, but make it easy for them and your work will come back in due course.

Don't expect a rapid response or to see yourself in print the following week. Magazines work several issues ahead and the queue can be long. Don't hassle them or they might just return the work to get rid of you, but a polite query as to whether or not they are likely to be interested a couple or three weeks after sending it is perfectly in order. If there is no sign of action after several months you might feel it's time to ask for the return of the material: tell them another magazine is interested and you want the material back to send on to them. If the "other" magazine is one of their competitors it might just work. By this stage you have nothing to lose.

Fees – If your work is being published to tie in with an exhibition or book publication a photography magazine will not normally expect to pay to publish the images. As they are giving you free publicity neither should you expect a fee. The same goes for a photography magazine publishing a portfolio of your work where, presumably, you value the exposure. However, if they expect exclusive use of the work – and particularly if you are providing the text to accompany the images – a fee is not unreasonable. What the magazine's view of this is will vary from title to title, there is no set rule. You will have to take a view yourself, which in your situation is likely to be that publication with no fee is better than no publication. If there is no add-on publicity value to you and you are supplying a full feature package then even most photography magazines will pay. It's maybe best not to ask about money until the decision to publish is made. If the first question you ask them before any real interest has been shown in your work is "How much?", you may not be giving a good first impression. But even artists need to live and negotiation of a fee once they indicate their intention to publish is simply professional and nothing to be embarrassed about.

How much? – How long is a piece of string? But let's say you are not going to be able to retire overnight. If you have researched the magazine in

the BFP's handbook an idea of fee levels might have been given, but many play it safe by describing fees as "negotiable". In many cases this is because they don't want to put anyone off by admitting how little money they have available to pay freelances. As getting the work into print should be your priority, is it really worth haggling over a few pounds? You may think it is worth two or three times what they are offering, but if the gap between their idea of a reasonable fee and yours is that wide then never the twain shall meet. They are your images and it's up to you. It is worth pointing out that many of the most famous names in photography have worked

for nothing in their early years in order to get their names into the pages of magazines such as *Vogue*. Think of it as investing in your future; and if the magazine gives your work a good spread, think how much it would have cost as advertising space. But maybe that's just a magazine editor speaking …

Particularly if you have settled for a modest fee, most magazines will happily send you a few "voucher" copies of the issue which you can use as press cuttings and keep in the back of your portfolio. If the title in question is particularly prestigious it is even worth going out and buying a few copies yourself.

William Curwen's on-going project involves tricolour photography – colour images captured by exposing three frames of b&w film through red, green and blue filters, and then combining them as colour channels in Photoshop. His images were published in **Ag** – as part of a technical article. © William Curwen.

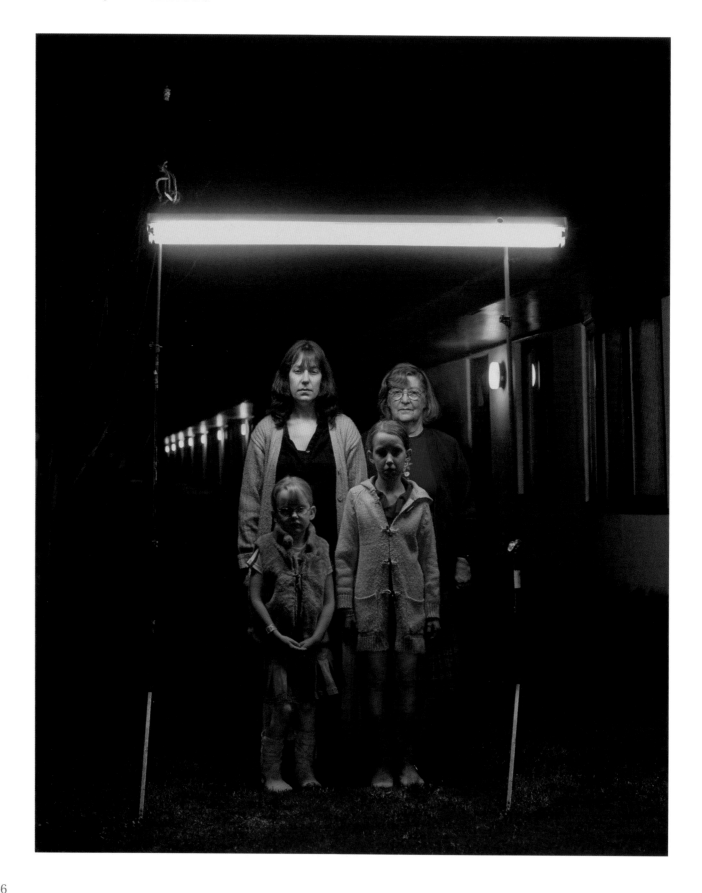

Aim for the Hall of Fame

*Don't overlook awards that offer the potential for free publicity,
an exhibition, publication in an awards book… even prize money*

PHOTOGRAPHY COMPETITIONS might sound somewhat peripheral to your personal project and, in many respects, they are. However, they are worth mentioning here because they do offer the opportunity to get your work into print and an exhibition at someone else's expense, and in the case of the more prestigious awards the publicity can be substantial. If you are trying to organise an exhibition of your own or raise funding to get the work into print, an honourable mention, or better, in one of the major awards will enhance your CV in the sense of being a seal of approval from a group of independent arbiters. This can tip the balance in your favour in opening doors, and is something you can use in marketing a self-published book. Most importantly, success in even the big competitions is not as hard to achieve as most people would think.

I make that last statement with confidence because over the years I have served on many dozens of awards judging panels, some for prestigious international prizes, many much more modest. But all seem to have had a couple of things in common. A remarkably high proportion of entries simply don't cut the mustard: whether it be because the imagery is poor aesthetically or technically, the presentation slapdash or the link to the brief tenuous, so many seem to have been entered in hope rather than expectation. That said, the judges' cliché about how hard it was to settle on a winner is in fact often true; but the point is that it is usually very easy for the judges to arrive at a shortlist. And if the award or competition is marked by an exhibition as well as prizes, to get on the shortlist means that at least you will probably be part of the show. I am not certain why the average standard of entry is often relatively poor. You can put some of it down to people not really trying, not reading the brief properly and just digging something out from the shoebox under their bed. I'm also sure that some folk are put off by thinking they haven't got a hope; but take it from me, you

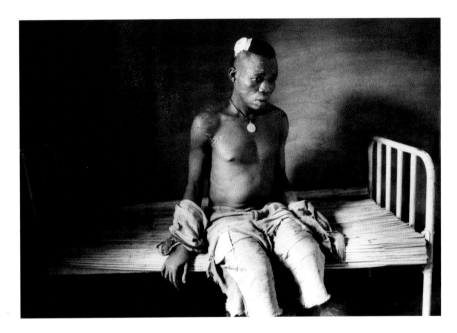

have. It is in the interest of the organisers and their sponsors that the competition should attract as much publicity as possible and you can benefit from this too – as well as having the chance of some material gain. On top of an exhibition of the best entries – sometimes at very prestigious venues – there may be a book or catalogue published to accompany the show. National newspaper supplements publish selections from the work and photography magazines gobble up what represents free editorial, and free publicity for you.

Entry criteria vary and the subject will typically be dealt with in one of two ways: either there will be a very specific brief, or maybe a single word or phrase that is left deliberately open to interpretation. My advice is always to read the brief very carefully and follow it to the letter; this alone would get you onto the shortlist of many of the competitions I have judged. That means, of course, that if the brief is very specific the chances of your

*Above: **Marcus Bleasdale** won the **Ian Parry Award** bursary, sponsored by **The Sunday Times** newspaper, which funded one of his projects. This image is from his book **One Hundred Years of Darkness** – more images on pages 30–35. © Marcus Bleasdale.*

*Facing: **Ric Bower** won third prize in the **Schweppes Photographic Portrait Prize** 2005. His image is titled **Three Generations** and is from his project series **Prayer**. © Ric Bower.*

Schweppes Photographic Portrait Prize
www.npg.org.uk.

Association of Photographers
www.the-aop.org.

Ian Parry Award Bursary
www.ianparry.org.

Prizes & Awards, published by Dewi Lewis Publishing, £12.99, 320 pages softback, ISBN 1-904587-16-X.

project work fitting the bill are small. But this is not a problem, it just makes it easier to choose which competitions to enter. Indeed two of the UK's highest profile annual awards have themes which are open to endless interpretation: the Schweppes Portrait Photography Award culminates in around seventy of the entries being exhibited at the National Portrait Gallery in London and in the accompanying book, and the only entry criterion is that the photograph be a portrait. And I can tell you that the organisers' definition of a portrait is extremely liberal. Another example is the annual Awards of the Association of Photographers (you have to be a member to enter) where the competition is divided into simple categories such as people, landscape and so on. Again there is a high profile exhibition of entries which tours, and the opportunity to get your work in the associated book – modestly called *The Book* – is what motivates many of the commercial advertising and editorial photographer members to enter. This is because *The Book* has long been used as a source book by art directors in agencies and on magazines. Of interest to a greater number will be the Association's annual Open competition: the Open may not have the same commercial cachet as The Awards, but as the title suggests you don't need to be an Association member to enter. A "longlist" of entries is exhibited and the winners usually get a fair amount of press coverage.

Some award schemes offer a bursary as the prize, designed to allow the winner to carry out a project that would otherwise not see the light of day. One such is the Ian Parry Award for young photographers and students, promoted by *The Sunday Times*, in memory of a photographer who died on assignment for the paper, when aged only 24. To enter you submit a portfolio of work with a proposal for the project you wish to pursue – see *www.ianparry.org* for details and previous winners.

On a slightly more down-to-earth note, your success in any competition can be exploited. What better recommendation for your book than one of the images winning a prize? Send your local newspaper an image and a press release with details of the book and make sure the local bookshop has some copies. If there is no bookshop, then stock up the newsagent. You will be very unlucky if the information doesn't get published. And the retailer would be mad not to stock some copies if you offer

a sale or return arrangement. So how do you find out details about photo awards and competitions? The internet, of course, is a good source of information. Enter "photography awards" into Google and more than 90,000 results are returned. There are many photo-related sites that list a selection, as do many photography magazines. There is also a recently updated book from Dewi Lewis Publishing (see bottom left) which gives comprehensive information on the more significant awards, including bursaries aimed at funding projects and book publication, which is right up your street. Many of these awards are international.

Terms & conditions – As an adjunct to the advice about careful reading of the brief, all the competition rules should be read in detail. This is not just a matter of maximising your chances of success, the terms and conditions attached to entry should be studied too. All competitions will – or should – have a set of conditions, and it is normal for entry to imply acceptance of these. So far so fair. But you need to keep an eye out for any conditions relating to copyright and usage of entered images. Established awards' schemes are not usually a problem here, any issues of potential conflict between the promoter and photographer will have been ironed out previously; it is with one-off and new competitions that you need to tread carefully. The worst-case scenario is where a company has discovered that its picture library is somewhat down at heel, and sources of imagery for promotional purposes and in its annual report are seriously lacking. "I know", thinks someone in the PR department, "let's run a photography competition, give away a few bob in prizes and restock that way. Much cheaper than hiring a professional for a few days or buying from a stock library, and we might get some publicity out of it too." Yes, even in big companies, there really are people as crass as that.

Steer a very wide berth around anything that reads like a "rights grab", that is terms that imply that the organiser acquires copyright or any unreasonable usage rights over images that are entered. On the other hand it is entirely fair and reasonable that the organisers have the right to use images in the promotion of the competition and in publicising the results. And it is in your interest, too, that they do so, assuming you are among the winners. Similarly, it is perfectly reasonable that

they use the images for next year's corporate calendar – so long as that intention is made clear in the entry details and that you are happy with the possible reward. And that's the point: it is up to you to decide when reading the terms and conditions whether you are happy with the deal. You have to balance what is in it for you against what the organisers are claiming in return. Most awards and competitions come with few if any strings attached; those that do need looking at long and hard.

Most competitions are free to enter, but by no means all of them. Don't be put off automatically if an entry fee is involved, although you may well think longer before deciding to opt in. Fees are charged for two principal reasons: to help raise finance towards costs such as prizes, an exhibition and maybe a book or catalogue; and also to try to raise the overall standard by putting off no-hopers. From experience the latter aim is not always achieved, but it does reduce the quantity of entries which makes things less tiresome for the judges. As with the terms of entry you will balance this expense against the potential benefit, but don't be put off just because there is a cost. In general, the awards with an entry fee are those with the most prestige attached; and this is why, I guess, they can charge a fee and still attract entries.

You didn't create your body of work with a competition in mind, I'm sure. But don't dismiss the idea out of hand, you could be missing a trick.

*Wildlife specialist **Steve Bloom** (©) was among the winners in the 2005 **Association of Photographers' Open** competition. Each judge picks his/her own winner, there is an overall best in show, and the public can vote in another category via the AoP's website. The longlisted entries are exhibited at London's Association Gallery. www.aop-open.com.*

Working with printers

If you are new to it, commercial printing is something of a black art. Here's what you need to know to see your project through to print

UNLESS YOU PLAN to limit your break into publishing to a copy or two produced on your own inkjet printer, you will be seeking the services of a commercial printing company. This printer may offer both offset lithographic or digital printing, but as the latter is specific to small quantities and on-demand printing we will leave that for now (see pages 108–115) and concentrate our attention on lithographic printing.

First find your printer – And, because no matter how much care and attention you have lavished on your image making, it is by the results from the printer that your work will be judged for posterity, this is a very important decision. There are two basic approaches here: either contact the printers direct, or employ the services of a print broker. A print broker – often known in the trade as a print farmer – is an individual or business that specialises in matching a client's requirements to a printing company. They will have a large number of contacts and know which particular firm is best suited to the job in hand; further, they will handle the liaison with the printer and, of course, earn commission on the job. You will pay them, rather than the printer. Now potentially this can be more expensive than dealing directly with the printer, but not necessarily so; brokers will be able to buy more cheaply than you, if only because they place a lot of work, so the overall bill may not be higher than what you would pay by going direct. And even if it is a bit more costly, the advantage of having a print professional acting on your behalf could be worth the price if you are inexperienced in the field. Just Google "print broker" to come up with a long list of possibilities.

If you prefer to deal direct with the printer where do you start? There is no better recommendation than word of mouth, so if you know someone who has already been down this route take advice from them. Check out bookshops for volumes similar to that which you have planned; often the printer will be credited in the "imprint", the listing of legal and copyright information usually sited at the front or back of the book. This way you can put together a shopping list of contacts from which you can get estimates for comparison. Price is one principal concern here, but the other, of course, is quality.

Before asking a printer for an estimate, check first that they are set up to tackle the job. For instance, do they have the right size presses for the page size you have in mind? Are they equipped to do the finishing and binding that you require? Most printers will quote for a job even if they have to sub-contract (hence print "farming") some element of it to another firm, but in these circumstances you are unlikely to be getting the best price overall as they will add a handling fee on top of whatever their sub-contractor charges them. Ideally you should visit the printer in person; it will help you get an overview of the operation and help you gauge whether you want to entrust them with your masterpiece. Few printshops are pristine and tidy, but the way printed sheets are stacked and stored and the amount of scrap paper and trimmings littering the floor will tell you something about how much pride they take in their work. It is always a good sign if they are busy, and a visit in person will help you get to know the people you will be dealing with when your own job is on press.

A brief aside about geographical location. Many commercial book publishers choose to print abroad: for instance in Europe, Italy and Spain offer high quality work at very competitive prices; similarly the Far East, Hong Kong and now China are popular for the same reasons. However for your rather smaller enterprise, if you factor a visit or two to the printer into your budget, you may be persuaded to stick closer to home. Further, overseas printers – particularly those in the Far East – will be unwilling to print a job without a full set of accurate colour proofs, and that will stretch the budget too. Finally, if you have not worked with the printer

Facing: *Damme, Belgium,* from *Gardenscapes* by *Lynn Geesaman.* Details on page 82.

before he might ask for some payment up front; in part as a sign of good faith, but also to cover him for, say, the paper, which he will have pay for even if he doesn't receive payment for the job. If he doesn't ask for payment of any sort in advance, he is very likely to expect payment on delivery from a new customer.

For the printer to give you an accurate estimate you will need to supply a detailed specification. So here we look at the various elements to be specified, discuss what the choices are and the way these will affect the final cost.

Specifications

Trim size – The finished size of the book, expressed as height x width, usually in millimetres (or centimetres) as paper sizes are metric. The printing paper is slightly oversize and after printing, folding, collating and binding, the book block is trimmed down to size with a guillotine to produce a neat, regular finish. Hence "trim" size.

Extent – Total number of pages, that is "sides", or twice the number of individual leaves. With a paperback book the covers will normally be in addition to this and specified separately, being printed on a heavier paper or card. For economy the pagination should be based on the size of sheet that the press is designed for: an SRA2 (oversize A2) press will print four A4 pages to view (on one side of the sheet) therefore eight pages on each sheet or section. It will therefore be most economical for your book to have a pagination divisible by eight. Printing, say, five eights and a four will not save a significant amount over six eights: there are still the same number of sections to print and bind, and the same number of plates to be made. You may save a tiny bit on paper, but better to have the extra four pages. Similarly, you may save money by printing on a larger press, say one that can print 16-page sections, because fewer sheets will be required to complete the job; the downside is that your book will need to be a multiple of 16 pages – or 32, 48… .

Covers – Specify whether the inside covers are printed or not, and the material to be used. Also any special finishing such as lamination (outside only?), or varnishing. Rememeber that the width of the spine will be affected by the number of pages and the paper thickness. If you are opting for a hardback (case binding) the specification here will get more complicated and include features such as endpapers; it is probably safest to put this part of the spec together in discussion with the printer.

Dust cover – An optional extra, but usually desirable on a cloth-bound hardback which can be embossed, but not printed on.

Process – The number of colours to be printed which in turn affects the type of press on which the job can be run, the number of plates to be made… . For a book of photography the obvious choices are:

Monochrome – single colour black.

Duotone – Two colours, black and grey. Two points to make here: this process is designed for the superior reproduction of monochrome images; the second colour adds more ink to the page improving the range and graduation of tones, and the choice of the precise colour of grey – neutral, warm or cold – will enhance the image in the same way as your choice of paper, print developer and process type does in the darkroom. Tritone and quadtone printing operate on the same principle and use two or three greys, respectively, in addition to black.

Process colour (four-colour or full-colour, *see facing page*) – Clearly this will be your choice if your photographs are in colour, or if you want to use colour in other aspects of the book's design. However, if your images are monochrome, consider duotone printing and using the second colour (grey) as a way of brightening up the design. You will save a certain amount on the actual printing, and there will be fewer plates to make which will bring down the cost. Anyway, the combination of black, grey and the white paper can make for a classy look. Magazines commonly use four-colour printing for monochrome imagery, but this is really a consequence of needing full colour elsewhere in the publication; printing monochrome using all four process colours ensures a full tonal range and good maximum density, but poses the printer the problem of retaining a neutral colour balance. Tiny shifts in ink weight or registration can turn b&w photography pink, or blue/green, and retaining a constant colour tone over all sides of all sections is more difficult because the printer is trying to balance four colours against each other.

Paper – Your choice of paper will be one of the most significant defining factors in the quality and appearance of the finished book; it will also be one of the most significant costs. Large-scale publishers who buy paper by the tonne can save money here by purchasing their paper stocks from a paper

merchant (wholesaler) or even direct from the mill, thus avoiding the mark-up the printer will charge for handling and storage. Because your book will require a relatively small quantity of paper, you will look to the printer to supply it. The printer will generally hold stocks of paper in popular weights and finishes that experience has shown produce good results with their presses. Choosing one of these is likely to be the most economical option; however, the printer will also be able to supply a wide range of alternatives and show you samples from their usual sources if you are after a sheet with a particular texture or colour. However, papers outside the printer's usual stock range are likely to cost you more and often will be subject to a minimum order quantity which could be well beyond what is required for your book.

There is a bewildering range of printing papers available and unless it's your pet subject it is wise to take advice from the printer. That said, there are at least two basic paper qualities that you should have formed an opinion on before approaching the printer: finish and weight. Paper weight is specified in grammes per square metre (gsm). There is obviously a relationship between weight and thickness of the sheet, but you do get "bulkier" papers which are relatively thick at a particular weight, and being less dense may feel softer and less rigid. A particular paper product will be offered in a range of weights; what this range comprises will vary, but for example might go from 80gsm to 300gsm or above, with several intermediate weights. Papers are costed by weight so remember that if you are tempted to increase the specified paper weight

CMYK: A demonstration of the ink weights of the four constituent process colours. Clockwise from top left: cyan, magenta, yellow and key – or black. Notice how little black is in the image: density is built up by the other three colours, with the black used to enhance the tonal detailing – hence being referred to as "key".
The Atlantic Ocean, from Traigh na Clibhe**, on the western coast of the Isle of Lewis.© **Chris Dickie.

by 20% the paper bill will increase in proportion. To generalise, magazines are printed on papers in the range of 80-90gsm, although top quality productions will go heavier still. For your book you might look at a minimum of 115gsm as a good starting point; heavier is better, but needs justifying against the extra cost. Remember that the weight of the cover stock needs quoting separately. Here a good starting point might be 300gsm for a softback (now becoming referred to as a firmback if a decent weight of card is used), i.e. more than twice the weight of the text paper.

Finish – The surface of any half-decent printing paper is coated to enhance the paper's printing performance, and this coating also affects the physical appearance of the paper and therefore whatever is printed on it. As with photographic papers, a gloss finish helps to reproduce good apparent maximum density, and this in turn appears to enhance sharpness through its effect on micro-contrast. The downside of a gloss finish is that in many lighting conditions flare off the page becomes a problem; also, a high gloss finish is not necessarily aesthetically "right" for an art book. At the other extreme, a thick page with a matt finish can mimic the appearance of a fine art print; if the tonality of the original images suits then this can be the most pleasing solution. However, achieving a high maximum density and contrast range can be an issue as matt paper reflects less light and sometimes the surface fibres can stick up through the ink and 'grey' the shadows. For these foregoing reasons a large number of high quality fine art books are printed on some form of semi-matt or "velvet" paper to try and get the best of both worlds. Paper choice is clearly a very important part of the specification and a complex one too; if your printer is able to show you printed samples of papers you are considering this is bound to help in your choice.

Opacity – This third paper quality should never be overlooked. "Show-through" is the phenomenon of being able to see what is printed on the back of a sheet from the other side, or being able to see the page beneath it. Show-through can really spoil an otherwise quality production. A particular paper will have an inherent opacity which, naturally, increases as the weight of the sheet increases. For a high quality finish you should make opacity one of your selection criteria. As a rule of thumb the less white a paper is the more opaque it will be, and a

less than pure white paper is certainly not to be seen as a problem with a book of photographic art. It is easy to compare opacity by laying sample sheets on top of a magazine or newspaper page – you may be surprised how much the show-through varies between samples. As well as being important in its own right, this quality of a paper could well be a deciding factor if you are stuck for choice.

Binding – Leaving aside the various forms of spiral and comb binding that you might use for a hand-made book, the two most common forms of binding the printed sheets into book form are saddle stitching and perfect binding. The former is the least expensive and is commonly used in magazine production. The printed sheets are folded and dropped on top of each other on the binding line, like a saddle on to a horse (hence saddle stitching), beginning with the centre pages and finishing with the covers. The sections are then stitched together using two or three metal staples, and finally each copy is trimmed flush by guillotine at the top, bottom and outside edge to finish it off. If your budget is tight or the book has too few pages to suit the square-backed style of perfect binding, saddle stitching will be your choice.

Perfect binding is more expensive but it produces an object immediately recognisable as a book, rather than a brochure. Instead of being dropped on top of each other in the bindery, the folded sections are collated side by side and the folds milled off to create a spine, which is then glued. A paperback's spine attaches directly to the cover, whereas a hardcover (or case) is attached via end papers (a heavier grade paper than the book itself) which are glued to the inside covers and first and last page of the book. Alternatively, you can do away with end papers and have the cover glued directly to the first and last pages. This "self-ending" is cheaper, but less sturdy. A variation on perfect binding is notch binding where the folds remain intact except for notches cut across them where the glue is inserted.

An alternative form of square binding is to sew the pages together. This is stronger than simple gluing – especially when a coated paper to which glue adheres less readily has been used – and it helps to prevent the whole thing falling apart in use. When case binding a book the covers are made out of heavy board around which is wrapped cloth (or leather!), or a printed sheet protected by varnish or lamination. This is the most robust, but expensive,

form of bookbinding, and an additional dust cover is often used to provide a printed wrapper for the book. The options available for case binding are many, so this part of your specification should be put together in discussion with your printer.

Special – To improve its appearance and durability the cover of your book (assuming it's a softback) should be varnished or laminated. In either case you have the choice of a matt or gloss finish. Varnishing is less expensive, but if you can afford it go for lamination; it is much more durable, allows marks to be wiped off without fear of damage to the cover, and will add weight and stiffness. Matt lamination, in particular, gives a class finish.

If you still haven't spent all your money you might consider special finishes such as spot varnishing. Here a layer of varnish is applied over the images to lift them out from the page, typically by making them glossier than the paper on which they are printed. The varnish is added during the printing process by an additional unit on the press, after the ink has been applied. In effect you are printing an additional colour and you will need to provide the printer with files wherein these blocks of "colour" are accurately positioned for the plates to be made. If you leave it down to the printer to do this for you the extra cost could be significant, to the extent that the money might be better spent on some other aspect of the production, such as the paper. But it is well worth considering if you are capable of producing the files, and a much cheaper option is to have a sealant applied over the whole page which will have the same effect of lifting the image reproduction, but without making the pictures stand out from the background paper. Either form of sealing the images helps to prevent offset of ink from them onto facing white paper.

Material supplied – Suffice it to say that the less work the printer has to do on the material you supply before making the printing plates, the lower the cost to you. Indeed, you should aim to supply files that are ready for going straight to plate. Go back a generation and you might have expected to pay for typesetting the text and page artwork, and certainly the halftone screening and colour separation of images. Now with a variety of desktop publishing programs you can do all of this yourself. For the purposes of the estimate the printer will want it confirmed that there is no pre-press work involved prior to plate-making; for your part there

are a number of technical issues you must be aware of and these will be dealt with in the coming pages.

Quantity – This is self-explanatory, but for the purposes of the estimate specify how many copies you are intending to produce, but ask for a run-on/run-back price per 25 or 50 copies. This will allow you to change the print run at the last minute without the need for a requote. Also, the printer will print more sheets than needed to fulfil your order to avoid wastage during the finishing and binding process leaving him short. It is therefore common to end up with a few more bound copies than were ordered which, if you are lucky, you may be given for nothing; if you're not so lucky then at least the run-on price gives you a basis for negotiation. If you want any 'overs' available always negotiate: apart for one or two file copies and samples, an extra box of books is not much use to the printer.

HAVING SELECTED your shortlist of possible printers approach at least two, or maybe three, for an estimate. If you have done your homework properly you will have your own order of preference based on the quality of previous work they have done. Quality and reliability are always more important than cost, but as you are operating on a budget it cannot be ignored. Be honest with the printer: if your preferred printer does not come up with the best price (as is the most likely scenario) go back to him and explain that although you are keen that he does the job, his price is too high by whatever amount. Don't expect him to drop the full amount as he won't want to give the impression the original price was expensive, but it is very likely some discount will be offered to secure the job.

Preparing the job for the printer
It is most important that you and the printer understand precisely what the job comprises, both for the sake of producing an accurate estimate in his case, and for you to supply material in the correct form for him to do the job without intervention. This is not intended as a full-blown manual on desktop publishing, that is a book or two on its own. However, preparation of files for a litho printer differs from producing documents for your inkjet printer in a number of ways, and you need to be aware of these if it is not something you have done before. Therefore it is assumed that you are competent in the software you intend to use for

KEY POINTS
• *Semi-matt or 'velvet' papers are popular for art books because they can carry a full range of tones, avoid flare in direct lighting, yet look the part.*
• *A commonly overlooked quality of paper is its opacity. Don't let your book be ruined by show-through from the pages below. Off-white papers are generally more opaque than bright ones.*
• *Keep the price down by doing all the pre-press work yourself, or calling in a favour from someone who can help out. Although we can't all be a Jack Of All Trades, a 21st century visual creative should be able to do this stuff.*

Duotone printing – (see overleaf): The image on the facing page was shot on black and white infrared film and the negative scanned into Photoshop to prepare it for print.

The large version is in duotone – black and warm grey – to mimic the tonal choices available to the darkroom worker, or maybe toning after the print is made.

For comparison, the image bottom left is printed in single colour black (greyscale), and bottom right is the greyscale version converted to four-colour (CMYK) which – in theory! – allows a greater tonal range through putting more ink on the paper.
*© **Chris Dickie**.*

document production and image editing, but the next section highlights issues to be addressed for litho reproduction as opposed to desktop printing.

File format – You can be using the most esoteric software on the planet and produce successful printouts from your own computer, but this becomes an issue if the file is to be sent to another computer for printing. If the other computer can't read the files you're stuck. You have two basic choices when supplying files to your printer: you can either supply your book as a file "native" to the software in which it was produced, or export it from that software into a universal format such as pdf (portable document format). In the latter case it doesn't matter to the printer what software the document was produced in, he will be able to open and output the file from Adobe Acrobat Reader, which is a free download from the company's website.

For making up the pages files the two industry standard software packages are Quark Xpress and Adobe's InDesign. For many year's the Quark product had the upper hand, but InDesign has made a big dent in Quark's business by not only being a good product at a competitive price, but by linking with established graphics-related packages from Adobe such as PhotoShop and Illustrator. If the price or complexity of these professional level programs are beyond you, there are many cheaper but less versatile packages, and most word processing applications can be made to fit the bill too. If you are providing a native file your printer will need to have the relevant software to open it; you should also advise which version (development stage) of the software you are using in case there is a compatibility issue to be addressed. Additionally you will need to supply all the graphics files used in the document – most importantly your pictures – and the printer will need to hold the typefaces (fonts, more of which later) used in the design. The images *embedded* in the document are simply header files for on-screen display and do not contain the actual image data from which the picture will be printed. Conversely, if the file is supplied in pdf format you can imbed everything in the document so all your printer needs is the pdf file. It is relatively easy for both you and the printer to check that all is as it should be if he runs out a set of laser or inkjet prints as proofs on receipt of your files. To minimise the chance of anything going

awry between the two computer systems (yours and the printer's) the best format to supply is pdf, because of its ability to carry all the data in a single file. Adobe developed the pdf format and its Acrobat software (the full version, not the freely distributed Reader software) will be required if the program you are using for the page makeup does not allow for export in pdf format. (There are other pdf creation programs available, but as an Acrobat user the author has not had occasion to test them.) In any event, so long as you are using a reasonably popular software package your printer should be able to handle it – but check.

Fonts – Fonts have the potential to cause the most annoying problems when output from a different computer system to the one used to create the file. In computing the word "font" has come to mean a type family, whereas in the real world of typography it actually means a particular size of a specific typeface – ie 9-point (abbreviated as 9pt) Times New Roman Italic. There are two basic types of font: *TrueType* and *Postscript*. Always use the latter if at all possible. In essence they differ in that TrueType fonts comprise a single file used by the computer for both display on-screen and printed output; Postscript fonts comprise two files – one is for display and the other is a printer font for output via a Postscript device, Postscript being the page description language developed by Adobe. Postscript fonts are designed for the accurate rendering of type in commercial printing situations, TrueType fonts are typically supplied as part of the computer's operating system for display of on-screen text, whether that be in email, simple text editing or those dreaded error messages. A typical problem with using TrueType fonts for your book is that your printer's version of, say, Helvetica may not be quite the same as yours, and when opening your document the text may run to fewer lines – or worse, run longer and disappear off the page altogether. You can use TrueType fonts, but be aware of the dangers and check proofs carefully.

So, in the world of professional publishing, of which you are now part, Postscript fonts are the ones for the job. Needless to say, your printer will need the fonts in order to output the job. Digital fonts are small computer programs and like all software are protected by intellectual property legislation; in law your printer should own his own copy of the fonts and you are not allowed to

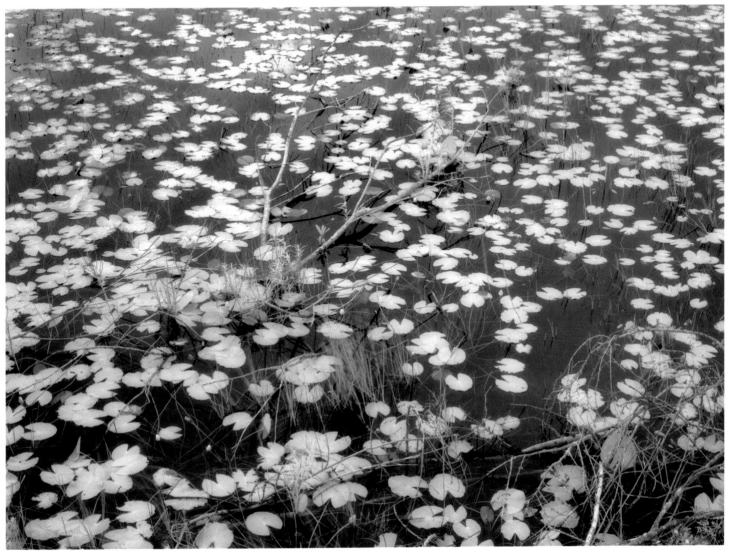

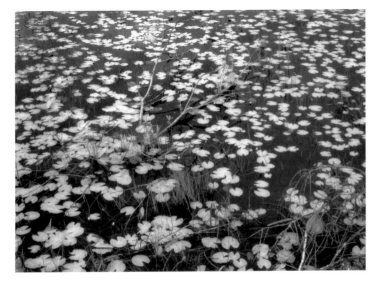

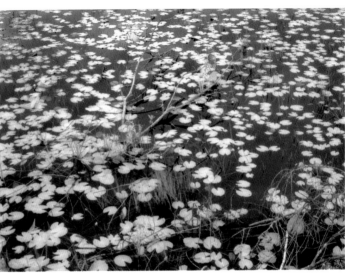

distribute them to him for the purpose of outputting your book. In practice very many people ignore this and in doing so break the law, however you can get round the problem by supplying in pdf format, where the fonts can be imbedded. The font data are held within the document to allow accurate rendering, but are unavailable to be 'stolen' and used in other work. Having pointed all that out, printers hold a large library of digital fonts these days and so long as you don't get too exotic in your design there is a fair chance they will own the fonts already. And, because many font licences allow you to install on more than one output device you may be acting legally, even if you think you aren't.

Images – The default colour format for digital cameras, scanners, page makeup software – and inkjet printers – is RGB (red/green/blue); this is also the format used by computer displays and televisions. If you are printing your book in colour your palette and your pictures will need to be converted to the four process colours: cyan, magenta, yellow and key (CMYK). CMY are the complementary colours to RGB and K, or key, is the printer's term for black. Black is used in the printing process to enhance the tonal range, graduation and detailing of pictures, as well as for printing text, and helps avoid muddy-looking shadows that might arise using CMY only *(see page 73)*. Most image editing software will allow conversion from RGB to CMYK, but be aware that some of the cut-down versions distributed with scanners and printers may not, as it is not a requirement for their successful operation and is only used in commercial printing.

With four-colour printing it is vital that you ensure all your files are in CMYK. If an RGB file sneaks through it will import into your page makeup software okay and look fine on-screen, but when the printer separates your document into the four constituent colours for printing, your RGB file will reproduce as greyscale. The same goes for any colours you use in the design or typography.

The standard and recommended file formats in which to supply images are .tif (tagged image file) or .eps (encapsulated Postscript) – never use .jpg or native PhotoShop files. Remember not to resize your image files after they have been placed on the page as they will output the wrong size, and never change the filename because the output computer won't be able to find them at all. As with my earlier comments about document design this is not a

book about PhotoShop – there are zillions of them. However there are relevant points to be made about image and document preparation for litho printing which, unless you have worked this way before, need highlighting. In addition to supplying images in CMYK format the key issues here are: size and resolution; and dot gain. But first a quick word about duotone *(see example, previous page)*.

Duotone printing allows the superior reproduction of monochrome imagery without running to the expense of full-colour. In addition to black a second ink, a shade of grey, is used to enhance the tonal graduation of the images and often to impart a warm or cool tone as well. This second colour is usually specified as a Pantone colour, that is from an industry standard range of premixed coloured inks, also commonly referred to in use as 'spot' colours. Professional standard software such as PhotoShop and QuarkXPress/InDesign have Pantone colours already specified in their colour palettes from where you can make your choice; however, as your printer no doubt has more experience in duotone printing than you do, seek advice on colour choice, in particular the optimum density/darkness of this second ink. Once you have settled on the specific grey you will use in the images alongside black, add it to the colour palette of your page-makeup program for use in enhancing the design. You might as well, because you will be paying for two-colour printing whether or not you use it in the typography or other design elements. And when you create the book document, remember that you have only two colours – and tints thereof – to work with.

Image size and resolution – It is not vital that the image files you supply are exactly the same physical size as they appear on the page. However their resolution (in dots per inch, or dpi) is highly significant; so to ensure that the resolution is correct you might find it easier to size and specify the correct resolution at one and the same time in your image editing software. During this process ensure that the file is big enough to start with: if anything you should be reducing the size of the file when specifying the image's dimensions and output resolution, not increasing it. If you do the latter all you are in fact achieving is stretching the image; you are asking it to reproduce itself from information that isn't there and quality will suffer. The same applies when outputting an inkjet print.

The optimum resolution will depend upon the screen "ruling" your printer intends to use for printing the images and any tones in the graphic design. You will no doubt be aware already that to print tones by lithography they are first converted into a pattern of solid dots surrounded by white space: large dots for the darker tones, small ones for light tones. This process converts the continuous tone original into a "halftone". The dots are very small and close together and fool the eye into seeing a continuous tone; how small is determined by the screen ruling (measured in line pairs per inch, or millimetre) selected for reproduction. The finer the screen the higher the quality of reproduction, assuming the paper quality is adequate to keep the dots separated and not bleeding into each other. Here you need to take the advice of your printer as he will have a much better understanding of how the paper selected will perform on his press. However, it is likely a screen of 150lppi (or maybe 180lppi) will be used and the rule for image file preparation is to set a resolution of numerically double the screen ruling. That is 300dpi or 360dpi in the examples given. And remember this is at the printed size, not whatever size the image starts out, and that is why it makes sense to resize it and specify the resolution in a single conversion. Experience suggests that you can enlarge an image by 10% or even 20% after this process without running into trouble, but if you change the layout drastically it is safest to return to the original image and size it and its resolution afresh in your image editing software. Remember to bin the first conversion so it doesn't get used by accident.

Dot gain – This is something else on which you need to refer to your printer, as it is a factor resulting from the combination of paper and printing press used. In short, it describes the phenomenon whereby the actual size of a printed dot in a halftone is larger than it was in the original file and on the printing plate. This is caused by a combination of the characteristics of the paper and the degree to which the ink bleeds on its surface, and pressure applied by the press which can 'squash' the dot. Dot gain is expressed as a percentage, a typical value might be 15%, and you can compensate for this by specifying a value in your image editing software. It is one more way you can help the printer produce an accurate facsimile of your masterpieces, so ask for a specification.

Bleed – If your book design requires an image, a block of tone or a rule to go right to the edge of the page, you need to 'bleed' it beyond that point to ensure that when the paper is trimmed during the finishing process this element does indeed reach right to the edge of the page. The accuracy with which the pages are trimmed is not just dependent upon how the guillotine is set up, but on the accuracy with which the sheets are folded down to make single pages and then bound together. It is impossible for even the most careful of printers to have all the page edges in perfect register at this point, and if you have extended a design element to just the edge of the page in your make-up software, if the page is trimmed slightly oversize you will be left with a fine white stripe between the picture and the edge of the page. Extending or bleeding the image (rule, panel, or whatever) beyond the theoretical edge avoids this problem; the industry standard bleed is 3mm outside the intended trim, but your printer might have a different specification. Check.

Proofs – Although digital desktop technology has made all of this easier, at least to the extent that you can do all of this pre-press work yourself and save a lot of money, it has introduced an extra stage

Bleed: A screen shot of the page make-up software Quark XPress showing the top corner of a right-hand page at high magnification. The green vertical line to the right is a guide set 3mm outside the edge of the page to serve as an anchor point for a bleed image. This extra 3mm of image will be trimmed off after the book has been printed and bound, leaving a clean finish with the image extending right to the page edge. Similarly, the righthand side of the box rule around the page number is guaranteed to be trimmed off.

into the final proofing process. You know exactly what your book is supposed to look like, but your printer doesn't, and because of the potential for translation errors between your two computer systems previously discussed, the first proofing stage is to check that no such glitches have occurred. Your printer should supply you with a set of digital proofs run directly off his system to check that all is well. It will help if you supply a set of, say, laser proofs with the electronic files, so he, too, can check that everything is appearing on the page as it should on his system, including no reflowing of text. If you are running a properly colour-managed and profiled digital workflow you should be able to supply an accurate set of proofs in colour, and this will have the additional advantage of being available to the printer during the printing process for colour matching.

Colour matching – Once both parties are satisfied that the book is outputting correctly the next stage is plate-making and then printing. Both you and the printer have a vested interest in accurate colour reproduction, but how best to achieve this is something of an issue because of the potential costs involved.

Wet proofs – Once upon a time "wet" proofs were all that was available. You can still ask for them now, but they are hideously expensive, so don't. The high cost is down to them being properly printed pages using the actual plates and paper, so you end up paying twice for all the make-ready costs that are a significant part of your bill with a short print run. They will usually be supplied in seven parts as a package termed a 'progressive'. One sheet will be the full four-colour version, one sheet each of the four colours printed on their own, and a sheet each of the first two colours and first three colours. These last two will vary depending on the order of colour printing favoured by the printer, but will usually be yellow and magenta, and yellow/magenta/cyan; key (or black) being the final colour. Clearly, these are the best type of proof available, but ruinously expensive in this age when many jobs are printed without any colour proofs at all. Your best option, and a compromise, is to pass the job on press by inspecting 'running sheets' (below) having first seen a good quality digital proof, maybe a "scatter" proof (also below).

Film proofs - In the days before computer-to-plate (ctp) technology an intermediate film negative, or positive, was made for each of the four colours printing each side of the sheet, and these were exposed to the printing plates in an ultraviolet vacuum printing frame. As the film represented the final stage before platemaking, various ways were devised by which it could be used to provide a colour proof for both the customer and the machine minder who would print the job. One such, that became an industry standard, was the Cromalin system, a heavy laminated proof made using dust inks in a contact exposure process. The lamination stopped the dust inks from smudging off. Printers not yet using ctp technology may still use these proofs, but they are not cheap and are generally agreed to be slightly warm compared to the original file and therefore not a perfect match.

Digital proofs – Most ctp printers will have alternative digital proofing systems: there is a digital version of the Cromalin, and others such as Matchprint. But many are now using wide format inkjet printers to provide relatively inexpensive colour proofs which confirm accuracy of file translation, but can be a bit hit-and-miss for colour matching. These are often output to give their machine minders something to go on in the absence of anything else from the client. Such are the realities of the downward pressure on print costs brought about by digital technology.

A good compromise for all concerned and with the quality of the finished print job is "scatter" proofing, and although it is an option you will usually have to pay for, the cost should be small. Indeed your printer might produce one for nothing in the knowledge that is going to help him get the job right. The printer's computer operator creates a document, say a double page spread, not of the book itself but of images taken from it, ideally at least one from each side of each sheet to be printed. This is then output using a high quality digital proofing system giving a colour proof of use in colour matching every sheet from the job. There is nothing stopping you supplying your own scatter proof document and choosing specific images where you are concerned about colour matching.

Colour bars – A final method of colour checking, which the printer will usually exploit for his own satisfaction, is to print industry standard colour bars on the edge of the sheet, outside the page area. These comprise blocks of the four process colours, tints and combinations thereof,

and screened patterns, all of which can be used to check print density, registration and performance. It is rather like using a step wedge in the darkroom. By using a densitometer to measure the colour bars the ink weight (density) can be checked and adjusted and the job run "to weight" without reference to any colour proofs. In theory, if the supplied files were colour perfect, this procedure should be fool-proof; but the world isn't that perfect and maybe your files won't be either. Hence the value in checking running sheets.

Running sheets – Printers are used to having clients pass a job "on press", and although many might prefer not to have amateurs cluttering up the print room, they are happy enough to comply in order to ensure that the job is done to everybody's satisfaction. As this involves a visit to the printers, maybe over more than a day, choosing a firm within striking distance has its advantages. Be prepared for a long day – or days – as you might see one side of one sheet at two-hourly intervals. Take a good book.

The principle of the press pass is that the printer will clean up the press, fit the plates and then run up the job to his initial satisfaction (generally using waste paper from a previous job) and present you with a sheet to inspect. Here you will have to be prepared for compromise. Colour can be adjusted within limits on-press, but you can't start performing Photoshop-style changes. Remember that he is printing what you supplied and that some imperfection might be down to you. The object is to achieve the best possible result which, if you are fortunate, might also be perfect.

If you don't have a set – or if it's only a partial set – of colour proofs to compare the printed job with, it is useful to both you and the printer to have original prints (or accurate inkjets) to refer to. Just remember to allow for the possibility that these might not be a precise match to the file you supplied, but they still provide something to aim for.

First keep an eye out for small spots printing on what should be white paper; these spots always appear for no apparent reason during plate making. But this is such a basic issue for a machine minder that a good one should have already scrubbed them from the plate before offering you a sheet to look at.

The weight of the four inks can be adjusted independently across the sheet, that is at right-angles to its travel through the press. Always have this direction of travel in mind when suggesting

inking adjustments, because any change will affect all the images in line with the one you want to tweak, even at opposite ends of the sheet. And always take the advice of the machine minder, in this situation he's the professional. Rather than making suggestions about specific colour adjustments – more cyan and less magenta, whatever – try and explain what you are trying to achieve, or both of you refer to an original print for comparison. It is the end product that is important, not your personal idea of how to get there.

In costing the job the printer will have taken into account how long it will take and will have made allowance for a certain amount of paper wastage. Don't over-extend the time it takes to pass each sheet for printing; if it is taking more than a handful of tweaks to get there, either the material you supplied was not top notch, or the printer isn't – or maybe a bit of both.

Then, once the final sheet is passed for press, that is the last you will see of your work until a van drops a whole load of boxes on your doorstep – and the bill. From receipt of the files to finished job should not take more than two weeks, and it can certainly be done quicker – unless you are printing on the other side of the world. Depending on the number of pages involved and the size of the press, the actual printing may take just one or two days. But allow a fortnight in your timetable because the initial proofing process can hold things up and the longest part of the process is usually the binding.

Accurate reproduction of imagery is obviously paramount in a photography book, and here Lynn Geesaman talks about her project *Gardenscapes*, where the style of her photography posed potential pitfalls for the printer.

Lynn Geesaman's book *Gardenscapes*, published by the Aperture Foundation was the culmination of ten years' work photographing the subject in colour. The experience also taught her something about the need for an element of compromise by the artist in the transition of an image from a carefully hand-crafted print to the printed page. While always striving and aspiring to the best possible reproduction of one's work, it has to be accepted that some limitations are inherent in the reproduction process. And while anyone who succeeds in getting a commercial publisher to produce a book of their work will obviously be

• With a properly profiled digital workflow you should be able to supply the printer with accurate inkjet prints to match to. This is an economical way of colour proofing.
• However, you won't get accurate colour by outputting from your page make-up program – unless you have had that profiled too. Use prints from your image editing software.
• A good and cheap way of providing proofs is the "scatter" proof. Select images from each side of each sheet for matching.
• Don't ask for Photoshop-style adjustments on press. Ink weights can only be adjusted across the sheet, at right-angles to its progress through the press.
• When passing on press try and explain to the machine minder what it is you are trying to achieve. This works better than telling him his job.

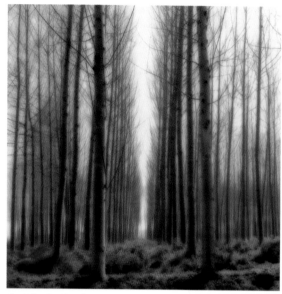

Andalucia, Spain.

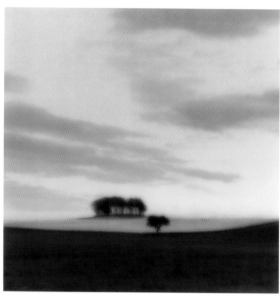

Brechin, Scotland.

Featured project:
GARDENSCAPES
By Lynn Geesaman
Theme: *A body of work representing ten years of photographing gardens in colour. A selection is viewable online at* **www.thomasbarry.com.**
Exhibitions: *Five USA galleries who represent the photographer's work have exhibited 20–30 of the images at a time from a total of 60. 71 images appear in the book.*
Book: *Published by Aperture Foundation at $40.*
Format: *10x9in, 112 pages plus cover, casebound with foil-blocked spine and four-colour dust jacket, printed four-colour.*
Designed by *Judith Michael; text by Verlyn Klinkenborg (nature writer/editor, New York Times).*
ISBN: *1-931788-20-0*
Print run: *2500, printed in the Czech Republic.*
Production cost: *$2000–3000 in preparation of proofs, thereafter print production costs borne by the publisher.*

delighted, they may also have to accept some compromise on, say, elements of design in the light of say-so from the publisher's marketing people. Also, someone else controls the production schedule and the speed – or lack of it – at which progress towards the finished product is made. Things that the self-publisher does not have to worry about. Conversely, the difficulty of matching originals on the printed page affects everyone.

"I had been photographing in colour for ten years and had a body of work ready for publication," says Geesaman. "My dealer in NYC, Yancey Richardson, helped me to assemble the work and to approach Aperture. Previously I had been working only in black and white, and a book, *Poetics of Place*, had been published some years previously.

"Since I work on the image as I print it, the original colour negative could not be scanned to represent the finished photograph, necessitating scans of the actual finished prints. Matching the scans to the colours of the prints proved to be both expensive and difficult, although there might have been a better way for someone who is more digitally competent.

"The finished work was exhibited at five galleries in the US who represent my work. The exhibits were coordinated in one case with a talk at PhotoLA, and otherwise associated with promotion and sales of the book, as each gallery purchased a fair number of copies to sell and have on hand. While I did not receive funding for these shows, I benefited in the end with sales of my work that would not have been so plentiful without the added promotion of the book.

"It was very easy to work with Aperture. I am delighted to have a published compilation of my favourite colour images over a period of ten years. I like the pairing and use of double-page spreads of details, which breaks up the sameness of the layout. It is helpful to have an index of reference numbers of the photographs in the back index, so that individual images can be absolutely identified in case of inquiries.

"I was told at the outset, by a photography dealer, not to expect the result to look like my photographs: this is true, to my disappointment, but I don't know how it could have worked better. I like the back cover a lot, but am not enthralled with the dark cover, the title *Gardenscapes*, and the white lettering (I am told these were choices made by the marketing department). I would have preferred no text with each photograph, and that the occasional remarks could have been printed smaller for less distraction, but I am told that people want to know more about photographs in books these days, in the photographer's voice.

"Scanners seem to sharpen automatically, so if your images are 'soft', as mine are, the person making scans should bear this in mind and you must check the results. Above all, a schedule for printing the book must be firmly established and adhered to, for your sanity. I was very happy with the writing of Verlyn Klinkenborg, and I like the idea of a literary voice in a book of images."

Bagatelle, Paris.

Parc de Jeurre, France.

Waddesdon Park, England.

Hot Springs, Arkansas. All © Lynn Geesaman from Gardenscapes.

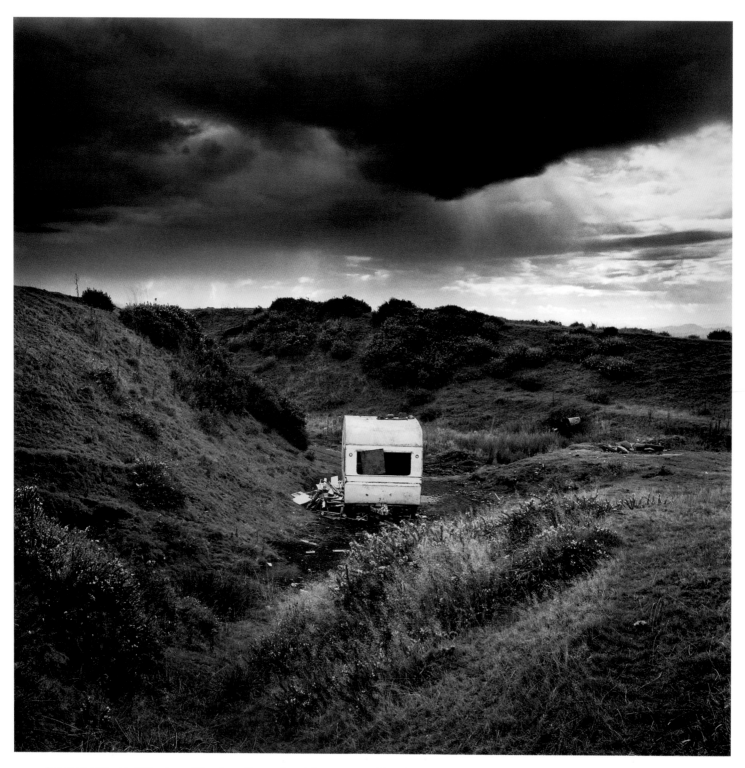

*Dumped caravan, Titterstone Clee, from **Quarry Land: Impermanent Landscapes of the Clee Hills**, by **Simon Denison**, details page 89.*

Someone to share the bill

Funding bodies and awards schemes exist to help in the pursuit and publishing of arts projects

WE HAVE CONSIDERED the importance of budgeting in the planning stage of a project in an earlier section. The more ambitious you are, the more complex this becomes, and if an exhibition and/or a publication feature in your plans the complexity and costs increase. Throughout this book photographers talk about raising funding or sponsorship in order to be able to complete their project, mount an exhibition or publish a book – or all of these. To succeed here you need to do what they have done: persuade the person with the money to part with it – in your direction. In those earlier sections we described this as a sales process and emphasised the need to present yourself, your idea and your work in a fully professional manner, just as you would approach a job interview. But where do you start looking?

In the UK the main funding agencies are the four national Arts Councils and their regional boards and offices. Each has its own website and you should check these out for detailed information on applying for their grants for the arts – and the very best of luck! There are also commercially backed bodies and foundations that run programmes of awards and bursaries for artists; these are a little more difficult to track down, but many receive mention in relevant periodicals. A good place to start is *Prizes & Awards*, a guide published by Dewi Lewis Publishing which has been updated recently (details on right). It includes information on many national and international schemes, including contact and entry details, and caters for artists and writers, as well as photographers. Here we look at two projects that benefited from funding, and as a result were exhibited and published as books.

Tessa Bunney has found that the involvement of a gallery in the process of pursuing a project can pay dividends when it comes to raising funding to support the project itself, mounting an exhibition and book publication. And although *Moor and Dale* which features here is one of her personal projects, it began as a commission.

"I have a particular interest in different landscapes and the way they are shaped by human activity through agriculture and associated traditions. Working closely with communities and individuals, my work explores people's relationship to the landscape, often combining text and sound with the photographs. Aiming to investigate and record the relationship between the area's landscape, wildlife and people, *Moor and Dale* was commissioned by Nidderdale Area of Outstanding Natural Beauty (AONB).

"I was approached by the AONB and the Mercer Art Gallery (both of which are part of Harrogate Borough Council) to put forward a proposal to produce a series of characteristic images of Nidderdale AONB that captured the relationship between the area's landscape, wildlife and people and allowed the community to see themselves reflected through the eyes of an outsider. I chose to undertake a project looking at land management in Nidderdale AONB, activities which maintain the

Text continues on page 88

*Marking lambs, by **Tessa Bunney**, from **Moor & Dale** (details overleaf).*

Prizes & Awards is published by Dewi Lewis Publishing, ISBN 1-904587-16-X. dewilewispublishing.com.

*For **contact information** on the UK's **Arts Councils** and regional boards see page 127.*

Above: **Heather burning,**
Upper Nidderdale.

Top right: **Bottles for pet
lambs,** Greygarth Farm.

Right: **Dipping sheep,**
Gouthwaite Farm.

Featured project: MOOR & DALE by Tessa Bunney

Theme: Investigating the relationship between the landscape, wildlife and people of Nidderdale in Yorkshire, an Area of Outstanding Natural Beauty (ANOB). A selection of images is viewable online at **www.tessabunney.co.uk.**

Exhibitions: Mercer Art Gallery, Harrogate, organised as a collaboration between the gallery and the ANOB, supported by a grant from the Arts Council RALP (Regional Arts Lottery Programme). 57 images exhibited; shown at four other venues.

Book: Published by Harrogate Museums and Arts, Harrogate Borough Council at £6.00.

Format: 200x240mm, 32 pages plus cover, sewn paperback, printed four-colour.

Designed by Groundwork Design, Skipton; text by Paul Burgess, Nidderdale AONB and Anne McNeill, Director, Impressions Gallery, York. **ISBN:** 1-898408-08-4.

Print run: 1000, printed by Triangle, Leeds.

Production cost: Approximately £6000.

Funding support and sponsorship: Principal funding from The Arts Council, with additional support from The Friends of the Mercer Art Gallery and Harrogate Borough Council.

Above: **Bird man**, Swinton Estate.

Right: **Hand clipping sheep**, Brandwith Howe.

Far right: **Flanker**, Upper Nidderdale.

All © **Tessa Bunney**, from **Moor & Dale**.

landscape as we see it today, providing both a haven for wildlife and a place of recreation for local people and tourists as well as a way of life for some.

"The AONB provided me with a list of contacts as a starting point; I was given the freedom to spend time getting to know the area and to follow avenues which were of interest to me. The final exhibition documents the working lives of hill farmers and gamekeepers and is my personal response to the people and landscape of Nidderdale.

"Although the views in Nidderdale are spectacular, I enjoy photographing details which might otherwise remain unnoticed. The peat lines on the gamekeepers hands showing a lifetime of work on the moor; the different cloth caps of the farmer and his two sons concentrating on the job in hand and the way the grouse beater ties his flag to the stick as it has been done for generations are all things which interest me. In each photograph I have tried to include an element of the landscape: this might be an expanse of open moorland, or maybe just be a glimpse of a dry-stone wall or barn in the background. In addition to the touring gallery exhibition which was first shown at The Mercer Art Gallery, Harrogate, an earlier exhibition took this work back into the landscape through an exhibition in a shooting box on Lofthouse Moor. Two miles from the nearest village, a walking route brought the public to the venue via a series of photographs along the path.

"The photographs were made over a period of two-and-a-half years, including an enforced break during the nationwide foot-and-mouth outbreak. The production of the work was funded as a commission from Nidderdale AONB who in turn received funding from The Countryside Agency for the project. The cost of materials and processing was in the region of £2000. We received a substantial grant from the Arts Council RALP (Regional Arts Lottery Programme) to fund the exhibition. RALP funding was only available to organisations and not individuals, so in applying for this funding the form-filling was a collaboration between myself and the curator of The Mercer Art Gallery.

"When it came to publication of the book The Arts Council was the main source of funding, and additional backing was received from The Friends of the Mercer Art Gallery and Harrogate Borough Council. The book is only available for purchase from the gallery, The Nidderdale Museum, Pateley

Bridge, and myself, because the gallery doesn't have the resources to go into wider distribution. Another benefit was that one of the conditions of the Arts Council grant was that I would have a number of free copies of the book myself so that I could send them out to relevant people as self-promotion.

"My most successful projects have always been collaborative, not only with the communities I work with but also with gallery curators who have been extremely helpful to me in the development of my work and fundraising to continue the projects. *Moor and Dale* started off with a modest budget for the production of photographs, but it developed into a major exhibition and publication through continued fundraising by the AONB and gallery as the project progressed and I had further work to show potential funders.

"I often begin projects by funding them myself to show what I am trying to achieve and then try to obtain grants or sponsorship for materials to take the project further. An advantage of working with a gallery early on in the project is that it has access to funding not available to individuals and the skills to be successful in applying for those funds."

Simon Denison's Quarry Land was the second of his personal projects to be published in book form. The work was made over a three-year period and here he summarises the project: "These are photographs of the abandoned post-industrial landscapes of the Clee Hills in rural Shropshire, made to express ideas of the passage of time, impermanence and loss, and the transience of all things mortal and man-made. This work covers derelict quarry buildings and other structures, wrecked and burned vehicles, dead or dying trees, the life and death of sheep, air crash sites and memorials to victims of World War II flying accidents. Ideas of impermanence have underpinned much of my photographic practice, and when I moved to the Clee Hills area in 1996 I quickly realised I could make work here.

"These images of the Clee Hills form a melancholy portfolio, undoubtedly reflecting my own vision of the world and not, by any means, an impartial documentary record of the Clee Hills landscape…. But melancholy is a bittersweet emotion – it is not the same as 'depressing'. In mourning for our losses, for the inexorable passage of time and the brevity of human life, we become

Featured project:
QUARRY LAND:
Impermanent Landscapes of the Clee Hills
By Simon Denison
Theme: The abandoned post-industrial landscapes of the Clee Hills in rural Shropshire. *simondenison.co.uk.*
Exhibitions: Midlands Arts Centre, Birmingham; The Art Space at Queen Elizabeth Hospital, Birmingham; Assembly Rooms, Ludlow. 35 images exhibited (60 in the book).
Book: Published by Greyscale Books, £14.95.
Format: 210x240mm, 72 pages plus cover, thread-sewn casebound, foil-blocked cover and spine and silk coated jacket, printed duotone with spot screen varnish.
Designed by Simon Esterson of Esterson Associates; foreword by Paul Hill, introduction by Simon Denison.
ISBN: 0-9541878-1-4.
Print run: 800, printed by Balding & Mansell, Norwich.
Production cost: Approximately £9000 for the book, plus £2800 in materials, marketing and framing costs.
Funding support and sponsorship: £9954 from Arts Council, £250 from South Shropshire Arts.

Above: **Conifer stumps with birch trees, Brown Clee.**

Right: **Burned-out car with water trail,** Clee Hill village, Titterstone Clee.

All © **Simon Denison.**

more intensely aware of the wonder of human existence and its fragility.

"Photographic books are often said to 'accompany' shows, playing second fiddle to the framed prints on the gallery wall. At the level of individual images, an exhibition print naturally has far more power than a small ink-printed version of the same image on the page of a book. But with a body of work like this, the whole is greater than the sum of the parts, and for that reason the book, in my view, is really the main work – as it represents the complete work, including all relevant texts, sequenced and arranged according to an over-arching plan. Yet a book like this is immensely expensive to produce, and given the difficulty that publishers have in selling all but the most commercial of photographic titles, the only way it could have been published was with the backing of a funding agency such as the Arts Council. Few photographic publishing projects receive such backing – so I regard myself as extremely fortunate to have had it. But this raises questions about fine art photography in this country: about the difficulties that artist-photographers face in realising their ideas, and about the accessibility of most artist-photographers' work."

What, then, are the economics of getting a project like *Quarry Land* into print? "The publisher Dewi Lewis once told me that he estimated the number of people in Britain who regularly buy photographic monographs to be 800. Isn't that amazing? So that's me, plus 799 others. And this, despite the fact that photographic books, indeed all books, are extremely cheap, generally, compared to most other products, judged on the basis of unit production cost plus profit margin. The unit cost of *Quarry Land* (produced to the highest standards, that is hardback, thread-sewn, with stochastic screening, in duotone with spot image varnish on heavyweight silk art paper, with foil-blocked covers, from arguably the best duotone printers in the country) was about £11.50 – while I decided the price, to sell well, shouldn't be higher than £14.95. Take retail discounts, marketing and distribution costs off that and it would be impossible to make a profit from the book even if every copy were to sell."

The book was distributed through photographic and art bookshops nationally, Waterstone's branches nationally, online bookstores, Blackwells and Tesco Books, bookshops in the Clee Hills area,

art galleries, and Denison's website. Complimentary review copies, sent to national, regional and local press and radio, generated substantial publicity, and leaflets and posters in the local area also promoted the book. Further interest was generated by giving talks to local schools and camera clubs.

So, how does one find financial backing? "The Arts Council won't look at you until you have at least one, and preferably a series of confirmed exhibition venues in place, and also grant aid from your local authority. Many county or district authorities have arts funding budgets; generally they disburse only modest grants, but these provide crucial leverage with the big agencies. All authorities have different systems, but the way it worked for me was that I had to provide a short written statement about my work and an overall budget, and then stand up and make a pitch for funds before the relevant panel.

"The Arts Council requires the same information – but more of it, and in much more detail. The proposal is made in writing, to your regional branch. You have to be able to demonstrate not only that your work has artistic and conceptual merit, but also that it meets at least some of the Arts Council's own funding aims and objectives, which are politically determined and liable to change. You also need to be able to show that you have the relevant experience and skills to manage the type of project you propose. In other words, you have to be able to write very persuasively.

"The other side of the proposal is the budget – and the Arts Council requires you to complete a very detailed projected budget, for both income and expenditure. This aspect is likely to be the most hair-raising for those with limited experience of accounts; but you will be managing public money without supervision and I think they simply want to be reassured that you have a reasonable head for figures and a clear grasp of the project's cost.

"This written proposal was followed up with at least two lengthy telephone interviews – so you have to be persuasive orally as well as on paper. I don't think anyone would say it was easy to get funding, particularly if you are asking for a substantial sum. The Arts Council told me that it was rare for them to fund publications, so I feel lucky and grateful to have received its support. Without the Arts Council award the project could not have gone ahead in the same way."

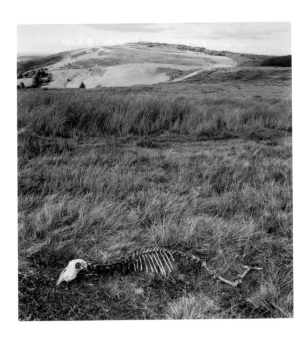

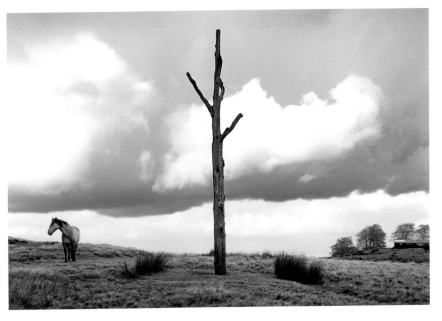

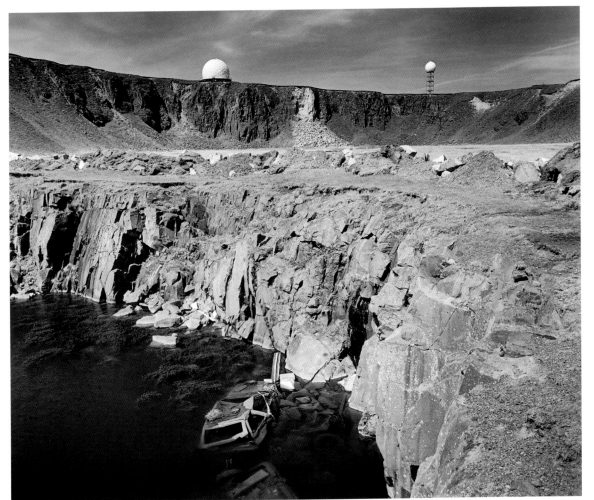

From top left, clockwise:
Dead sheep, Brown Clee.

**Tree-post and horse
(the 'Three-Forked Pole'),
Random, Titterstone
Clee.**

**Abandoned quarry with
two drowned cars,
Titterstone Clee.**

*All © **Simon Denison**,
from **Quarry Land:
Impermanent
Landscapes of
the Clee Hills.***

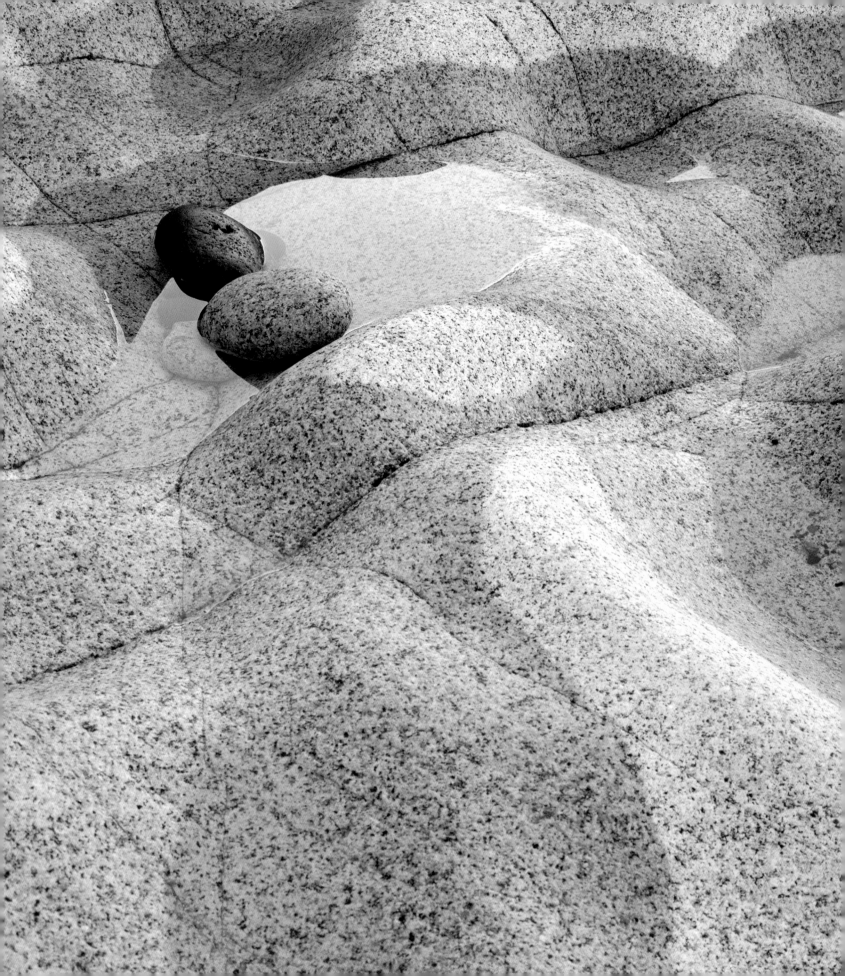

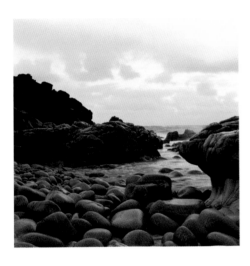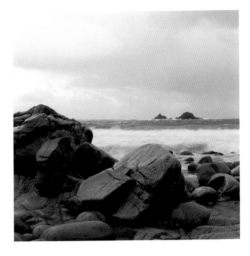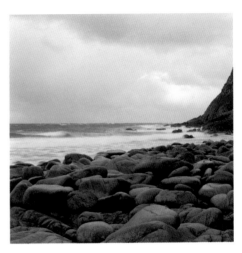

Want the job done properly?

Unwilling to compromise or to justify your existence to a funding body that won't be interested anyway? Then knuckle down and do it yourself

THE IDEA OF "VANITY" PUBLISHING has been around since the earliest days. It originated among publishers who realised that the many rejected would-be novelists and poets who approached them – artists who slaved away at the kitchen table and gained nothing more than a string of rejection slips – must include some who would be prepared to fund the printing and publication of their own magnum opus. To this day you will see these publishers advertising their existence in the literary review pages of the newspapers and magazines that are sufficiently well-bred to carry, erm, literary reviews. To get a commercial publisher to take up your cause is even harder for a photographer than for a first-time novelist. The international market for a photography monograph is tiny compared to that for a novel and the production costs are many times higher, so for most some form of self-publishing is the only option. The nature of your project may fall outside the remit of the funding bodies that can help with the cost of book production (see previous section) or, like Andrew Nadolski whose work is featured here, you may not personally wish to go down that route. Having decided to "do-it-yourself" you have a choice about how to publish your work and we will start with a look at the most rewarding option – and most expensive – the casebound book.

Andrew Nadolski's project has been ongoing for almost ten years. It began as a documentary study, became an exhibition that generated coverage in national newspapers, and then came the book. Nadolski describes this process of evolution: "The series *The End of the Land* is a study of the unique and changing landscape of a remote beach, Porth Nanven, in West Cornwall. The original aim was to make a series of pictures over two days; now, over nine years later, it has culminated in a book and a touring exhibition. The first images were made on a wet and windy August bank holiday in 1996. Although I had exhibited previously, these pictures were never intended for show – they were taken for very personal reasons. I had been exploring Porth Nanven for over seven years prior to making 'serious' pictures there. It is a place that exerts a fascination over the visitor.

"It was over the initial two days of photographing that the title and the theme which was to shape the work developed. As I climbed around this landscape I became fascinated with the idea of change and transformation underpinned by a wonderful sense of balance and purpose. The sharper angular granite of the rugged cliffs changes as you descend into the tidal zone. It becomes softer, in a sense more organic. As I explored this tidal zone I found the act of setting up a tripod and composing images

*Above, facing and overleaf: images from **The End of the Land**, by **Andrew Nadolski** (details on page 95). The subject of Nadolski's project is the changing face of Porth Nanven beach on Cornwall's coast. © **Andrew Nadolski**.*

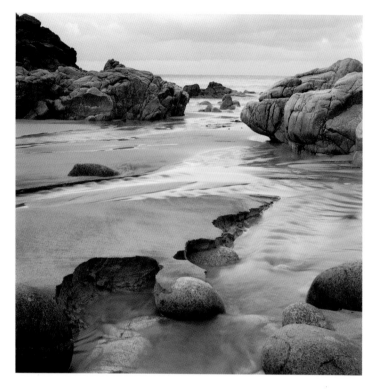
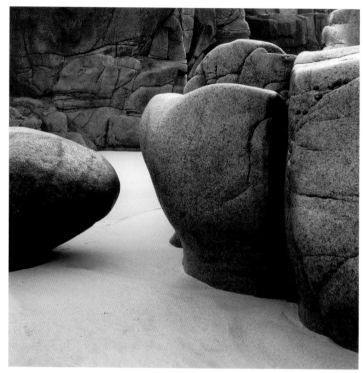
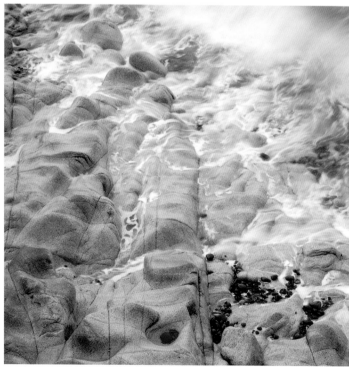
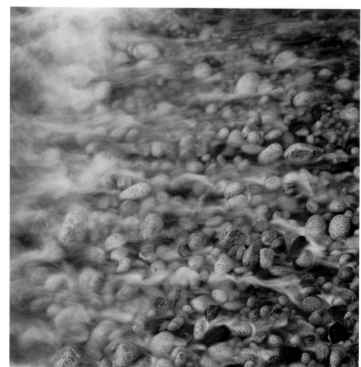

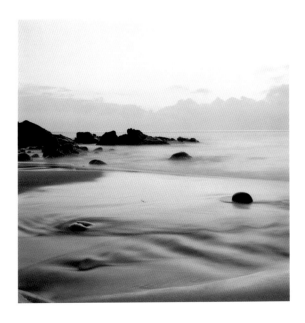

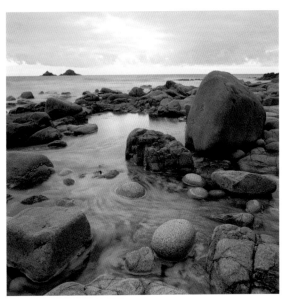

*All photographs are from **The End of the Land** (see right) © **Andrew Nadolski**.*

Featured project:
THE END OF THE LAND
By Andrew Nadolski
Theme: The unique and changing landscape of a remote beach in West Cornwall, documented over eight years. Online at **www.nadolski.com.**
Exhibition: Toured nationally, with a London show to mark the book launch.
Book: Self-published (Headon House) at £29.99.
Format: 295x295mm, casebound with a dust jacket. 130 pages (including a gatefold triptych).
Printed four-colour.
Designed by Andrew Nadolski; foreword by Tim Smit of the Eden Project; essay by Dr Richard Scrivener of the British Geological Survey.
ISBN: 0-9549244-0-1.
Print run: 3000 copies, printed in Spain.
Production cost: approximately £16,000 including proofs. Published with the support of the British Geological Survey.

on a ground glass screen made me look more closely at something I thought I was familiar with.

"I haven't kept a record of costs, I know the negatives fill two albums but I haven't counted the rolls of Reala I have used. I have received no funding or financial support for any of the photographic costs of this work. I have funded it myself by working as a graphic designer and photographer. I think I have resisted looking for funding as I don't want to have to justify this work. It has no social agenda and I suppose its only 'controversial' aspect is that it is popular with the general public as well as art professionals. I want to engage people with this work. Producing ugly images and proclaiming them to be high art does not appeal to me.

"The work is on a national tour and has been exhibited in part in previous years. I managed to arrange this national tour after a large exhibition in Derby. The show had attracted national publicity including a full-page review in *The Times*. I sent cuttings and a small catalogue to a number of museums and art galleries in the UK and was asked to exhibit by five of them. The exhibition comprises between thirty and forty large prints depending on the gallery space. The centrepiece is a large triptych which is over nine feet long when hung. The museums and art galleries don't charge for the space – it is not for hire; you are asked to exhibit if the curator feels the work has merit. The museums pay for most of the transportation costs, host the private view and pay for the invites and posters.

"The book was self-published. I couldn't bear the prospect of hawking my work around publishers. They are running businesses and who would publish a book about one beach? But more important was the fact that I wanted complete artistic and editorial control. The book, to me, is in a sense the culmination of the work. It is the one chance the reader has of seeing the scale of the work and that it works best as a sequence. I always described the work as a 'visual poem' and what can be more appropriate than producing a book?

"Over a number of years I have developed a relationship with the British Geological Survey. My fascination with Porth Nanven led me to contact Dr Richard Scrivener, of the BGS, who informed me that Porth Nanven had been of interest to geologists for many years. In fact the raised beach that so intrigues people today featured in one of the earliest published books on geology, *The Natural History of Cornwall* by the Rev William Borlase, published in 1758. Dr Scrivener wrote a fascinating and in-depth essay on the unique nature of the geology of the area with some wonderful quotes, references and historical images that form the

Featured project:
**SEVEN DAYS
IN HAVANA**

By John Claridge
Theme: *The title says it
all. Samples from five of
John Claridge's books
are online at*
**johnclaridgephotograph
er.com/books.html**
Exhibition: *The
Association Gallery,
London. 48 images.*
*Book: Self-published at
a modest £825.*
Format: *Hand-bound in
embossed leather, cloth
slip-cover by Book Works,
printed hand-pulled
duotone.*
Designed by *Adrian Pini,
text by Louisa Gonzales.*
ISBN: *0-9543994-0-4.*
Print run: *Limited edition
of 50, printed by Alan Cox
of Sky Editions.*
Production cost: *The
project cost around £300
in materials, the total cost
of book production was
£34,500.*
Sponsorship: *Exhibition
sponsored by The Leagas
Delaney Partnership and
Stirling Ackroyd.*

Images © **John Claridge**.

perfect introduction to my photographs. He and I
now do joint talks combining science and art. Far
from the science 'rationalizing' my art it has in a
sense reinforced it: my fascination with change and
transformation is the same as that at the very core
of the science of geology.

"I was fortunate to secure a foreword by Tim
Smit, one of the creators of the Eden Project in
Cornwall, who has very publicly supported my work
(in fact he bought three large framed images for his
office). His foreword is eloquent and passionate and
the great thing for me was that he fully understood
the ideas behind the pictures.

"I went into the distribution process very naively.
I have been very lucky that due to the publicity
surrounding the book and exhibition people have
been ordering copies from their local bookshops –
so the distributors/bookshops have been coming to
me. I have had very good support from the
bookshops in Cornwall and the books sell well at
the exhibitions.

"The only marketing I undertook was employing
a PR consultant that I had used previously. That led
to good editorial coverage in *The Daily Telegraph*
and *The Guardian* newspapers and a three-minute
piece on local TV.

"The book seems to be selling by word of mouth
which is fine, I am in no hurry. Already the book is
over three-quarters of the way to break-even. I don't
have the time to do any more marketing, but I am
confident that the book will soon reach a profit.

"The process of arranging a touring exhibition is
an exhausting one that is rewarded by seeing your
work hung in fantastic spaces and appreciated by
thousands of people. But it is frightening that all
that time spent eats into the time I can allocate
myself for my own photography. The book was even
harder work but it was something I was determined
to do and do myself. I wanted people to see 'the
whole story': the book and accompanying text are
the closest they can get to me giving them a
personal tour of Porth Nanven."

John Claridge has been photographing since the
age of fifteen. His long and busy career as an
advertising photographer has brought him many
awards, but he has always set aside time for
personal projects, exhibitions and self-published
books – five to date. The example shown here –
Seven Days in Havana – was published in a limited

edition of just fifty copies, produced without compromise and bound by hand in embossed leather. An expensive exercise with an end product aimed very much at the collectors' market; the book is stocked at "selected" fine art bookshops. John grew up in the East End of London and now lives in the south of France. Here he describes the self-imposed discipline behind the project:

"Every so often in one's career one stands back and takes stock. Although shooting a great deal of advertising work I have always made time for my books and personal projects. I started out at fifteen years of age documenting the East End of London. For me at that time the photographs were taken instinctively without any kind of influence, also without the professional knowledge I was to acquire in the future.

"I suppose the photographs had a naivety and innocence, and I guess innocence is knowing sod all. And I suspect a certain degree of naivety, and certainly that innocence, is now gone; but the question remained did I still have that raw instinct? So I took one camera, two lenses and film and gave myself seven days in Havana to document things that I instinctively related to without the restraints of any commercial ideology or influence. That is how the book came about. Obviously for me this was an important project, but most importantly it was an incredibly rewarding experience. We never stop looking and learning – never compromise."

*The images reproduced on pages 96–99 are all from **Seven Days in Havana,** © **John Claridge.***

*Scrap return incline, by **Alan Knowles**, from **Biscuits**.*

The book of the show

An exhibition provides the perfect excuse for you to burst into print

AS SEVERAL of our featured photographers have commented, an exhibition – or a series of exhibitions – goes hand in hand with a book of the work. If a commercial publisher is to take on your project, having a series of shows lined up presents an excellent opportunity for book sales at the venue(s). And the same is true for you as a self-publisher. Also, if you have secured funding for the project from an arts body, an exhibition will frequently be part of the package – indeed having set up an exhibition programme will get you some way down the line to finding funding in the first place. The exhibition catalogue is often a scaled-down publication: cheaper to produce and therefore less expensive to buy; it may not carry reproductions of all the work exhibited, but it will show at least a representative selection. With a show catalogue the exhibition has given you an excuse and the opportunity to burst into print. And well-designed and reproduced catalogues, affordably priced, most certainly sell. Here we look at two photographers who have produced books linked to exhibitions. One is a commercial commission and personal project combined – the former helping to pay for the latter – and the other a monograph of fine platinum prints, where it is hard to say whether the book or the exhibition came first.

Alan Knowles has a thing about biscuits. New Zealanders are fond of celebrating their locally-created icons, whether they be a child's toy, a famous artist, the national rugby team, a woollen shirt, Maori tiki or white gumboots. These icons make up the kiwi culture and are the subject of interminable books and magazine articles. But no one had held up the ubiquitous and beloved biscuit

as a cultural icon, and so Wellington-based Alan Knowles decided to say: "Hey, take a look at this!"

"Who among us can forget our early encounters with biscuits? My grandmother's favourites were the ornately decorated and opulent-smelling Super Wines, with their explosive crunch and comforting vanilla sweetness. There was a neighbour who served elegant Swiss Cremes, with their fine-textured melt-in-the-mouth fillings, and an aunt who gave us Cameo Cremes, which we prised apart for their delicious coconut filling. Wasn't it at the vicar's we got jammy Shrewsburys with their glorious chewy texture? And who can forget Girl Guide biscuits, tasting of condensed milk and sticking to the teeth? There is something reassuring about these biscuits, with their familiar names, shapes, tastes and smells. They seem to have remained the same for generations: wafers of consistency in a world of change.

"It was through contemplating the place of biscuits in our culture that I came up with the idea of photographing them and their manufacture – an idea which eventually led me to the grassy banks of Waiwhetu Stream, in Eastern Hutt. Here the Griffin's biscuit factory looms over traffic on Wainui Road as a cathedral of commerce not unlike the Edmonds baking-powder factory of Ferry Road, in Christchurch – alas, now torn down.

"The manager, Bruce Vine – who seemed disarmingly young to be in charge of 270 staff – talked about the factory, my project and the biscuit business. From his briefing I concluded that the

Featured project:
BISCUITS
By Alan Knowles
Theme: Celebrating a locally-created cultural icon. Online at alanknowles.com/exhi_biscuits.htm.
Exhibition: Dowse Art Museum, Lower Hutt, NZ, 48 images exhibited.
Costs: NZ$1260 (£515) on film, processing and work prints, covered by clients; NZ$550 (£225) exhibition prints.
Book: Self-published (Mediawork Communications) at NZ$15 (£6).
Format: 140x140mm, 24 pages self-cover, saddle-stitched firmback (250gsm throughout), printed duotone.
Designed by Dave Kent Design; introduction by Dr Sydney Shep, Lecturer and Printer, Wai-te-ata Press, Victoria University of Wellington.
ISBN: 0-473-08800-2.
Print run: 500, printed by Valley Printers, Petone, Hutt Valley, NZ.
Production costs: NZ$3800 (£1210) for design, scans, pre-press and print.
Funding support and sponsorship: NZ$800 (£325) Creative Communities grant from the Hutt City Council; NZ$1500 (£610) exhibiting fee from the gallery.

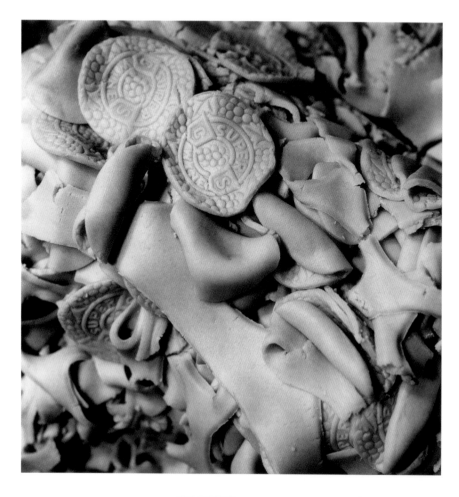

Above: *Scrap (Super Wine)*.

Right: *Dump Hopper (Meal Mates mix)*.

Facing, top left clockwise: *Sesameal packing table; Alan Harris; Christopher Schuster (steam cleaning the jam kettle room); Colin Leitch (dough room)*.

All © *Alan Knowles*, from *Biscuits*.

religion preached at this shrine to the sweet tooth was commerce of the old-fashioned kind – much like the biscuits being produced. Loyalty and long service were still rewarded here with a gold watch, and staff valued the family atmosphere.

"After fitting me out with white coat, steel-capped shoes and hair net, Vine took me on a tour of the sprawling plant, introduced me to the shift managers and left me to photograph what I liked. [The photographs were taken over two years, with a further year in planning the exhibition and catalogue.] Upstairs I introduced myself to Rosalie Paewai, whose job was to assemble the 'small' quantities of ingredients required for each batch of biscuit mix – though there was nothing very small about any of the quantities here. These quantities of ingredients such as salt and baking powder filled brown paper bags, and were added to the bulk ingredients by the bakers whose task was to feed the hungry maws of the giant batch mixers. Once the heavy soft mass reached the correct consistency and temperature it was dumped into hoppers that disgorged directly onto conveyors and rollers on the floor below, and thence to the cutters, stampers and rotary moulds that formed the biscuit shapes. A continuous metre-wide sheet of dough, rolled to the requisite thickness, was fed into a cutter or mould, depending on the biscuit to be formed.

"Fancy biscuits such as Hundreds & Thousands had icing applied by an ancient enrober which had been in service since the factory's inception. Also dating from that time were three of the five ovens – massive cast-iron affairs made by Baker Perkins or Vickers, of England. At the end of each 30m oven a team of packers places the biscuits on to plastic trays and sends them off on conveyors to be machine wrapped, boxed and dispatched.

"In its heyday in the 1970s, the factory employed up to 600 staff, but increasing mechanisation and the rationalisation of production – including shifting the manufacture of chocolate biscuits to Auckland – have halved the payroll. Even so, the Waiwhetu plant is the biggest biscuit factory in New Zealand, and the largest employer in the Hutt Valley.

"While printing an exhibition of these photographs for The Dowse art gallery, I had ample time to mull over why the factory had survived when most of its ilk had closed or moved off-shore. Anyone watching as faces from the Pacific Islands, Vietnam, Cambodia and the Philippines emerged

Featured project:
21ST CENTURY
PLATINUM
By Peter Dazeley
Theme: *A book of Peter Dazeley's platinum prints, doubling as an exhibition catalogue. Online at* **dazeleyfineart.com.**
Exhibition: *Coningsby Gallery, London, which also hosted the book launch.*
Book: *Self-published (Rawkus) at £15.*
Format: *225x225mm, 32 pages plus cover, softback, printed four-colour monochrome.*
Designed by *David Clare, Senior Partner, Exposed Design Consultancy; foreword by Kay Saatchi.*
ISBN: *0-9545138-0-0.*
Print run: *10,000, printed by Lynhurst Press, Romford, Essex.*

from the developer could be excused for thinking the company had already gone. Instead, as HR advisor and former nightshift supervisor, Barry Hewer, observed, the opposite had happened – of the ninety staff on nightshift, only eight were of European descent. It appeared that instead of moving overseas Griffins had simply imported its workforce.

"For whatever reasons, the factory has survived and for me it is proof that old-fashioned business practices do work. What impressed was the atmosphere of permanence that pointed to a refreshing absence of restructuring. By promoting from the shop floor they had avoided that facile practice of modern administrators who hide their ineptitude by fiddling with the business structure. Salaries and wages were modest, but in return for long-term job security staff responded with fierce loyalty. And by dodging the corporate raider Griffins seems to have escaped the accountants' habit of evaluating a business on the worth of its real estate and the scrap value of its plant, rather than the human capital and the wider economic benefits from being part of a community.

"I approached the local Dowse Art Museum with a suite of photographs, and following prolonged discussions arranged for the director and curator to meet with the factory manager, who had never been in an art gallery. Broadly, the exhibition was agreed to at the meeting, and what followed had elements of a comic opera. The director flirted with the factory manager as a possible commercial sponsor; the manager remained bewildered by the role of the art gallery, but saw a marketing opportunity for his firm. The curator took off on flights of fancy about installing half the factory in the gallery. And the poor photographer, fearing his show would be subsumed by a circus, fought the lot of them for wall space, with only partial success. And they gave me $1500 towards my costs, a figure agreed verbally which seemed to be the standard exhibiting fee.

"Initially I was going to concentrate solely on photographing product to contain my costs and time, but the company was keen for me to photograph staff, which I secretly had wanted to do. And so they paid for the film, processing and proofs to get me to agree 'reluctantly' to shoot staff.

"Mine was an entertaining, frustrating, exhausting and eventually rewarding (not fiscally) experience. There was the hooking in of a sceptical management that had never been inside an art gallery, the convoluted process of pitching for a measly grant, and then pushing the printers, who had little experience in art photography printing, working their two-unit press to its limit, and winning them a Gold Medal in the printing industry *Pride In Print Awards*, to their absolute glee.

"The catalogue was sold through the gallery and directly to staff at the factory. A direct approach by me to art-oriented bookshops nearly always succeeded with sales of two or three books. Having it registered on bibliographic databases meant libraries and bookshops ordered it direct. It is now available through dealer galleries representing me.

"It's hard to say how many hours I spent over three years on this project, but it took a large hunk out of the time available for me to earn a living. It was effectively a labour of love. A satisfying aspect of the exhibition was to see the awed and proud faces of the factory workers when they saw themselves on the gallery wall. I would venture that none of them had ever been in an art gallery, and this aspect was gratifying for the gallery in bringing a new audience.

"As a result of this project and approaches to other industries, I now understand that managers, preoccupied with production quotas, staff rosters, price rises, plant maintenance, accident prevention, consumer complaints, R&D and grasping shareholders, don't give a toss about art!"

Peter Dazeley is a fine art and advertising photographer. *21st Century Platinum* was an exhibition of his personal work and represented the result of an "eight-year journey of discovery", experimenting with different processes, lenses and techniques, looking for and photographing people and things that he found visually stimulating. The work was produced over such a long period that he can't begin to estimate how much he spent along the way. Coinciding with the completion of the project he was approached by Andrew Coningsby to show the work in his gallery, an exhibition which doubled as a book launch. Dazeley set up his own publishing company, Rawkus, to produce the book which features reproductions in four-colour monochrome of the 34 platinum prints in the show. Printing 10,000 copies, Dazeley created for himself a publication that serves as a monograph of his personal fine art photography, a promotional tool

X-ray of Nautilus shell, by Peter Dazeley from 21st Century Platinum.

*Above: **Chit Ying and Shin-Yee.***

*Facing, from top left clockwise: **Allium**; **Amanda in shadow**;*
***Solarized Aladdin tulip**; **Alyssa blur**. All © **Peter Dazeley**. www.dazeleyfineart.com.*

for his commercial work, and a classy exhibition catalogue. He handled distribution of the book himself and additional copies went out through the bookshop at The Photographers' Gallery in London. Here he summarises the experience.

"The overall success and experience of the project made it really worthwhile. It subsequently led to work being exhibited at the Stephanie Hoppen Gallery in Chelsea. To coincide with the exhibition, 6000 30x20in posters were designed by Exposed, produced by Maritime Printers and flyposted around London for the duration of the exhibition by poster company Diabolical Liberties, which made a real impact on London's West End. Further awareness-raising activity was provided by Praxis PR consultancy.

"I held two private views of the exhibition on consecutive evenings, where signed copies of the book and posters were given away. The turnout was fantastic and it proved a great way to introduce my work to new potential buyers.

"This monochrome work was produced as platinum prints in limited editions of 25. I work in close collaboration with a father-and-son team of specialist printers, Paul and Max Caffell of 31 Studio, Gloucester, England. The exhibition was about taking photography back to its origins: hand-coated papers produced to the original platino method devised by William Willis in the 1870s. The starting point is a precious metal, the noble metal platinum, which is used in this art of chemical alchemy. Platinum prints have a far wider tonal range than can be achieved with conventional modern black and white print processes, and give a distinctively rich, luminous quality with great shadow detail and warmth. They are archival, lasting many lifetimes, which makes them a worthwhile investment.

"The photographic press were really fantastic, with coverage of the project both in this country and abroad. Here's just one example from *Image* magazine: 'Many of the images have a grotesque beauty which is strangely compelling. In his anamorphic work, the lens stretches and morphs the human form creating an effect similar to Giacommetti's famous elongated sculptures. The detail and tonal range achieved in the images is quite remarkable and also telegraphs their fine art credentials. For this exhibition is very much about Peter Dazeley the fine artist.'"

*Rock in water, from **Frank Watson's Haydn** project.*

Short run strategies

The hand-made artist's book – a long-time favourite for very short print runs – is now joined by digital "on-demand" print services

SOME OF THE EARLY PHOTOBOOKS contained images actually glued in by hand; this makes them very collectable today, but expensive to produce at the time – and now. Today this form of production is still used in limited edition art books and the prices can be astronomical; but now, with desktop computer technology, the high quality hand-made printed book is within reach of anyone with the time and inclination to create one. And there is nothing stopping you including a hand-crafted print as a frontispiece, for example. An advantage of the do-it-yourself approach is you retain full control over the process and can indulge your creativity with a wide choice of paper media and binding styles that are not available with commercial short-run printing. The images are all your own work, so why not the whole book? Frank Watson talks about his *Haydn* project and hand-made books in the pages that follow: the processes involved in design and printing are similar, but it is in the binding into book form that the individuality of each project emerges. You can use a simple ready-made folder of transparent leaves designed for a small portfolio, or the more adventurous might tackle hand-sewing and casebinding to create an object of great aesthetic value in its own right. In between there are several inexpensive binding systems available from stationery suppliers – hot glue systems or a wide variety of spiral and comb bindings – or you could splash out and take the sheets of your finished book to a commercial bookbinder for a truly professional job – at a price. But you're worth it.

Frank Watson's ongoing project has an unusual genesis, as he explains. From the resulting images he creates hand-made books, some of which combine the images with his poetry. Then, in the true spirit of the artist, he gives them away! "My relationship to photography – always black and white – has been similar to that of exploring an old house. Entering a room, you look around and

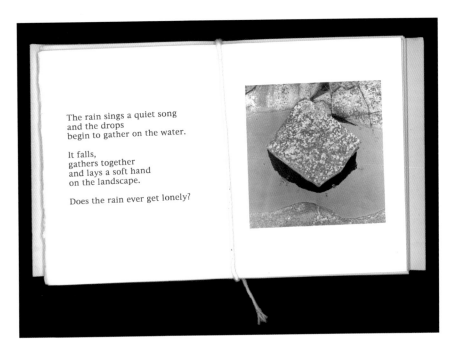

The rain sings a quiet song
and the drops
begin to gather on the water.

It falls,
gathers together
and lays a soft hand
on the landscape.

Does the rain ever get lonely?

*The centre spread of a hand-made **Rain/Haydn** book by **Frank Watson**. It is printed on watercolour paper and bound with simple cotton string. Text and image © **Frank Watson**.*

discover a door leading to another room. On exploring that room, you discover even more doors that lead on to more rooms and so on. The rooms in my photographic house were my projects that led me from one thing to another, a voyage not always planned or controlled, with many dead-ends and rooms just looked into and acknowledged as being there. They have all had two things in common: my love for photography and my curiosity. Curiosity about what I am photographing – what does it look like from behind, around the corner, why are these people the way they are? – and for the photographic process – how can I make it do what I want it to do, what happens if I do the opposite of what the book says? Almost all of these aspects are present in my project *Haydn*.

"I am an American, raised in Miami, Florida and I moved to Sweden in 1969 at the age of 26. The Swedish climate and landscape are entirely different

The first book **Frank Watson** made was **The Sad Landscape**. "I bound it by punching holes in the paper and screwing them together with small bolts." © **Frank Watson**.

Facing: All images from **Frank Watson's Haydn** project.

from that which I grew up in. My family has a cabin in northern Sweden, on the coast outside of the town of Örnsköldsvik. There is, for me, something of Haydn's music in this landscape. I have for many years, every time the Swedish classical radio station plays Haydn, gone into in this landscape with my Walkman and my camera and tried to photograph the feelings that the music creates in me.

"There are many reasons behind my working this way. One of them is that I have noticed that I am more attentive to and appreciative of a live performance of music than I am of a CD which easily becomes background music. The vitality of the broadcast and the fact that I am out of the house and free from practical distractions emulates this live performance characteristic. I am also out in nature and fall easily into a sort of stream of consciousness manner of working. A sort of symbiotic flow starts – me, the music, my surroundings – and causes me to notice and photograph things in a special way.

"Another aspect of working this way is that I don't choose when to photograph. Thus I get away from the sequence of 'Oh what beautiful light' and then 'I must go out and take a picture'. It amuses me to think that there is someone, somewhere, in the corridors of the Swedish Radio system who sits at a desk and decides when Frank Watson is going to take pictures. And they do pick their times: I have been out photographing in the dark at midnight, and desperately trying to protect my camera in the pouring rain.

"Why Haydn? It all started when we had guests who we were showing around at the same time as the radio was broadcasting a Haydn concert that I didn't want to miss. So while we showed our guests around I listened. I had my camera with me, took some pictures and so it started. Haydn seemed to be the perfect project: clearly defined, cheap and

enjoyable. And since I seldom got to photograph, I never tired of it (they only broadcast Haydn music about four times each summer) and I do like Haydn. It involved no great expense: no travel, no new equipment, and a limited number of rolls of film. Since I mix my own chemicals from bulk, processing was practically free and, with so many of my colleagues switching to digital, I printed on all the leftover paper they gave me. And lastly my exhibitions were successful: people liked the pictures. Small wonder since I was photographing in one of the most beautiful parts of the world, but if they wanted to think it was because I was so artistic and talented, well, who was I to argue?

"Meanwhile, back at the ranch, I was doing other things as well. I have always been a fan of photogravure and started doing a lot of it when polymer gravure came along. Then my friend with the printing press moved and (until the day I find another press) I started digital printing in quadtone. I used pictures from one of my digital projects, gardens, for the covers of birthday cards and the like. The realisation that I could print on double-sided digital art paper and then fold them and create instant 'mini-books' led me almost immediately to yet another project conceived with the idea of these artist's books as the final product. *The Sad Landscape* used my pictures and poems together, something I thought I had finished with 25 years ago. When I started writing a new series of poems, *Rain*, my experiences with *The Sad Landscape* led me around to connecting with my *Haydn* pictures and recycling them in artist's books with the *Rain* poems.

"That is where I am right now. I am going through my 'Haydn' pictures and looking at them in a new light. Previously I would try to print each picture with a paper and developer combination that I thought would match the photograph. I would try to collect these 'matches' into groups of three or more as I thought that the effect would be better in an exhibition. Now I am trying to match the photographs and poems in a manner that will complement and enhance both, finding new photos and streamlining the poems to give about the same reading time as the photographs. I need not tell you that this is very exciting and great fun.

"What do I do with these books? So far I keep them in a box or, if I feel confident enough, give them away to friends."

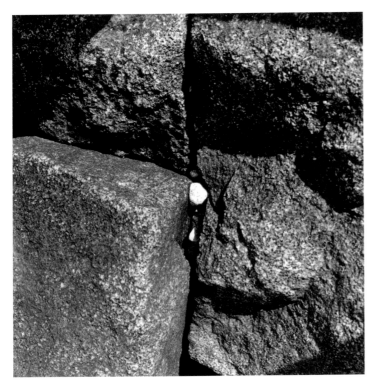

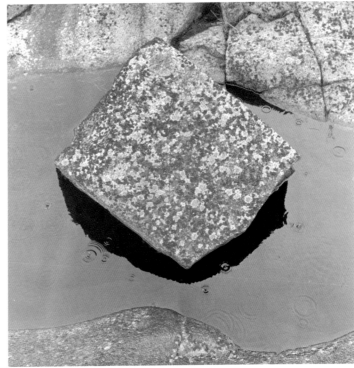

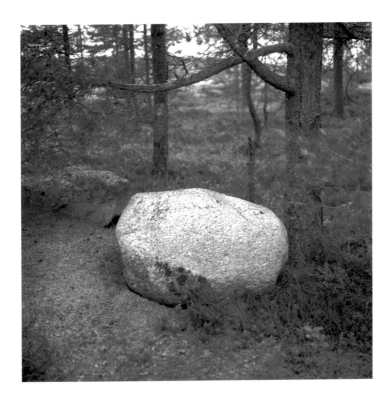

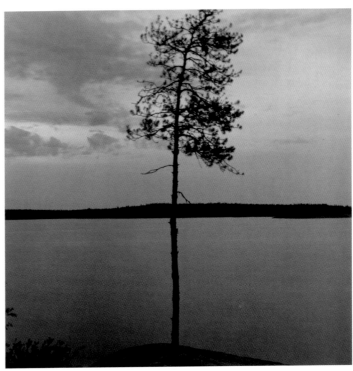

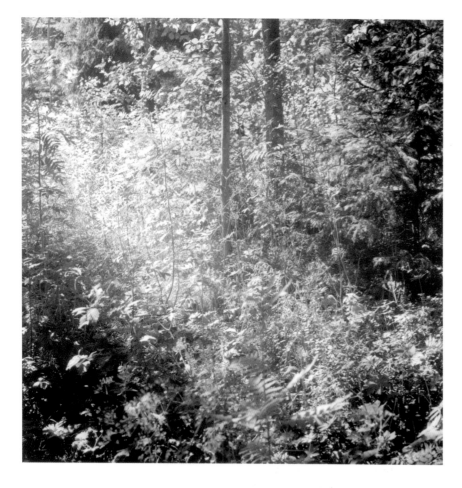

Above: Sunlight in woods.

Right: Camouflaged tree.

Both from the Haydn project. © Frank Watson.

On-demand printing is the commercial equivalent of the hand-made book. It was originally conceived for print runs of high value but low volume, and became possible in the early days of digital print technology. A good example of one of these early on-demand publications would be the technical manual for a jumbo jet: something that it's vital to have (if you are an aeronautical engineer) and with a high ticket attached, but not something the publisher wants to print and warehouse in large quantities. So, the printer would store the book as a digital document and, on receipt of an order – probably for just a single copy – output the pages on a duplex laser printer (one that prints both sides of the sheet) and bind them together into a book, probably using a form of spiral binding. Manuals work best when they lie open flat. Thus you only incur printing costs when you have already sold the item. Since those early days the technology behind on-demand printing has advanced considerably and high quality productions in a variety of sizes, finishes and bindings are now possible, and at remarkably low cost.

So that is how on-demand book production came about; but apart from the convenience, it is also by far the most economical way of printing a small quantity. This is because of the much lower fixed costs involved, compared to conventional offset litho book production. Fixed costs are "fixed" because you incur the same amount whether you are printing one copy or 10,000, and these are the costs incurred before you print a single copy. In the case of offset litho these costs are often referred to as "make-ready" and will include the making of printing plates, cleaning the press ready for action and running up the job to the point that accurate ink weight and colour registration is achieved, which can waste a fair bit of paper. Further time and paper will be lost while the small spots that appear on the plates during their making are removed. Unless you are printing an adequate number of books – this will vary, depending on the printer and the job itself, but let's take 1000 copies (or a little fewer) as a guide minimum figure – the effect of the fixed costs on the unit cost of production will be uneconomical. Which is where on-demand digital printing comes in.

A digital printing press is far too expensive for us all to have one in the studio, but it costs a fraction of the price of a four-colour lithographic press.

In from the sea
– The Isle of Lewis –

CHRIS DICKIE

Left: The cover of *In from the sea*, a book of landscapes exploring the environment of the west coast of the Isle of Lewis, published by the author, using the on-demand digital print service *www.lulu.com*. © *Chris Dickie*.

THE PROS AND CONS OF ON-DEMAND DIGITAL PRINTING

The upside
• It is the only economical commercial option for very short runs.
• Individual copies can be customised by supplying different files for each.
• The number of pages is flexible. Litho paginations are dictated by sheet size.
• It can act as a digital warehouse for your book and a sales ordering point, at no cost to you.

The downside
• The process is highly automated. As you won't have a friendly printer checking your files before committing them to print, great care must be taken in their preparation.
• Limitations on paper types, weights and sizes.
• Reproduction may be good, but not up to the best quality litho.

Straight away the digital printer has much lower costs to pass on, as well as savings in the size of premises and numbers of staff. As a digital press is effectively a glorified colour copier or laser printer there is little make-ready to pay for, just the business of preparing the file for output. Thus, with minimal fixed costs, even printing a single copy becomes viable. However, for the same reason, the unit cost does not reduce significantly, if at all, as you print more copies. And because the consumables – just as with your inkjet printer – are more expensive than in litho printing, if the print run is big enough there comes a point where it is cheaper to take the traditional lithographic route. The actual point at which this crossover occurs will depend very much upon the size and complexity of the print job and whether the litho and digital printers you choose are inherently pricey or cheap; you will just have to do the sums yourself. Suffice it to say, that if you are thinking of a small run in double figures or less, on-demand digital will

definitely be cheaper. Litho becomes more economical once the print run rises to three figures, at some point before you reach 1000 copies.

Ed Swinden has recently self-published a book of his work called *Lost & Stolen* (overleaf) using the on-demand internet print service lulu.com. "It's hard for me to comment about publishing with lulu as I have nothing to compare it with, not having published my work with any other web publisher. But I can say it was a fairly straightforward task and that I was pleased with the results.

"It's great to have almost total control of the process, although it is a double-edged sword. It's easy to be self-indulgent when you don't have an editor telling you that a particular image isn't really necessary or relevant. But, because the longer the book the more it costs to print, you do tend to self-edit quite thoroughly. My book could have ended up at 200 pages, but I trimmed it to half that. You have to be firm about the scope and theme of the

lost
and
stolen

ed swinden

work, otherwise it can become an unruly mess. Although there is guidance on the website on technical matters such as trimming and bleed, it helps to have some skill and knowledge of design yourself if the book is to look professional. And it is important to get someone to check through for spelling mistakes and so forth as no-one will do it at the other end. Initially, I only made the book available to myself, and ordered one copy as a 'proof'; only when I had checked through and was happy with this did I open it up for sale to others.

"It is interesting having to set your own 'royalty' amount [the sum you make from each copy sold at the lulu.com site] – I suppose theoretically I could have set this to a million dollars and hoped to sell just one copy! But I set my royalty very low to keep the price down, reasoning it was better to sell many copies and make a little on each because the reason I published was to get exposure for my work rather than to make money. After all, I could have earned much more from shooting a day's PR work than spending a week putting the book together.

"As for the quality of service from lulu, the front cover photograph didn't print in quite the shade of yellow I expected, but this was probably a colour-calibration error on my part. The internal images all printed as I had hoped – I had worried they would be too dark and not of the correct saturation, but they were fine.

"The only slight irritation is the purchasing side... as I have had friends who wanted to purchase copies and became frustrated with the online ordering process and who have asked if they can buy from me direct instead. But this may simply be my friends' lack of computer skills.

"I was featured in my local newspaper as a result of publishing the book – it gave me a hook, otherwise I doubt I would have been 'newsworthy'. Having sold a few copies it seems to have lent me kudos with both clients and galleries, and so I think it has been worth the effort. And above all I have a lasting record of a period of my artistic life, which would otherwise exist only on a hard disk somewhere and in a few tattered photos taken on the opening nights of my exhibitions.

"So I'm happy. But next time I hope to be published by one of the big commercial publishers as they could help with the marketing and so forth which is so important... and give me a multi-million pound advance."

Sample spreads from **Lost and Stolen,** an on-demand digital book, printed at **lulu.com.** Facing: the cover of **Lost and Stolen** © **Ed Swinden**

The world is your oyster

With a global marketplace and distribution costs of next to nothing, the internet offers photographers many attractive publishing options

George Kavanagh

Locations
Commissions
Automotive
People
Black and White
Awards
Contact

gallery 01
gallery 02
gallery 03
gallery 04

George Kavanagh's site – georgekavanagh.com – was created in Flash by Bite Digital (see overleaf). Owning your own domain inevitably looks more professional than joining a gallery site where your work will be buried among that of hundreds of photographers of mixed ability – although the latter is much cheaper. In a recent survey, a remarkable 85% of Ag readers with websites designed and built them themselves.

THIS SECTION discusses using the internet as a publishing medium; by the time you read it things will have changed. The internet is a highly dynamic medium with possibilities limited only by the imagination of those publishing on it; it costs practically nothing to reach a global audience, which has obvious appeal, and this is why internet publishers can be counted in their millions. At the time of writing the popular search engine Google has notched up an index of 8,058,044,651 pages and counting. The flexibility of the medium means you can exploit it in many different ways, or a combination thereof: as a gallery; as a library; as a diary; as a delivery medium for a book in electronic format, an e-book… .

Treating the internet as an online gallery to exhibit your work, you can opt for your own standalone website – a solo show, as it were – or you might join in one of the thousands of gallery sites which house work from a whole range of photographers – a group show. Having your own site will project a more professional impression, although there will be less time and effort involved in uploading images to a group site which already has its infrastructure set up and a stream of visitors in place. These group galleries may represent special interests such as a particular process or subject matter, and there are commercial sites where the emphasis is on print sales, such as peeledeyeprintshop.com.

A variation on the static website gallery is the weblog, or blog. This is in essence an internet diary where you upload text and images whenever the fancy takes you and in doing so can keep the rest of the world appraised of the progress of your project. Because, by their nature, weblogs are constantly being updated they attract a higher proportion of return visitors than, say, a gallery site which is updated infrequently. They do, however, require the commitment to keep adding fresh material.

A rather different way of exploiting the internet is not to use it to display your work, but as a way of distributing it. Less of a gallery and more of a bookshop. And this is where the concept of the e-book comes in, made all the easier by Adobe's invention of the portable document format (pdf). Adobe is the company that developed the Postscript page description language that has been the universal platform for electronic page make-up and desktop publishing and printing for many years now. The pdf format was developed to facilitate the distribution of documents between computer platforms with the accurate rendering of images and typefaces, both on-screen and in print-out. Documents are read using the freely-distributed software Acrobat Reader, available at Adobe's website for most types of computer operating system, and the company makes its money from sales of the full Acrobat program which is needed to

*Above: **Foto Post Toronto** is a web-based magazine available as a free **pdf download** (see pages 124-125). Top right: **Peeledeyeshop** is a commercial community gallery of photographers selling art prints. Right: The **weblog** "diary" style of site allows for easy, regular updates, but does require serious commitment.*

create the pdf files in the first place. And now that pdfs have become such a popular way of distributing documents, it is increasingly common for the software used in their creation to incorporate the facility to export the file in pdf format; the most recent version of Quark XPress is an example, as is Adobe's own InDesign which is rapidly gaining popularity, so you don't necessarily need the Acrobat software as well.

So, by turning your book into pdf format, you create a file which can be distributed electronically – by download from a web page, or via email – and will render faithfully on whatever computer your reader happens to own, so long as the free Acrobat Reader software is installed. These e-books are sometimes offered for free download, sometimes they cost just a few dollars. Because you don't have the significant cost of printing the book, you don't need to charge a fortune for its download to show a profit. The less you charge the more copies you'll sell. As a form of self-promotion, charging nothing at all will always pay off.

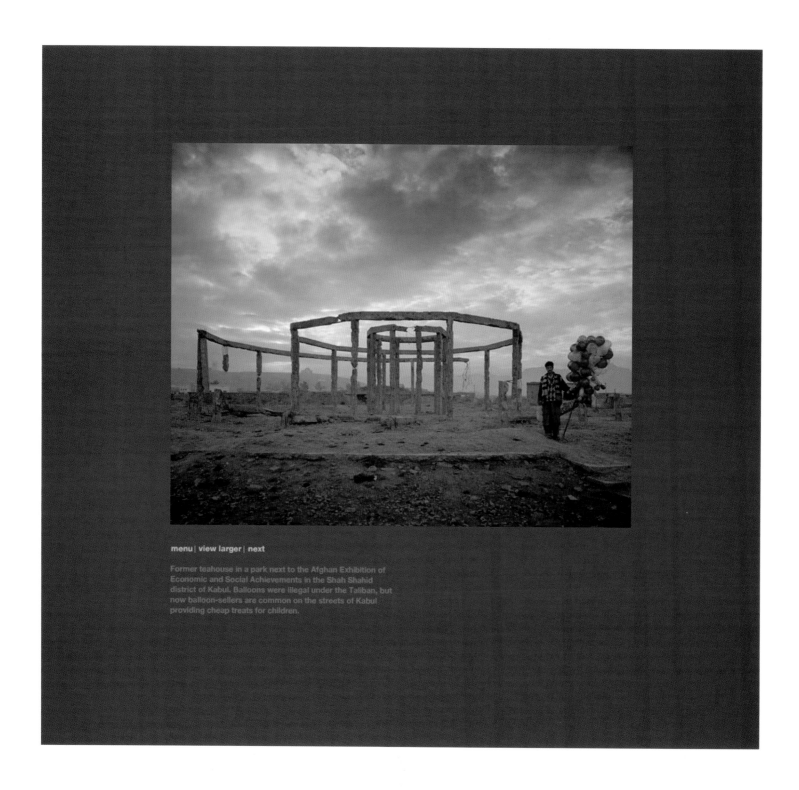

menu | view larger | next

Former teahouse in a park next to the Afghan Exhibition of Economic and Social Achievements in the Shah Shahid district of Kabul. Balloons were illegal under the Taliban, but now balloon-sellers are common on the streets of Kabul providing cheap treats for children.

Simon Norfolk's website **www.simonnorfolk.com** was designed by *Bite Digital* (www.bitedigital.com).

Simple site solutions

Web publishing is versatile yet relatively straightforward – which is why it is easy to get carried away with the design of your website

SO, LOOKED AT SIMPLY, publishing your work to be viewed on the internet can be done in two ways – by taking your place in a group gallery site, or by opting for a personal presence. Many gallery sites operate as online communities where photographers show work to each other for peer review. This can be fun and beneficial for enthusiasts, but it has limited appeal to professionals and is not really effective in promoting your work. It is the equivalent of participating in an enormous group show in preference to a one-man exhibition. As the point of the exercise is to blow your own trumpet, having your own site is the way to go. There is, however, something to be said for ganging together with a *small* number of individuals to present a united front, sharing costs and technology, and benefiting from each other's traffic without getting lost in the crowd. The peeledeyeshop.com site is an example of this, with just over 20 photographers offering prints for sale.

The starting point is to register a domain name, or internet address. Unless you trade under a business name, ideally this should be your own name. Many internet companies offer registration services, so shop around to check out prices and the cost of ancillary services such as website hosting. Take advice from friends on which companies seem reliable. (I use www.uk2.net, and so far so good.) As domain names are handed out on a first come first served basis, *yourname.com* might have been registered already, in which case you may have to opt for something like *yournamephotos.com*. The registration sites have search facilities to allow you to find out what is still available to register. Having got your domain name, next comes creating the website itself. What, then, are the basics for an effective photographer's website?

Bite Digital is a design company set up by Deighton Lowe and Jerry Young in 2000. It

Home Artist Galleries Contact Commercial Publications Order Prints

Portraits Landscape Night Food-Kitchen

Still Life Toys Botanical

Paper Negatives Observation Figure/Body

Galleries: Here you will find thumbnail links to the ten galleries of my work.

These thumbnails represent a range of the styles and techniques that have interested me for many years.

There are also techniques which are not yet represented here, such as pinhole, gum printing, cyanotype and hand colouring amongst others. These may be added at a later date.

Clicking on a thumbnail image here will take you to the individual gallery page.

andrew sanderson

specialises in photographers' portfolio websites and numbers several high-profile names among its clients including Simon Norfolk (see left), Nick Georghiou, Niall McDiarmid, George Kavanagh and Betsie van der Meer. As Deighton Lowe explains below they favour the software Flash for creating these sites, and here Lowe offers some pointers to what makes for a successful website – whether you design it yourself or seek professional help.

"The web has opened up fantastic opportunities for photographers to publish their own work. It enables them to reach a wider audience: it makes it easy for people to find out contact information or agent's details; it enables art directors or commissioning editors to view work instantly without the photographer having to mail out his book straight away; it can be updated instantly and can even be used to sell prints. So what makes a successful website and why do so many photographers manage to get it wrong?

andrewsanderson.com.
Andrew is a photographer
and the author of several
books on photography.
As you can see, he
photographs a wide range
of subjects, but he has
kept his website easy to
navigate by organising
the work into clear and
recognizable categories.
© Andrew Sanderson.

Peter Cook is another client of Bite Digital. His website follows the philosophy of a dark grey background to display the images, simple navigation and galleries presented in thumbnail form to let visitors quickly access the online imagery. Images © Peter Cook.

www.bitedigital.com

"A successful website should be quick to load and straightforward to navigate. The images should be of optimum size and quality. The structure should be clear and the content should be accessible.

"This sounds so simple to achieve but there are plenty of things that can go wrong. The number of bad photography websites out there is testament to how many pitfalls there are to be avoided. For instance, there are sites which start with excruciatingly long download times; there are sites with completely pointless animation zapping around the screen; there are sites with overly contrived and impossible to use navigation systems… . These sites seem designed specifically to annoy, frustrate and infuriate the user. All too often the designers have been overly ambitious and have lost sight of the prime purpose of the site. The golden rule when it comes to creating a successful website is to keep it simple.

"We advise using Flash rather than HTML when it comes to constructing a website. The main advantage of using this software is that you have much more control over the look of the site. Flash enables the designer to use more sophisticated typography and makes it possible to fade images in and out more smoothly. No matter what method is used to construct the website though, the design principles remain the same. A minimalist approach

will help to create clarity. Less is more. An individual photographer really doesn't need an elaborate logo or brand identity. Simple legible type will suffice. When it comes to background colours for image pages, dark greys tend to work best. Black can be a bit too harsh and oppressive, while white can be overpowering and bleach out the image.

"A structure that works well is to split the portfolio into galleries of thumbnail images; this helps the user to scan through many images in a short time. You can divide your work naturally into galleries by having each represent a specific genre such as portraiture or reportage. Around 12-15 thumbnail images per gallery page is a good number, as it enables you to keep the image size and quality reasonably high. Clicking on to a thumbnail brings up a full-size version of the image. Left and right arrows can be used to spool through all the photos in the gallery, while a back button returns you to the thumbnail page. Ideally the website should be structured so that the user can get to anywhere in the site in within two clicks maximum.

"It is tricky to decide at what size to show images on the web. Too big, and the images take too long to load and may not fit on everyone's screen size. Too small, and the quality will be so bad it becomes a waste of time – worse, counter-productive. When deciding the size of image, consider your target audience and the type of photography you are showing. If your main objective is to create a folio to show to large advertising agencies then you can assume they will have speedy broadband connections and a big monitor, in which case you can get away with using large images. On the other hand, your audience may be more likely to have slow computers and a small screen size – so you may need to take this into consideration. Photography that is quite graphic and simple can be shown at a fairly small size without loosing quality, while landscape photography may completely loose impact if you try to shrink it down too much. Although there are no hard and fast rules when it comes to image size, a good average would be around 540x430 pixels for a 5x4 format image, or approximately 600x400 pixels for a 35mm format frame, 490x490 for 6x6cm and so on.

"No matter who is constructing the website, it should be the photographer who prepares the final images. This is because when you save images for

www.peeledeyeshop.com represents a small community selling fine art prints.

www.guyjbrown.com is a 'home-made' site which follows the basic rule of simplicity.

web in Photoshop you need to strike a compromise between image quality and a file size small enough for quick downloading. Only the photographer can judge whether the jpg created is a fair representation of the original photograph. Although, again, there are no fixed rules, a typical quality setting using the 'Save For Web' option in Photoshop (which provides automatic conversion to an optimised jpg file) would be 55-65%. Prior to saving the image, you may wish to compensate for the slight softening that occurs when you reduce the image size. Use the Unsharp Mask filter in Photoshop to sharpen the image. Also be aware that there will be a colour balance shift if you try to save your images for web while in a customized colour space such as Abode RGB. Make sure you are happy with the colour balance with the image in standard RGB setting.

"Finally, when designing a successful photography website, you will need to consider how the site is to be kept updated. One way is to ask your web design company to add or replace images for you. Alternatively, you could have the site designed so that you can update it yourself at any time. There are two methods for doing this: either you edit the site from within the website creation software itself, or you can update images using an 'FTP' application. FTP (file transfer protocol) software allows the uploading and downloading of files to and from the fileserver on which your website is hosted. Using an FTP application to update the site is less complex and thus less expensive when it comes to constructing the site, however it does require you to learn a certain amount of web language in order to operate it successfully. Updating using a password-protected web page designed for the purpose within the site is certainly the simplest method to operate, however it does require more complex programming when the site is being constructed.

"Of course, you can build the whole website yourself. This can make publishing on the web very cost-effective. Learning how to construct a professional-looking site does take time, so it is worth weighing this up against how much a web design company will charge."

Ed Swinden (whose e-book features on pages 114–115) is a photographer, who has constructed his own website, and here are his views on the pros and cons of publishing photography on the internet. "Briefly, the pros are that it's quick, cheap (if not free), international, and fun. Also it can be very interactive. It is easy for people to get in touch and this open feedback is often helpful. I get emails from all over the world asking how I did such-and-such, and I am usually happy to explain.

"Web publishing is great for avoiding the politics that sometimes exist in the gallery and art school worlds. It isn't necessary to do what is fashionable at the time, or to know how to go about hiring an exhibition space, and so on. When I had an exhibition in a physical gallery last year probably only around a thousand people visited as against the tens of thousands of people who have gone to look at my images online. But the flipside is that there is a lot of rubbish on the web, and what you do yourself is diluted by this. It also can feel ephemeral and disposable, so a web exhibition can feel as if it lacks the gravitas of a physical one.

"Another downside is that you can never be sure whether viewers see exactly what you intended: their monitors may be set too dark, too bright, or to a different colour balance. Also, I believe that web publishing only works for certain kinds of photos. They have to be bold. Anything that relies on a single detail or on its large scale just won't work. I do a lot of landscapes – but not the sort of lovely sunset vistas that work so well in the luminous colours of a PC monitor. They are bare deserts or empty streets with a few tiny figures in them – so in a gallery at 16x20in or larger they look great, but on a computer screen they can look pathetic.

"Another problem is that people can copy and use or even alter your images very easily. You can lose control of them. I know technology is marching ahead to combat this, but at present…

"The self-censorship point I made regarding lulu.com *[see on-demand printing, pages 108–115]* is important as well. Because there is no additional cost it is all too easy to put up loads of either unfinished or second-rate images on the web, thinking: 'I can always take them down later'; but people will see them and judge you on them in the meantime – and I would be worried that it can damage your reputation quickly. It is therefore important to edit your work carefully before committing it to your online gallery, just as you would for a book or for an exhibition in a physical gallery."

Ag: the finest in photography - four times a year

the international
quarterly journal of
photographic art
& practice

- new Ag weblog
- about Ag
- current issue
- back numbers
- **portfolios**
- features
- book reviews
- how to order
- subscribe
- contact

This site is
© Picture-Box Media.
All photographs are
© the photographer.

published by

picture-box media

Every issue of Ag magazine features portfolios of work from at least three photographers. Each is beautifully reproduced and comprises between 10 and 16 images, often accompanied by a critical appraisal by a well-known author. The images here are all copyright © the photographer and represent just a small selection of the outstanding imagery published. Click on the detail images to view some of the photographer's work as featured in Ag.

Click here for a further selection of portfolios.

Simon Johan · John Ganis · Andrew Nadolski · Tina Ruisinger

Laurence Demaison · Keith Carter · Branka Jukic · Sebastião Salgado

Hans Neleman · Simon Norfolk · Michael Kenna · Robert Stivers

SOFTWARE If you have the time and inclination to create your own website then give it a go. It is increasingly common for word processing or page make-up software to have the facility to export files in web-ready format. There are also software tools designed specifically for website construction. Macromedia's **Dreamweaver** is an industry standard, and anyone familiar with using desktop publishing software should find it easy to learn (www.macromedia.com).

User's of Quark XPress (and Macintosh owners) will find **Freeway** by Softpress even easier to work with – you can get a trial download at www.softpress.com. It's only available in Mac format unfortunately, but it is extremely intuitive and practically all the keyboard shortcuts and functions are the same as XPress. A particularly useful and time-saving feature for photographers is that it converts and optimises images on the fly, irrespective of the format or resolution that is imported to the page. You can place a cmyk native Photoshop file at 300dpi on the page and the software will automatically export it as an optimised rgb jpeg, with a resolution of 72dpi and cropped and sized as you specified.

Ag magazine's own website **ag-photo.co.uk** is principally a marketing tool and was constructed by the author using Freeway. It is updated at least each quarter to coincide with publication of a new issue. As well as information and images from the latest issue, all available back numbers are catalogued and there are sample portfolios from earlier editions to give visitors a taste of what the journal is about. Similarly there are sample features and technical articles to illustrate the range of material covered by the journal. To complete the marketing function visitors are able to purchase subscriptions and back numbers from the site using a secure server to collect credit card payments.

As a quarterly, **Ag** does not attempt to be strong on news. However, a while ago I set up a complementary weblog for the main website – **www.agenda.typepad.com** – as a way of allowing the journal to provide a news function and to drive traffic back to the main site. Now, I have to be the first to admit that as a one-man business I have found it difficult – at some times impossible – to keep the weblog updated as regularly as it should be. As postings appear with their date beside them it's obvious when you fall behind. So would-be bloggers beware!

HUGH SYMONDS' DIY INTERNET EXPERIENCE

"Website **registration of a domain name** is currently available for as little as £5.00, but typically ISPs (Internet Service Providers) like to charge more, even up to £50.00 for, say, two years. This is a renewable cost – you don't own this name for life – yet! **Website hosting** (locating your website on the internet for all to access) is also a rapidly changing cost and difficult to quantify. It is related to the size of your website and bandwidth used (the total size of files uploaded and downloaded at the site over a fixed period, usually a month), so if you spend a fortune on an animated style of presentation, you can pick up above average costs for launching it into space. However, it is true to say that server space has become much cheaper.

"I looked at a great many photo websites **before designing my own**, to see what was out there. While I enjoyed many and various styles of presentation I often found that once the site mechanism – animated graphics – were discounted, the quality of the photography was very poor; it had been **dressed up**. Some photography is well suited to clever presentation, probably that designed to promote commercial product: here the pictures and form merge into a shared experience.

"Website design is a massive topic. Costs here are, like any other profession, very varied. I can only say that **I chose to design my own** site, it is a very simple presentation, and it is only the experience of seeing photographs which concerned me. I have included some additional personal information and a page of links to other sites. Some links are by way of reciprocation, and this is internet protocol.

"Preparing your website for **uploading to the internet** is another massive topic. There are many computer programs for this operation, some suit simple sites like mine, but others are necessary for more complex visuals. If you are happy to put your pictures on a **shared site** – with a template format – there are host sites aplenty on the net. Apple currently offers an option as part of its iLife approach to, well, life. Costs for this aspect involve software, time and know-how.

"I was lucky to have an **enthusiastic teenage neighbour** keen to develop his web design skills and so he was happy to produce the site for me. I used a basic text editing program on my Macintosh to design the layout of the pages with the chosen images. This was then emailed to the producer together with the picture files. These are easily learned skills for a simple site like mine and I believe it will become ever easier as the internet develops.

"An **internet connection**: a simple search will reveal just what this costs, it's another very rapidly changing area of technology. It is essential to secure a **broadband** connection for picture viewing and transmission because image files are much larger than text files and therefore take much longer to upload and download to and from a website. As the internet develops and connection speeds increase to allow true streaming video, who knows what kind of cameras will be popular then? But it will still be the **picture content**, for me, that counts."

You can see a selection of images from **Hugh Symonds' Fonephoto** website **www.hupix.net** on pages 48 & 49.

Democracy at work

Like the idea of publishing a book without an invoice from the printers or any distribution costs? You could almost afford to give it away...

Featured project:
(H)ARRIS
By John Darwell
Theme: *An exploration of the coastline of the Isle of Harris in the Western Isles of Scotland. Online at* **www.johndarwell.com.**
Exhibition: *36 images exhibited on railway station platforms along the Cumbria Coastal Line, in collaboration with Fold Gallery, Cumbria.*
Book: *Published by DesignWorks as a free pdf download from Democratic Books (weblink on facing page).*
Format: *Two pages to view (approximately 8.25x4in nominal size) in a web browser. Designed for printing out and binding as a book. 26 pages including cover.*
Designed by *DesignWorks.*
Project cost: *Around £1400 on materials, not including the exhibition.*
Exhibition funding: *Fold Gallery, via Arts Council England North West (ACENW), and from Cumbria Institute of the Arts.*

IT DOESN'T REQUIRE A GREAT LEAP of the imagination to visualise the internet as offering a vast virtual gallery space and a global audience. What some photographers and other artists – and publishers – are now coming to realise is that it also presents a very versatile and effective distribution medium: we now live in the age of the electronic book, or e-book. These books are produced in a more-or-less conventional manner, but instead of then going off to be printed and becoming a physical object, they are converted into portable document format (pdf) electronic files. No forests cut down and no print bills. These files can be 'read' by any computer that has Adobe's Acrobat Reader software (freely available from adobe.com) installed, and can also be printed out to convert the virtual book into something you can hold. The files are placed on a website from which they can be downloaded to the reader's computer. Two business models are currently practised: the e-book may be available as a free download, or there may be a small single-figure price to pay. Even a very small charge can represent a lot of profit as costs are minimal, and the internet represents a huge potential readership. If the object is maximum self-promotion, free works best.

John Darwell's project is unusual in that he has published it in book form, yet will never receive a bill from the printer. And while thousands may end up owning a copy, he will never receive anything from the cover price – because there isn't one. Now most projects involve planning and groundwork, but others just appear "out of the blue". This is especially true if you are used to thinking and working in a project-based manner. John Darwell is such a photographer, and here he describes how his work *(h)arris* came about and its metamorphosis into a book distributed via the internet.

"This particular project came about almost spontaneously. I had planned to spend some time

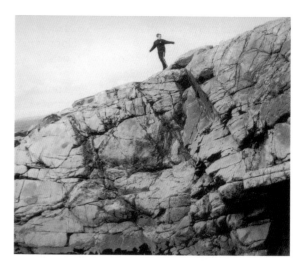

in the Western Isles of Scotland where my wife was working on an aquatic plant survey for the EU. In many ways I was looking for a break from projects, having worked non-stop for a number of years. The new environment instantly spurred me to look at the topography, this could have been as a result of no forward planning, no grant applications, or gallery meetings and so on. In effect, I just started to take photos just for the sheer fun of taking pictures. Sometimes all the other stuff can get in the way.

"I was told about an old abandoned lighthouse and decided it might be worth a look. This involved a three-mile trudge over peat bog in horizontal rain to find it. I spent a considerable amount of time exploring both the interior and exterior of the lighthouse and was fascinated by the objects the previous occupant(s) had left behind, especially the sea paintings. It was an intriguing insight into the mind-set of people who could see the sea from every window, yet were so much in its thrall that the art they chose to look at consisted of sea imagery.

"Over a number of weeks I combined this work with other images of the island and of my son, Matthew, as we explored the area. For some reason,

maybe as previously described, I found a new freedom within this work to produce whatever I wanted, free from the pressures of producing work for exhibition/publication.

"The exhibition came about as a result of discussions with Fold Gallery in Cumbria. They were putting together a countywide arts festival and I felt it would be interesting to place images from the series outside the confines of the gallery. What we did was to install two, or more, large (24x30in) images on each railway station platform along the Cumbria Coastal Line, thereby maintaining the link to the sea inherent within the images. There were 36 images in total shown along a coastline of approx 80 miles from Carlisle to Barrow stations. The funding for the images came from Fold Gallery via ACENW and from Cumbria Institute of the Arts where I work as lecturer/researcher.

"The book of *(h)arris* was published by DesignWorks in Cologne as part of its downloadable *Democratic Books* series. You simply go to their website and download your own pdf copy of the book, then follow instructions as to print and fabrication and there you go – instant book. To be honest I have never printed out a copy of my own but am told the process is very simple. Having seen examples of previous Democratic Books, I was impressed by the subject matter and their design, so got in touch with them. After a very brief discussion the *(h)arris* book went ahead.

"The title *(h)arris* came about after a great deal of thought and research. I knew what the work was about: basically being on the edge geographically, physically and in terms of time of life. For some time it was going to be called *The Edge*, but by chance when looking for alternative words that meant edge I found 'arris' – meaning an edge or sharp ridge. The images were produced on Harris and it was as simple as that.

"To date I have produced a number of books and have several in the pipeline. Thinking in terms of book projects is just a part of the way I work. Constant experimentation involves making books on my computer: working with layout and how images sit on the page (or pages); use of text within the design and so on. Basically anything to develop how my work can best be seen. Most of these 'books' never see the light of day, but they are useful for me in terms of how I perceive my images and my thought processes.

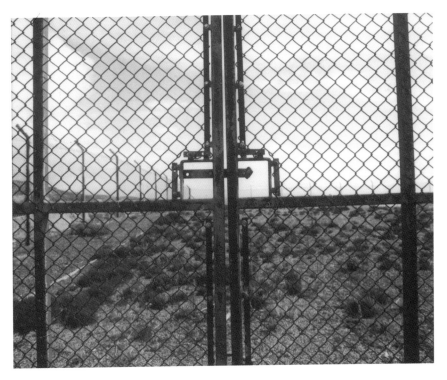

Download *(h)arris* by **John Darwell** at democraticbooks.org /HTML/*books10_9.htm*.

"I am sure as technology develops we will see more downloadable books of greater quality and production values appearing. Photography books are expensive to produce by conventional means and hard to sell in large quantities. Therefore only certain high profile names continue to be published, so the market for photography books may shrink. Books by the select few are getting bigger (very expensive) and more ostentatious. So publishing houses might bemoan lack of sales but they are essentially alienating a large section of their potential market as many people balk at spending £50 and upwards on the latest greatest hits package by an overly-exposed photographer. Surely it would be far better for these publishers to devote some of their budgets to creating an interest in up-and-coming artists with affordable books of their work, thereby creating fresh and ongoing interest in the medium?

"If the future of photography publishing is going to be based on downloadable files then at least the work is getting 'out there', which after all is what we are all aiming to do. But I for one still remember the thrill of receiving the first copy of my first published book and holding it my hands.

"It would be good if photographers in the distant future could continue to experience the sense of seeing and feeling their books in print."

Images © **John Darwell**, from his project **(h)arris**.

Several downloadable books can be seen at **www.lightreadings.com**. **www.artpost.info** has a number of free pdf downloads – including **FotoPost Toronto** and **Dislocation** – you just need to register with your email address for access.

Acknowledgements & contact information

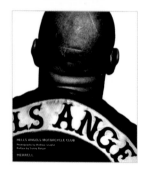

It will not have escaped your notice that without the considerable help of these photographers it would not have been possible to produce this book. Not only has each provided several examples of work from one of his/her projects, but importantly they have put their experience into words to share with others. Not only do they talk about their inspiration, but also of their efforts to secure a show and publication, and how in many cases they raised the necessary funds. The projects vary in scale from the grand to the tiny; from book sales counted in the tens of thousands, to a single hand-made copy; from carefully crafted imagery captured on large format 10x8in film, to little jewels shot on a modest camera phone; from bodies of work that received

Book jackets © top to bottom: John Claridge; Tessa Bunney; Peter Dazeley; Simon Denison; and Andrew Shaylor.

international awards and acclaim, to intriguing series to be found in an obscure corner of the internet. They may have little in common, but for the universal ingredient of a personal passion. My sincere thanks go to all these photographers who have shared this with us.

The web addresses are either the photographer's own site, or the main site featuring their work.

Marcus Bleasdale
Pages 34–35, 67
marcusbleasdale.com

Tessa Bunney
Pages 85–88
tessabunney.co.uk

John Claridge
Pages 96–99
johnclaridgephotographer.com

William Curwen
Page 65
freespace.virgin.net/william.curwen

John Darwell
Pages 125–125
johndarwell.com

Peter Dazeley
Pages 104–107
dazeleyfineart.com

Simon Denison
Pages 84, 88–91
simondenison.co.uk

Beth Dow
Pages 50–53
bethdow.com

Lynn Geesaman
Pages 70, 81-83
thomasbarry.com

Nigel Green
Pages 12–17
photoworksuk.org

Paul Hart
Pages 62–63

Richard Heeps
Pages 42–43
richardheeps.co.uk

Anthony Hopewell
Pages 36–41
anthonyhopewell.com

Alan Knowles
Pages 100–104
alanknowles.com

Chrystel Lebas
Pages 52–57
chrystellebas.com

Betsie van der Meer
Pages 30–33
betsievandermeer.com

Andrew Nadolski
Pages 92–96
nadolski.com

Simon Norfolk
Pages 18–23
simonnorfolk.com

Mark Power
Pages 15, 24–29
markpower.co.uk

Andrew Shaylor
Pages 44–47

Ed Swinden
Pages 113–115, 122
lagado.freeserve.co.uk

Hugh Symonds
Pages 48–49, 123
hupix.net

Frank Watson
Pages 108–112
centrumforfotografi.com

… and website design specialists

BiteDigital
Pages 116, 118–122
bitedigital.com

ARTS COUNCIL NATIONAL AND REGIONAL OFFICES

Arts Council England, National office
14 Great Peter Street
London SW1P 3NQ
Tel: 0845 300 6200
Fax: 020 7973 6590
Textphone: 020 7973 6564
Enquiries - this number and email address applies to all funding and general enquiries nationally.
Tel: 0845 300 6200
Email: enquiries@artscouncil.org.uk

Arts Council England, East
Eden House
48-49 Bateman Street
Cambridge CB2 1LR
Tel: 0845 300 6200
Fax: 0870 242 1271
Textphone: 01223 306893

Arts Council England, East Midlands
St Nicholas Court
25-27 Castle Gate
Nottingham NG1 7AR
Tel: 0845 300 6200
Fax: 0115 950 2467

Arts Council England, London
2 Pear Tree Court
London EC1R 0DS
Tel: 0845 300 6200
Fax: 020 7608 4100
Textphone: 020 7973 6564

Arts Council England, North East
Central Square
Forth Street
Newcastle upon Tyne
NE1 3PJ
Tel: 0845 300 6200
Fax: 0191 230 1020
Textphone: 0191 255 8585

Arts Council England, North West
Manchester House
22 Bridge Street
Manchester M3 3AB
Tel: 0845 300 6200
Fax: 0161 834 6969
Textphone: 0161 834 9131

Arts Council England, South East
Sovereign House
Church Street
Brighton BN1 1RA
Tel: 0845 300 6200
Fax: 0870 242 1257
Textphone: 01273 710659

Arts Council England, South West
2nd Floor
Senate Court
Southernhay Gardens
Exeter EX1 1UG
Tel: 0845 300 6200
Fax: 01392 229229

Arts Council England, West Midlands
82 Granville Street
Birmingham B1 2LH
Tel: 0845 300 6200
Fax: 0121 643 7239
Textphone: 0121 643 2815

Arts Council England, Yorkshire
21 Bond Street
Dewsbury
West Yorkshire WF13 1AX
Tel: 0845 300 6200
Fax: 01924 466522
Textphone 01924 438585

Scottish Arts Council
www.scottisharts.org.uk
12 Manor Place
Edinburgh EH3 7DD
Tel: 0845 603 6000 (local rate within the UK).
If you are calling from outside the UK, call +44 (0) 131 240 2444 or 2443
help.desk@scottisharts.org.uk

Arts Council Wales, Central Office
www.artswales.org
9 Museum Place
Cardiff CF10 3NX
Tel: 029 20 376500
Fax: 029 20 221447
Minicom: 029 20 390027

Arts Council Wales, North Wales Office
36 Prince's Drive
Colwyn Bay LL29 8LA
Tel: 01492 533440
Fax: 01492 533677
Minicom: 01492 532288

Arts Council Wales, Mid & West Wales
6 Gardd Llydaw
Jackson Lane
Carmarthen SA31 1QD
Tel: 01267 234248
Fax: 01267 233084

Arts Council of Northern Ireland
www.artscouncil-ni.org
77 Malone Road
Belfast BT9 6AQ
Tel: 028 90385200
Fax: 028 90661715
info@artscouncil-ni.org

AWARDS & COMPETITIONS

Prizes & Awards, published by Dewi Lewis Publishing, ISBN 1-904587-16-X.
www.dewilewispublishing.com.

The AoP Open
www.aop-open.com.

Schweppes Portrait Photography Prize
www.npg.org.uk.

Ian Parry Award
www.ianparry.org.

British Journal of Photography publishes information on upcoming awards in its news pages about every six weeks. Subscribers have access to a full listing at the magazine's website *www.bjp-online.com*. If you're not a subscriber you can sneak in the back door via *www.chiff.com/art/photo/awards.htm*, a site which links to several awards listings, another of which is *proofpositive.com/contents/photocontests.htm*.

PROJECTS & PUBLICATION

Ag magazine – the quarterly international journal of photographic art & practice – is edited and published by the author, Chris Dickie. Each issue carries portfolios from photo projects by both high-profile and emerging photographers and there are regular features on publishing photography and the requisite skills and technology.
www.picture-box.com.

If you can find a secondhand copy of *Publishing Photography*, Cornerhouse Books, 1992, ISBN 0-948797-81-9, buy it. Although publishing technology has moved a long way since the book was published, it still contains a great deal of must-have information for the virgin publisher and book designer. Its author, Dewi Lewis, went on to found his own publishing business.

The Freelance Photographers' Handbook is published each year by the Bureau of Freelance Photographers.
www.thebfp.com.